*Watkins to*
*Weston:*

# 101
# YEARS
# OF
# CALIFORNIA
# PHOTOGRAPHY

## 1849-1950

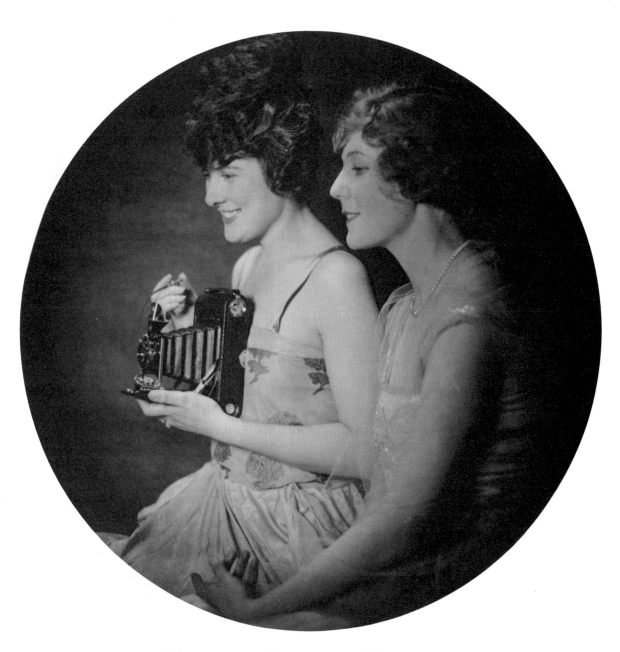

Karl Struss (1886–1981), *Two Women with Kodak Camera*, 1914.
Bromide print. The Oakland Museum, Burden Photography Fund.

Front cover: Dorothea Lange (1895-1965),
*Tule Lake, Siskiyou County, California*, 1939.
Gelatin silver print. Anonymous loan.

Back cover: Alma Lavenson (1897-1989), *Self Portrait*, 1932.
Gelatin silver print. Dr. and Mrs. Leo Keoshian Collection.

# Watkins to Weston:

# 101 YEARS OF CALIFORNIA PHOTOGRAPHY

## 1849-1950

SANTA BARBARA MUSEUM OF ART
IN COOPERATION WITH
ROBERTS RINEHART PUBLISHERS

Published in the United States of America
by Roberts Rinehart Publishers
P.O. Box 666, Niwot, CO 80544

Published in the United Kingdom and Europe
by Roberts Rinehart Publishers
3 Bayview Terrace, Schull, West Cork,
Republic of Ireland

International Standard Book Number 1-879373-20-3
Library of Congress Catalog Card Number 91-67723

Printed in the United States of America
Design: John Balint and Erin Reinecke Balint
Typography: Balint-Reinecke, set in Bauer Bodoni
Editor: Andrea Belloli
Publication Manager: Cathy Pollock
Copyright © 1992 by the Santa Barbara Museum of Art

## EXHIBITION ITINERARY

Santa Barbara Museum of Art
Santa Barbara, California
February 29 through May 31, 1992

Crocker Art Museum
Sacramento, California
June 19 through August 14, 1992

Laguna Art Museum
Laguna Beach, California
January 17 through March 28, 1993

## LIBRARY OF CONGRESS CATALOGING-IN-PUBLICATION DATA

Fels, Thomas Weston.
    Watkins to Weston: 101 years of California photography/
      Thomas Weston Fels, Therese Heyman, David Travis.
    p.   cm.
    Includes bibliographical references and index.
    ISBN 0-89951-085-X
1. Photography—California—History. I. Heyman, Therese Thau.
II. Travis, David, 1948-  . III. Title.
TR24.C2F45  1992
770'.9794—dc20  91-33095  CIP

# TABLE OF CONTENTS

# LIST OF LENDERS

The Art Institute of Chicago
California State Library Photograph Collection
Center for Creative Photography
Collection, Canadian Centre for Architecture
Dennis and Amy Reed Collection
Susan Ehrens
Fahey/Klein Gallery, Los Angeles
Fraenkel Gallery, San Francisco
The Gilman Paper Company Collection
Harvard University, Gray Herbarium Archives
William Heick
Imageworks: Merrily and Tony Page
The Imogen Cunningham Trust
J.A. Partridge, Jr. Collection
The J. Paul Getty Museum
Jan Kesner Gallery, Los Angeles
Jany Levy Reed Collection
Lee Wolcott Collection
Leland Rice Collection

Leland Rice and Susan Ehrens Collection
Dr. and Mrs. Leo Keoshian Collection
Los Angeles County Museum of Art
Rose Mandel
Marjorie and Leonard Vernon Collection
Michael G. Wilson Collection
Michael Shapiro Gallery, San Francisco
New York Public Library
The Oakland Museum
Paul M. Hertzman, Inc., San Francisco
Ron and Kathy Perisho Collection
San Francisco Museum of Modern Art
Santa Barbara Museum of Art
Stanford University Library
Stanford University Museum of Art
Andrea Gray Stillman
Department of Special Collections,
University Research Library, UCLA
William Brian Little Collection

# CONTRIBUTORS

THOMAS WESTON FELS is an independent curator and writer specializing in photography and American culture. His publications include *O Say Can You See* (MIT Press, 1989) and numerous articles and calatogues. He has also performed research and organized exhibitions for a wide variety of institutions including The J. Paul Getty Museum and the Canadian Centre for Architecture. In 1986-87 he was Chester Dale Fellow of the Metropolitan Museum of Art.

THERESE HEYMAN, an art historian and curator specializing in California photography and printmaking, lives in California. As Senior Curator at The Oakland Museum, she has acquired a number of significant photographic collections for the Art Department and is currently organizing the exhibition and book for *Seeing Straight: Group f/64.*

DAVID TRAVIS, Curator of Photography at the Art Institute of Chicago since 1972, has researched, lectured, and written extensively about both American and European modernist photography. He has initiated and contributed to large collaborative exhibitions and catalogues: *Niepce to Atget: The First Century of Photography from the Collection of Andre James* (1977); *André Kertész: Of Paris and New York* (1985); *On the Art of Fixing a Shadow: One Hundred and Fifty Years of Photography* (1989), as well as single author exhibitions and catalogues: *Starting With Atget: Photographs from the Julien Levy Collection* (1976); *Photography Rediscovered: American Photographs 1900-1930* (1979); and *The Art of Photography: Past and Present* (1985).

DERRICK CARTWRIGHT is currently involved with editing a collection of essays on California modernism to be published by The Fine Arts Museums of San Francisco and the Smithsonian Institution's Archives of American Art. He has lectured on and organized exhibitions about the institutional contexts of American art. He holds degrees from the University of California, Los Angeles, and the University of California, Berkeley, and is presently a Ph.D. candidate at the University of Michigan.

# ACKNOWLEDGEMENTS

Understandably, few people, other than one's fellow travelers in the museum world, appreciate the complexities of organizing a large exhibition from myriad sources with several contributing curators. The opportunity to be introduced to and to interact with private collectors, curators, and staff members throughout California as well as in several other places has proved both educational and rewarding. To work with three curators of the stature of Thomas Weston Fels, Therese Heyman, and David Travis could not have been more wonderful. Watching the exhibition take form in their experienced hands meant witnessing a creative process nearly as fulfilling as seeing the final version in place.

Our most important acknowledgement goes to collector Michael G. Wilson, who had the original idea for this exhibition, which Robert Henning, Jr., Assistant Director for Curatorial Services, quickly put into motion. Mr. Wilson's enthusiasm, persistence, and interest in the project, as well as his personal visits to many collections to gather information, contributed immeasurably. His insight as a collector—particularly of pictorialist works, an underappreciated area—proved invaluable to our assessment of a century of California photography. Violet Hamilton, Mr. Wilson's curator, provided extensive information from her many visits to private collections that enabled us to both select images and choose from a variety of prints of any given one. Mr. Henning also deserves sincere thanks for bringing me into the Santa Barbara Museum of Art to organize this exhibition.

At The J. Paul Getty Museum, Malibu Associate Curator of Photographs Judith Keller lent her considerable knowledge and gave suggestions at crucial moments. Curator Weston Naef was supportive of the project from the beginning, bringing it into the realm of the possible through his initial encouragement and commitment. Daily communications with Photographs Department members Joan Dooley, Kate Ware, and Andrea Hales during key periods forged a lasting appreciation for them and their counterparts.

Gary Kurutz, Head, California Section, California State Library, Sacramento, was continually helpful and responsive, as were Giles Lespard and David Harris, Canadian Centre for Architecture, Montreal, and Julia van Haaften, New York Public Library. Susan Roberts, Stanford University Museum of Art, and Margaret Kimball, Head, Special Collections, took it upon themselves to make the Stanford loans possible, for which I am grateful. Terence Pitts and Dianne Nilsen at the Center for Creative Photography were kindly responsive to needs and deadlines, as were Simon Elliot and Hilda Boehm at the Department of Special Collections, University Research Library, UCLA. Curator of Photography Verna Curtis and Beverly W. Brannan at the Library of Congress, as well as S. Bennett Fong and Julie Nelson-Gal at the San Francisco Museum of Modern Art went far beyond duty to aid in this project.

At the Los Angeles County Museum of Art, thanks go to Robert Sobiezek, curator of photography, for his understanding and humor, and to Sheryl Conkelton for her capable assistance. Lange Collection Curatorial Assistant Drew Johnson at The Oakland Museum generously contributed artists' biographical material, and the History Department there was also particularly helpful, as were John Blaisdell, Christine Droll, Kathy Borgogno, and Joel Hoffman. Pam Feld of the Ansel Adams Publishing Rights Trust was, as always, a pleasure to work with, and thanks also go to Mrs. Elizabeth Partridge at The Imogen Cunningham Trust.

Heartfelt appreciation goes to the many people and institutions who assisted in so many ways: family descendants of Sigismund Blumann and Anne Brigman, particularly Thomas High and Mrs. Willard Nott; The Mission Museum Library in Honolulu, Dr. Amy

Conger, Susan Ehrens, James Enyeart, Sarah M. Lowe, Katrina Miottel, Sandra S. Phillips, Lorna Price, Amy Stark Rule, William F. Stapp, Stephen Vincent, Leslie Wright, The Oakland Museum interns, Wanda Corn's Stanford University seminar participants, and Jenny Stern for her research on Anne Brigman.

One of the particular pleasures of organizing this exhibition has been the interactions with collectors and gallery owners. They have generously shared their knowledge, sources, and in many cases, parts of their collections. I wish to thank Bonnie Benrubi, David Fahey, Jeffrey Fraenkel and Frish Brandt, G. Ray Hawkins, Paul Hertzmann and Susan Herzig, Graham Howe of Curatorial Assistance, Leo and Marylis Keoshian, Jan Kesner and Amanda Doenitz of the Fraenkel Gallery, Allan Levy, William Brian Little, Dan Miller, Scott Nichols, Merrily and Tony Page, Ron and Kathy Perisho, Dennis and Amy Reed, Leland Rice, Michael Shapiro, Susie Thompkins, Marjorie and Leonard Vernon, and Lee Wolcott.

Special thanks go to my enthusiastic colleagues at the institutions sharing the exhibition with us: Jan Dreisbach, curator of the Crocker Art Museum in Sacramento, and Susan Anderson, curator of exhibitions at the Laguna Art Museum.

Needless to say, the Santa Barbara Museum of Art staff has shouldered a good deal of the work to bring this exhibition and book to fruition. My appreciation goes to the curatorial, registration, and installation staff at the Santa Barbara Museum of Art for their support, and to Publications Manager Cathy Pollock who worked to create the best publication possible. My respect and appreciation to Andrea Belloli, who edited the publication. Her professionalism and perspective enriched the project considerably. Thanks also go to Librarian Ron Crozier for his help in fact-checking. Most especially my profound gratitude to Jennifer Zemanek who researched and assembled most of the biographical material. In addition she dealt with the thousand details that demanded organization and solution, and did so with humor and care.

Finally, my deep gratitude to the photographers included here who are still with us, and whose work so richly deserves this closer look: Ruth Bernhard, Horace Bristol, John Gutmann, William Heick, Pirkle Jones, Rose Mandel, Hansel Mieth, Wright Morris, Peter Stackpole, Edmund Teske, and Brett Weston. The legacy of their work and that of their colleagues is both vital and enduring.

*Karen Sinsheimer*
*Consulting Curator of Photography*

## PHOTOGRAPHY CREDITS

Art-Repro, Curatorial Assistance:
   p. 85, 88, 89, 98, 140 (left), 146, 158, 1690 (top and bottom), 174
John Blaisdell: p. 73 (right)
Ben Blakewell: p. 138, 142, 147 (top), 160 (top and bottom), 161, 163
Center for Creative Photography: p. 76 (right)
Bill Dewey: p. 75 (right), 77
M. Lee Fatherree: p. 26 (top), 29 (bottom), 83 (left), 108, 110
David Folks: p. 30, 31, 51, 91, 102 (right)

# The Place of Photography

■ *Derrick R. Cartwright*

WE SHARE a preeminently photographic vision of California. The name of the place conjures distinct images—a panoramic view of San Francisco, a stand of eucalyptus in abrupt silhouette, the Yosemite Valley under a fresh snowfall—and it brings to mind certain faces— the grizzled miner, the migrant fieldworker, the Hollywood starlet. To a large extent we have assimilated this extraordinary visual archive, and we insist that such images are our own. But we also proudly recognize these representations as the work of specific photographers. The landscapes that we see in our mind's eye belong unmistakably to Eadweard Muybridge, Oscar Maurer, or Ansel Adams, and the portraits should be signed Dorothea Lange, Laura Adams Armer, or Arnold Genthe. Any effort to understand the place of photography in California must contend with this somewhat paradoxical experience. How did California become so closely identified with its photographic image? And how is it that we have come to possess this particular vision so completely?

The connection between photographers and California is, in fact, long-standing and complex. Historians of both the medium and the place have pointed out that the drive for statehood coincided neatly with the arrival of photographic operators on the Pacific coast.[1] Virtually from the outset, then, photography was available to serve the forty-niners and builders of the railroads. The daguerreotypist's shop became an obligatory stop for anyone who wished to obtain a souvenir, albeit a fragile one, of his or her appearance at the frontier. With the rapid expansion of early settlements and further exploration of the interior, demand for visual documentation of this widespread growth increased as well. Photography was uniquely suited to fill this representational need.

Photographic technologies progressed at a pace that seemed to keep step with other remarkable transformations in the region. Indeed, advances in the medium had an immediate and mutually reinforcing effect on photography's close association with the place. Armed with cameras that turned out large, exquisitely detailed images of their explorations, the survey expeditions produced a stunning encyclopedic record that enjoyed an audience on multiple levels. For land speculators these photographs promised a rich return on their investment. For scientists the geological wonders encountered in the richly toned plates might resolve contemporary mysteries about the planet's remote past. For most early boosters of the West, the survey album simply justified their strong sentiments. From 1850 forward, photographs were taken to be incontrovertible and, therefore invaluable proof of California's numerous attractions.

In that early phase of representing the place, Californians were quick to acknowledge the medium's documentary authority. Progress and empiricism dovetailed in the photographic image. This combination earned entrepreneurs like Carleton Watkins and Muybridge great status as artists, and their renown soon extended far beyond the state's borders. Accordingly, more and more photographers appeared in California, following their lead. There were other subtle reasons for this rise in practice.[2] It is safe to say, however, that the lure of California for photography owed as much to the thrill of exploration as it did to the hope of commercial success.[3]

There were scores of visual artists already in residence within a generation after statehood was achieved. Still, only a few of them competed in the same sphere of national celebrity as the leading photographers. Painters and illustrators flocked to the frontier after the Gold Rush, excited by the prospect of potential patrons among the new urban elites and by a bountiful landscape that was being made increasingly familiar through photographs. A number of these painters, like Thomas Moran, Worthington Whittredge and Albert Bierstadt, actually worked alongside the photographers on the government-sponsored surveys that established the nearby territories. Later, some were inspired to travel farther west to recover that dramatic landscape for

themselves. Bierstadt, for example, first arrived in California in 1863.[4] After a short rest in San Francisco, he proceeded directly to Yosemite.[5] The oil studies that he painted there deserve to be counted among the most impressive representations of the place, sharing with contemporary photographs a shimmering clarity and an awed appreciation of what the site offered. Bierstadt took up his Yosemite sketches again after returning to his Manhattan and Hudson River Valley studios, using them as sources for monumental compositions of the West. Yet the story of Bierstadt and, correlatively, of the reception for nineteenth-century California painting is one of brilliant but ultimately eclipsed appeal. Photographs set in the region, on the other hand, maintained a firmer place in the American memory.

California culture matured by the turn of the century, and artists benefited directly from its coming of age. Several art periodicals and reviews were in regular publication by 1900. A variety of credible gallery spaces were in place throughout the state, thus assuring that local artists could see advanced art.[6] Additionally, both men and women were being served by art academies, as well as by numerous more informal sketch clubs. Aspiring artists could therefore boast of professional instruction existing on a par with, if not better than, most other states. The successful founding of these institutions reflected a burgeoning economy, and

their vital presence goes a long way toward explaining the desire of so many artists to have their work identified with the thriving artistic reputation of California. But just as the taste for home-grown landscape paintings waned with the increased sophistication of the local marketplace, so too did photographers begin to measure themselves against an increasingly national yardstick of aesthetic accomplishment.

It was certainly possible for an advanced photographer to practice his or her craft here, and to even receive some attention for it at annual photographic salons, just as any painter might in those years. But no one could be thought of as truly advanced without casting a sidelong glance (and from time to time taking a more deliberate gaze), at artistic developments occurring elsewhere. What ultimately matters—both for our instinctively modern sense of photography and for that modernity's specific identification with California—is that such photographers never wandered very far in order to take those looks.

The Panama-Pacific International Exposition, which was held in 1915 to celebrate the construction of the Panama Canal, offered one clear proof of this. Almost nineteen million people visited the P.P.I.E. while it was open.[7] Once inside the gates and beside San Francisco Bay, the spectacle it offered fairgoers in terms of progressive architecture, monumental sculpture, and splendid mural

decorations marked a watershed in artistic developments for the state. The numerous exhibitions were calculated to overwhelm. The exhibition of fine art alone included 11,403 works.[8] Never before had Californians had an extended opportunity to study such a complete range of historic and modern art. Even a landmark exhibition like the Armory Show, held two years earlier in Manhattan's 69th Regimental Armory, could not pretend to represent the same international survey of modernist tendencies, although its terrific impact on both artists and the public is legendary.[9] In the same way, the P.P.I.E. flooded its public with unpredictable, modern viewpoints. California photographers were set adrift by these visions.

One has only to compare a selection of images showing the P.P.I.E. with pictures taken at the World's Columbian Exposition, held in Chicago in 1893, to get a sense of how photography had evolved over a short period of time. Both fairs provided the opportunity to show the world that American cities could bounce back from disasters—the fire of 1871 and the 1906 earthquake—without difficulty. In a real way, then, both fairs were proving-grounds for local culture. However, the official image of Chicago's "White City" was of a rational, axially planned, inherently ordered urban space. Photographs of the Chicago fair faithfully represented the corporate world

view of its organizers. In most instances, and absolutely in contrast, the P.P.I.E. appeared illusory—at once glowing and evanescent. The place lent itself to caprice, and the representations it found were hauntingly unreal. Photographers embraced the architecture, such as Bernard Maybeck's Palace of Fine Arts, as equivalent to their own grand, if equally eccentric, pursuits. The tendencies of artists like Francis Bruguière came to fruition at the P.P.I.E. because both the event and contemporary photographic aesthetics seemed to support a broadly romantic position. But if the moment was right for a subjective perspective like Bruguière's, or that of his colleague Anne Brigman, it was also right because pictorialism's goals were aligned with other dominant tendencies in California art of the time.[10]

The interest in identifying photography with fine art, and thus distancing it from an earlier designation as a mechanistic practice, was a profound aim of pictorialism. With it came a new insistence on the individual's role in producing the photographic image. The strong craft emphasis in California from the late nineteenth century on was certainly in sympathy with this objective. Influential painters like Arthur Frank Mathews and designers like Maybeck or Charles and Henry Greene predisposed the public to a taste for decorative works that bore the proud traces of hand work. Decorative ideals could then exist free of any pejorative cast and artists could pursue purely "decorative" effects in their art without fear of the criticism such an approach inspires today. Certainly photographers like Clarence White and Brigman shared this decorative impulse with Mathews and his many pupils.

The spirit of pictorialist photography was at odds with the objective, reportorial mode of California photographs which preceded it. Moreover, the pictorialists were preoccupied with technique to a much greater degree than was possible for earlier photographers. But this

was, first and foremost, expressive technique. That is, the various special ways of manually treating the negative, or of deliberately softening the focus were never placed above the desired end, which was not merely to create effects, but to make effectively "new" images.

Pictorialist photography was still not fully modern, although many of its proponents would eventually be considered the leading modernists. Adams, Imogen Cunningham, and Edward Weston all began their careers as pictorialists, and Watkins ended his career as one. The change in attitude of this cast of characters should not mystify us too much. Without always proving itself presciently modernist, pictorialism did deliberately affirm some of modernism's basic tenets. By insisting on the primacy of individual viewpoint, promoting a sensitivity to the special qualities of the medium (in addition to an exploration of its limitations), and by valuing poetic evocation above literalism, pictorialism cleared the way for more fully blown modernist depictions. The pictorialist agenda, in fact, amounted to a condemnation of traditional academic principles and was understood as such by its opponents (many of whom thought it bad enough that these photographers wanted to be considered artists in the first place).

Finding advocacy for such an extensive program of aesthetic change should hardly be mistaken for a *fait accompli*. It had to be imported in the form of Eastern photographic journals like Alfred Stieglitz' *Camera Work* (1903-1917) and in texts like Charles Caffin's *Photography as a Fine Art* (1901). It also arrived in the dynamic form of one of photography's most brilliant, early critics, Sadakichi Hartmann. Articulate, worldly, and utterly convinced of photography's legitimate place among the fine arts, Hartmann arrived in California in the late 1910s, stopping first for a couple of years in the San Francisco Bay area, before settling in Hollywood for a longer stay.[11] In New York, Hartmann published extensively

on photographic matters. He was just as familiar with vanguard painting and sculpture. He also enjoyed a close rapport with outspoken cultural doyens like Stieglitz and Walt Whitman. Once in California, he struggled to win over magazine editors to the more progressive topics he favored. He was successful, in any event, at promoting his ideas among young photographers like Edward Weston. In fact, Weston made a suitably moody portrait of Hartmann around 1920 as a tribute to him. The presence in Los Angeles of a critic of Hartmann's reputation and insight promoted photography to a new level of respect. Additionally, he served as a filter between the clique of local photographers and a cosmopolitan group of modernists who were also living in Southern California at the time.

Obviously, Hartmann was not the only American intellectual drawn to the South-land during these years. The attraction of its Mediterranean climate and coastal scenery was undeniable, and not just for Americans. Many European intellectuals who came to visit or came as political refugees stayed because of a surprisingly strong critical atmosphere. From 1920 through 1940 Los Angeles was host to scores of émigrés—Theodor Adorno, Bertolt Brecht, Aldous Huxley, Thomas Mann, and Arnold Schoenberg, to name only a few— whose ultimate contribution to the overall state of culture is only just beginning to be sorted out by art historians.[12] Further intrigued by the film industry, most of these figures were slow to move on. Ultimately, they were frustrated by their failure to make a permanent place for themselves in the local culture and reluctantly did go (as did Hartmann), dimming the intellectual scene and leaving the area's critical destiny only partially fulfilled.

The importance of Hollywood cinema during its classic phase has been widely recognized. The film industry's effect on promoting California culture in the thirties and forties was fantastic. In retrospect, however, it

presents us with a puzzling denial of the economic worry that prevailed throughout the state's huge agricultural industry. Even as film crews were issuing their own fictive representations of the California experience, Dorothea Lange and a select team of other photographers were providing a critical look at the hardship that characterized these years for so many.

The Historical Section of the Farm Security Administration (FSA) was a New Deal era agency that tackled this problem photographically. FSA workers were committed to bettering the condition of the farm communities that suffered terribly during the Depression. By hiring photographers like Lange, Berenice Abbott, Jack Delano, Walker Evans, Russell Lee, and Ben Shahn—whose photographs were in turn used to illustrate reports submitted to Congress—the Administration sought to gain short-term assistance in the form of legislative relief acts for farm laborers. The documentary images that Lange created for the FSA reports shared an aura of truth with earlier survey photographs. Yet this interpretation of the photograph as an objective document is hard to sustain given what we know about its rhetorical applications.[13] By this time the accomplished artist, such as Lange surely was, knew precisely how to evoke a response through the subtlest strategies—by cropping a negative to emphasize a cramped space, or by shooting up at a figure from below to create a sense of heroic monumentality.

The work of photographers associated with the Group f/64 provides a striking counterpoint to the documentary impulse of Lange. Whereas Lange brought her artistic sensitivity directly to bear on social causes, the work and attitude of fine art photographers like Weston and Adams tended to repudiate those themes.[14] Instead these men concentrated on what they felt were the timeless qualities of their subjects, and on the medium itself. Strict applications of the zone system and the most painstaking studio preparations resulted in a hitherto unmatched mastery of the photographic print.

The lustrous prints of Adams, Weston, Cunningham, and Minor White are perhaps the best known to us of all the work discussed so far. It is while contemplating their inscrutable finish that we recognize photography as most assuredly fine art. These are also the most deeply problematic works for the narrative of California photography as it unfolds in this introduction. For how can we explain a relationship that we so naturally feel between these images and this place? There is nothing, after all, intrinsically Californian about a bell pepper or a magnolia blossom. It is precisely, however, the *way* we have been shown these images—the subject treated as a discrete set of formal possibilities—that allows us, finally, to make the connection. We could say that the expeditionary gaze was rediscovered at Point Lobos.[15] Once there, it was brought under control, subjected to the greatest discipline, and set to explore once again—this time seeking rocks and waves, the sand and the nude, a bit of driftwood ensnared in seaweed.

"Everything worth photographing is in California," Weston wrote.[16] He felt no shame about mythologizing the place in which he had chosen to refine his art. He might have said, "Everything worth seeing is in California." The nature of his boast would not be changed significantly by such a substitution. We have, but briefly, seen how the connection between sight and site has a vivid photographic history here. This overview began with the assertion that vision and photography share something unique when it comes to California. Weston certainly believed that California was the photographic place par excellence, as Watkins must have before him, and we have little reason to dispute their authority in the matter. Especially since we are in the habit of making photographers' views our own.

## NOTES

1. In his biography of Watkins, Peter Palmquist refers to the published record of daguerreotypists in San Francisco from January of 1849 forward. See *Carleton E. Watkins: Photographer of the American West* (Albuquerque, 1983), 5. See also Therese Heyman, "Scenes of Curiosity and Wonder," in *Picturing California: A Century of Photographic Genius*, exh. cat. (The Oakland Museum, 1989), pp. 141-142.

2. The most complete source on this activity remains Weston Naef, *Era of Exploration: The Rise of Landscape Photography in the American West, 1960-1885*, exh. cat., (Albright-Knox Gallery, The Metropolitan Museum of Art, Boston, 1975). Another compelling interpretation is given by Alan Trachtenberg, "Naming the View," in *Reading American Photographs: Images as History, Mathew Brady to Walker Evans* (New York, 1989).

3. Philip Stokes, "Trails of Topographic Notions: Expeditionary Photography in the American West," in *Views of American Landscapes*, ed. Mick Gidley and Robert Lawson-Peebles (Cambridge, 1989), pp. 64-77.

4. The details of Bierstadt's trips west are discussed in Gordon Hendricks, "The First Three Western Journeys of Albert Bierstadt," *Art Bulletin* 46 (September 1964), pp. 333-365. For the most recent summary of his activity in California, see Nancy K. Anderson, "'Wondrously Full of Invention:' The Western Landscapes of Albert Bierstadt," *Albert Bierstadt: Art and Enterprise* [exh. cat., The Brooklyn Museum] (Brooklyn, 1991), p. 81. Bierstadt was himself no stranger to a camera. He undoubtedly took photographs while performing his duties for the geological surveys to which he was attached, and he sponsored his brothers' photographic business.

5. Bierstadt and his companion, the writer Fitz Hugh Ludlow, reportedly spent their last night in the city gazing expectantly at Watkins' photographs of Yosemite. See Ilene Susan Fort and Michael Quick, *American Art* (Los Angeles, 1991), p. 158.

6. Earliest among these examples might be The California Art Union which was established in 1865. The San Francisco Art Association traced its roots back to 1871. The E. B. Crocker Art Museum opened in 1873, and Sacramento hat its own art school as well by 1890. The M. H. de Young Memorial Museum (which opened to the public in 1895 as the Memorial Museum) and The Oakland Art Gallery (founded in 1916) combined to give Northern California a leading profile in the arts. Southern California lagged behind culturally, but only briefly. The Ruskin Art Club was one of the oldest associations in the area, dating from 1888. Commercially, the Kanst Art

Gallery operated in Los Angeles from 1895 to 1924. By 1911, Los Angeles had founded its first public art museum, the San Diego Academy of Art opened its doors to students in 1910, and the Huntington Library and Art Collections in San Marino were born in 1919. A useful chronology of early California art institutions can be found in Edan Milton Hughes, *Artists in California*, 1786-1940, 2nd. rev. ed., (San Francisco, 1989), pp. 7-8.

7. The fair was open from February 20 to December 4, 1915. See Frank Morton Todd, *The Story of the Exposition*, 5 vols. (New York, 1921), 5:159.

8. Ibid., 4:23.

9. The Armory Show was unable, for example, to exhibit works by the Italian futurists, whereas Giacomo Balla, Umberto Boccioni, Carlo Carrà, Luigi Russolo, and Gino Severini were all included in a special grouping within the P.P.I.E.'s International Section. For details about the Armory Show, see Milton W. Brown, *The Story of the Armory Show* (New York, 1963).

10. Pictorialists dominated California's earliest annual photographic exhibitions. In San Francisco, the First Annual Exhibition of Photographs was sponsored by the Camera Club in 1901, and was held for years afterwards at the Mark Hopkins Institute of Art. In Los Angeles, the First International Photographic Salon was held in January 1918, under the sponsorship of the Camera Pictorialists of Los Angeles.

11. The peripatetic Hartmann had recently tired of a stormy but, at bottom, productive working relationship with Stieglitz before making his way to the West Coast. His work for *Camera Notes* and *Camera Work* provided a steady audience for his ideas for nearly two decades. Details of Hartmann's biography are set out in the editor's excellent introduction and chronology in *Sadakichi Hartmann: Critical Modernist—Collected Art Writings*, ed. Jane Calhoun Weaver (Berkeley, 1991), pp. 1-48.

12. See Paul J. Karlstrom, "Modernism in Southern California, 1920-1956: Reflections on the Art and the Times," *Turning the Tide: Early Los Angeles Modernists, 1920-1956*, exh. cat. (Santa Barbara Museum of Art, 1990) pp. 16-17.

13. The Farm Security Administration (FSA) was originally called the Resettlement Administration (RA), and was responsible for producing nearly 300,000 photographs in the period between 1935 and 1942. For a critique of the objective status of these images, see John Tagg, "The Currency of the Photograph: New Deal Reformism and Documentary Rhetoric, " in *The Burden of Representation: Essays on Photographies and Histories* (Amherst, 1988), pp. 153-183. The richest analysis of Lange's rhetorical strategy is in Wendy Kozol, "Madonnas of the Fields: Photography, Gender, and 1930s Farm Relief," *Genders* 2 (Summer 1988): pp. 1-23.

14. In a letter to Adams dated December 3, 1934, Weston defended their position. "I agree with you that there is just as much 'social significance in a rock' as in 'a line of unemployed.' All depends on the *seeing.*" Letter quoted by permission of the Ansel Adams Archive at the Center for Creative Photography, University of Arizona.

15. The exception to this proposition, which might finally be said to prove its rule, can be found in Weston's own career. The landscapes that Weston undertook late in life, principally the two projects he turned to during and after his 1939 Guggenheim award—*California and the West* and his illustration for a special edition of Whitman's *Leaves of Grass*—refocus his trademark "close vision" onto a wider landscape. One could argue that among Weston's final gestures we find evidence of the expeditionary gaze returning in its purest form. In a symmetrical way, the photographs that initially made their way to California as part of the survey teams, reverse direction. Weston took his view camera and left his home in Carmel, proceeding east to create these landscape views. See Andy Grundberg, "Edward Weston's Late Landscapes," and Alan Trachtenberg, "Edward Weston's America: The *Leaves of Grass* Project," in *EW 100: Centennial Essays in Honor of Edward Weston* (Carmel, 1986), pp. 93-116.

16. Quoted in Bill Barisch, "Acts of Attention," in *Picturing Photography: A Century of Photographic Genius*, exh. cat. (The Oakland Museum, 1989), p. 7.

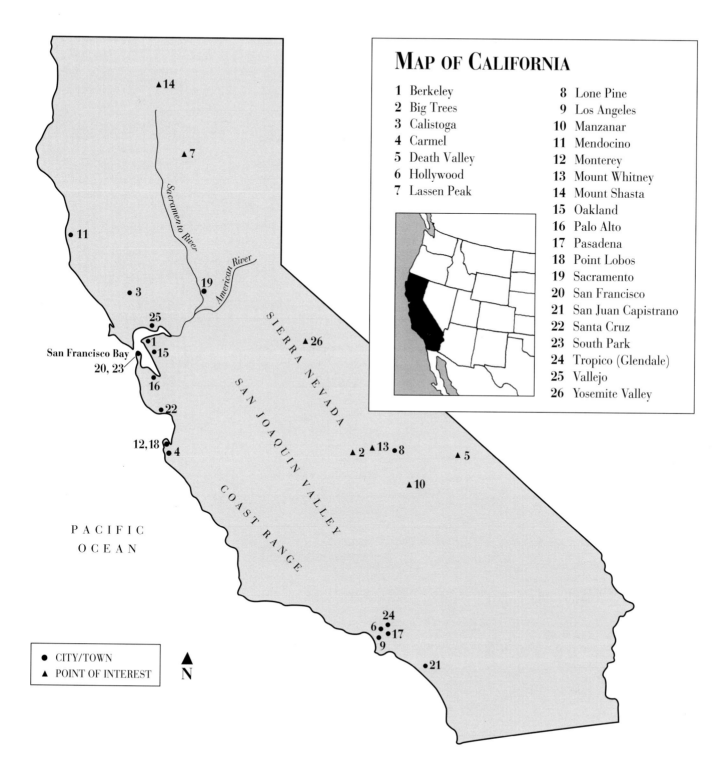

# MAP OF CALIFORNIA

1 Berkeley
2 Big Trees
3 Calistoga
4 Carmel
5 Death Valley
6 Hollywood
7 Lassen Peak

8 Lone Pine
9 Los Angeles
10 Manzanar
11 Mendocino
12 Monterey
13 Mount Whitney
14 Mount Shasta
15 Oakland
16 Palo Alto
17 Pasadena
18 Point Lobos
19 Sacramento
20 San Francisco
21 San Juan Capistrano
22 Santa Cruz
23 South Park
24 Tropico (Glendale)
25 Vallejo
26 Yosemite Valley

▲14

▲7

Sacramento River

American River

• 11

• 3

• 19

25

San Francisco Bay
20, 23

• 1
• 15

16

• 22

SIERRA NEVADA

▲26

SAN JOAQUIN VALLEY

COAST RANGE

12,18
• 4

▲ 2  ▲13  • 8

▲ 5

▲10

PACIFIC
OCEAN

24
6 •
• 17
9

• 21

• CITY/TOWN
▲ POINT OF INTEREST

▲
N

FROM THE BEGINNING California has been seen as something different. Idealized as a Garden of Eden and condemned as a hell on earth, endowed with scorching deserts and snow-capped mountains, encompassing both the highest and lowest points in the contiguous forty-eight states, alternately a haven of rural retreat and a bastion of advanced culture, California for all its variety is indisputably one thing: distant and distinct from most other concentrated sectors of American culture. Its Spanish and Native American history, and its brushes with the cultures of Polynesia, the Orient, Russia, and the Northwest, gave it a peculiarly Pacific flavor. As a region of the larger nation its meteoric progress came relatively late. Ceded by Mexico only in 1848 and admitted as a state two years later, California had recently experienced a military conquest, a wave of immigration, and spurt of explosive growth that forced it at an early time into a pattern in which high expectation coexisted with gritty reality, a pattern that persists in some forms until today.

In the mid-nineteenth-century the role of the California photographer was to reveal California. Few had visited the state, and little of the art that recorded it had reached the world outside its immediate borders. Those

# Visualizing California: Early Photography 1849–1890

■ *Thomas Weston Fels*

already living in the area sought confirmation of the basic nature, activities, and appearance of a place so new. It is easy, looking back, to see the Yosemite Valley, San Francisco, the Sierras, or the coast itself as obvious subjects for the camera. But before they were widely known, photographers played a key role in recognizing them as important motifs, defining them, and bringing them to the attention of the public.

On the basis of this early visual identity, later generations of photographers went on to pursue their own missions. In the following pictorialist era of the late nineteenth and early twentieth centuries, the prevalent role of the photographer in California, as in other parts of the nation and world, was to produce fine art. As part of this international movement, Californians had something unique with which to work, a specific visual vocabulary and way of life. For example, the haunting and often inhabited pines in Anne Brigman's photographs combine the sophistication she learned from advanced practitioners of photography with the Oceanic myths of her Hawaiian childhood and a freedom of line which may have been influenced by the European art of her time (pp. 76, 77). The motifs themselves, though, the gnarled cypress, the rocky cliff, the human torso, had a history and iconography of their own in California life and art.

In the succeeding generation, which included many of the pictorialist artists at a later period of their work, modernism was also filtered through California eyes. Artists equally as sophisticated but different from each other as Edward Weston, Imogen Cunningham, and Ansel Adams bent their sensibilities, distinctly affected by the West, to the prevalent uses of the day, ranging from direct responses to the modern age itself, to introspective reaction to it through development of an intensely personal or private style.

Through this as in all eras ran an affinity for indigenous places, subjects, and themes that distinguishes the state's photography from other bodies of contemporary work. Daguerreotypes from the late forties and early fifties, only a decade or so after the invention of the medium, portray some of the many men who came to seek their fortunes in the gold fields as well as their companions, employers, and other community members. Side by side with the familiar attributes of Eastern portraiture—books, framed prints, classical busts and columns—we find, either as wishful fantasy or desperate fact, picks, gold pans, revolvers, and knives (figure 1-1). Less frequently, such early images picture the claims and cabins themselves or the rough-and-tumble small towns in which the miners traded and passed the time. Prominent in these compositions are the sluiceways, placer piles, and aqueducts that were central features of California life (p. 48). Early views of San

**Figure 1-1.** Unknown, *Portrait of D.A. Phelan, Miner,* c. 1851, daguerreotype. Collection of Robert Shimshak.

Francisco frequently include the armada of abandoned ships which had brought American argonauts to the West.

With the advent of the glass negative and paper print known as the wet-plate process in the mid-1850s,[1] another range of subjects became prominent. The increased size of prints and the possibility (through negatives, copies, and the vastly popular stereoscope) of wider distribution insured both a larger audience and the broader treatment of a range of California themes. Series of views were made in the new, larger format or as stereo cards. All of these had an aesthetic appeal that more closely resembled that of popular prints and paintings than that of generally smaller and more intimate daguerreotypes. Treatments of cities (especially, because of its size and rapid growth, San Francisco, although views of many other towns were taken as well) recorded the opulent new houses of the few who truly had found their fortunes. Such buildings, like the larger edifices of commerce, were artifacts that bespoke the change in mining technology from the pan to the stamping mill; the vast growth in shipping, trade, and banking; and, later, the successful completion of the transcontinental railroad (p. 52,53). With the arrival of paper prints, landscape, limited by technical and aesthetic considerations in the earliest days of photography, became a business in itself. There were natural monuments to be shown, and the adventurous photographer willing to be troubled with the formidable quantity of necessary equipment and supplies found a public eager to place his dramatic views of mountains and seacoast on walls, in scrapbooks, or in the parlor stereoscope. All of these activities emblematized the growing interest in the wonders of California's landscape. Even industrial and commercial subjects—mining, manufacturing, logging, and agriculture were represented in views we still find very moving today.

Such themes of California land and life continue to motivate photographers and other artists of the state. In important ways the photography of California in the nineteenth century laid a base for succeeding generations. It is not, however, a tradition couched in the easily read language of a single unbroken style. Rather, the photographic link between the three eras discussed here—early work, pictorialism, and modernism—is one of approach, and outlook, and common adherence to a growing set of customs, institutions, and values that we identify with the primary strands of the California experience.

Indeed in California there was much to interest an early viewer. Travelers entering the northern and central parts of the state from the continental side first experienced the Sierras before reaching the broad central valleys and the coast. Passengers arriving by sea, having endured a voyage of several months to half a year in length, entered San Francisco Bay, the center of most shipping on the West Coast, a magnificent land- and seascape and a welcome harbor in the most essential sense of the word. In either case the effect was dramatic. Above the Sierras towered Mount Shasta, Lassen's Peak, Mount Whitney, and other less prominent natural monuments; beyond their foothills lay the fertile lands of the immense San Joaquin and Sacramento river valleys. The coast itself offered a wide geographical spectrum of sandy beaches, bluffs, wooded inlets,

and rocky outcroppings. San Francisco Bay was ringed with hills and had about it a rugged, primal air not dispelled by the city growing on its shores; its fogs and seal-covered rocks, treacherous to mariners, were a spur to romantic myth. Later, with the development of Southern California, forbidding deserts and dunes and the flora of a milder, even arid climate lent yet another visual dimension to the settling of the state.

Almost immediately, California photographers set out to distill emblematic images from these vast resources. In 1851 the daguerreotypist Robert Vance showed a sizable series of landscape views (now lost) in New York to great acclaim.[2] In 1858 Charles Leander Weed took a series of wet-plate scenic and mining views along the American River and in 1859 produced the first photographs of the Yosemite Valley (p. 54; 57, top). Carleton Watkins, to many the finest of all early California photographers, took his first set of Yosemite views, classics of the art, in 1861. In later years he made additional visits to the valley, producing work which was refined in different lights and from slightly differing points of view, until in each image he achieved a closely calculated artistic statement using nature as its vocabulary (p. 43, top). In the thirty years of his public career, between 1860 and 1890, Watkins covered a wide range of California subjects which could serve today as a survey of the land and culture of the time. Eadweard Muybridge, an Englishman working in San Francisco during the same era as Watkins and Weed, brought his own aesthetic to Yosemite in a series of often dramatic views emphasizing the romantic aspects of the valley. Like Watkins he depicted the coast and a broad spectrum of other California subjects as well. In addition, as in the daguerrean era, photographers produced a large number of portraits of those who settled and used the land.

**Figure 1-2.** Carleton Watkins, *Commencement of the Whitney Glacier, Summit of Mount Shasta*, c. 1870, albumen silver print. Amon Carter Museum.

The landscape views taken by Watkins, Weed, Muybridge, and their peers were most often destined for a public market. Other aspects of the land emerged, in this era of great growth in science and research, as an adjunct to the work of surveying, in the recording of feats of mining and engineering, and in the portraying of progress and change in the field of agriculture. These views, often taken on commission, show a wide range of attitudes which would surface again in later work. Such photographs approach the direct, objective portraiture of the land encouraged by the surveys; this is epitomized by Watkins' work for the geologist Josiah Whitney, director of the state survey of California. Informative documentary and scenic views along the state's rail and wagon roads comprise another, often less formal area of work. Views of the working landscape—fields under cultivation or irrigation, vineyards, or new orchards coming into bloom—offer a picture of the central valleys and their arable offshoots, the Eden to which many immigrants were drawn. Along the coast, shipping, commercial enterprises—especially mills and raw landscape were common subjects that spoke eloquently of the resources and activities of the state (p. 41). Collectively, these views—offering as subjects the growth and exploration of a major sector of a powerful new nation and as medium the novel photographic mode of presentation in which the vision of important new artists was being worked out—comprise, along with other California and Western views of the time, a body of work which has parallels in the history of other media only in their most fertile periods.

Another range of material descriptive of life on California's land was its architecture. Lacking a visual ancient history other than the geological and ethnographic, early California photographers fastened on the few available remnants of the past of the American West, most prominently the Spanish missions and occasionally the Native American populations. They also recorded, with the zealousness of converts to the new land, its contemporary buildings, which themselves often evoked the very history for which their eclectic styles attempted to compensate. For example, early views of South Park, a stylish section of new housing in San Francisco, reveal it to have been perfect in every urban detail and comparable to its counterparts in Boston or New York—and, before them Paris and London—except for the lack of a city to surround it (p. 39, bottom). Indeed houses and towns more ambitious than jury-rigged mining camps tended to reflect in style, materials, and relation to the land their Eastern, Midwestern, or European roots. Views of settlements such as Pasadena, with their new fields, orchards, or vineyards, their Midwestern building styles and their familiar farm layout, embodied the American spirit of colonization and community transposed to a new setting (p. 46, bottom). The encouragement of tourism and recreation was represented by numerous images of hotels and resorts, often ostentatious structures modeled on their counterparts in Saratoga or Virginia and often established, like them, at the sites of hot springs or other resources for health and recreation.

Perhaps indicative of this interest in the land are the writings resulting from Robert Louis Stevenson's visit to California in the late 1870s. Stevenson's enthusiastic but critical alertness to myth and tale allowed him to see the best of California while reserving a fund of skepticism for some of the inflated claims which surrounded it. Traveling for health reasons, he was especially sensitive to climate and land. Crossing the Midwest, of which he said summarily in *Across the Plains* (1895), "It was a sort of flat paradise," he reached Wyoming, which did not please him. His impressions reveal his familiarity with the prevalent imagery of the time:

Hour after hour it was the same unhomely and unkindly world...; tumbled boulders, cliffs that drearily imitate the shape of monuments and fortifications—how drearily, how tamely none can tell who has not seen them; not a tree, not a patch of sward, not one shapely or commanding mountain form; sage-brush, eternal sage-brush.... Except for the air, which was light and stimulating, there was not one good circumstance in that God-forsaken land.[3]

On reaching California, however, Stevenson awoke to considerable change. Even what he did not like he at least treated with interest and respect. His brief description of Monterey at the opening of the chapter entitled "The Old Pacific Capital" is a tour de force combining history, geography, metaphor, and his own piquant impressions of a new place.[4] He was intrigued by the windmills, the pervasive presence of the ocean, the missions, and the ruinous seasonal fires. His attention was caught by the dantesque contortion of the Monterey cypresses and the pitch pines, fixtures of California landscape (p. 43, bottom).

In *The Silverado Squatters* (1895), Stevenson narrates his voyage from San Francisco to the springs at Calistoga, to which he traveled by way of the Oakland ferry and Vallejo. At the latter place he described the identical scene—a ship loading at the Star Flour Mills and the nearby Frisbee House—captured by Carleton Watkins during the same era (p. 45, top).[5] In Calistoga Stevenson portrayed very well the jumble of names, events, and resources which was frequently poured into the new bottles of contemporary California history: the town had been named by its founder at a dinner party; the county was plagued by a highwayman who had been a local dentist; the healthful geysers heated the ground and the air to the point of discomfort; and in the midst of this remote settlement, "among the Indians and the grizzly bears," Stevenson received the first telephone call of his life. "So it goes in these young countries," he observed, apparently both pleased and dazed by his experience.[6] Interestingly, this was not exactly what he had expected. The sense of freedom and abandon which was a component of California's reputation in England gave way on contact to something far more varied and difficult to grasp:

It seems [from afar] as if, out West, the war of life was still conducted in the open air, and on free barbaric terms; as if it had not yet been narrowed into parlours, nor begun to be conducted, like some unjust and dreary arbitration, by compromise, costume, forms of procedure, and sad, senseless self-denial....[While there one] would rather be houseless than denied a pass-key; rather go without food than partake of a stalled ox in stiff, respectable society; rather be shot out of hand than direct his life according to the dictates of the world.[7]

On personal inspection, however, Stevenson found parlors as well as tepees, civility coexisting with barbarism. It is a paradigm for our subject that all of these strands—the youthful, romantic view of a casual foreign visitor, the objective view of the surveyor, the landscape view intended for a public market, and the chronicling of new building and development

**Figure 1-3.** Carleton Watkins, *Crystal Springs*, c. 1870, albumen print. California State Library Photograph Collection.

—all came together in many aspects of California life and thus in its photography. While geysers and hot springs, for example, may be a boon to health, they also indicate volcanic activity; consequently, architectural views of hotels and landscape views of springs are related to those of the surveyor with his more purely geological interest (figures 1-2, 1-3). Indeed one of Watkins' most striking series of images is that of quiescent volcanoes taken for the Geological Survey's Clarence King, a scientist and, later, an administrator. King's friendship with John La Farge, Henry Adams, and others of their circle, and his commitment to the principles set out by the English critic and historian John Ruskin encouraged in him a strong dedication to the arts. Some of these mountain scenes, then, represent simply, geologically, the uplands below which resort hotels were situated, while the resorts in turn represent leisure outposts of the activity of settlement and exploration represented by the surveys.[8]

Themes of California land, based in the nineteenth century on the recording of exploration and settlement, the interpretation of nature, and the development of a sense of local history and myth, appear in the succeeding pictorialist period as settings for allegorical tableaux or the subjects of personal meditation

or interpretation. In the modernist period they become uniquely precious in direct proportion to their increase in distance and decrease in number in the daily experience of the life of the time, as in the projected perfection of Ansel Adams, or the intensely personal studies of nature of Edward Weston and Minor White. Similarly, architecture, at the turn of the century, often becomes in photography a setting for poetic drama, rather than a report of progress; in a later, twentieth-century era its clean, clear lines or industrial complexity emblematize alternately the conquered challenges and still unmet difficulties of modern life. The same cypresses and pines of the Monterey coast that intrigued Robert Louis Stevenson appear in Watkins' series of contemporary landscape views. They appear as well as a part of later allegorical pictorialist scenes, and as the focus of even later modernist contemplation or mystical symbolism. In addition, the Depression and the group of photographers known as f/64 brought a return to a purely documentary style; a comparison of views of California land some sixty years apart, from the 1870s and 1930s, might well reveal more a change in artistic materials and technique, and in the straitened circumstances of the farmer, than in the attitude of the artist himself.

Another important California theme to emerge in the nineteenth century was the presence of commerce and human industry in a previously undeveloped land. A dam in an otherwise immense and undisturbed forest, images of shipping in San Francisco Bay and along the coast, a sawmill on the bank of a remote river or on the slope of an arid foothill all offer visual testimony to the aggressive will considered essential to survival at the continent's edge. Such images mix humanity and nature in a distinctly harmonious way (pp. 44,45, 49). The theme of harmony with nature, one of the strongest in California

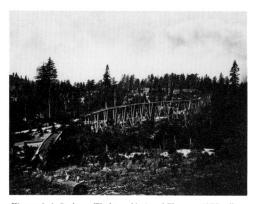

**Figure 1-4.** Carleton Watkins, *National Flume* c. 1875, albumen print. California State Library Photograph Collection.

history and art, goes to the heart of the questions California artists asked and the scenes they chose to depict. It is also a subject represented implicitly in a large number of nineteenth-century images in which, despite the absence of overt provocation, a viewer might well ask several questions. What was a surveyor doing in these mountains? Are picturesque mills and flumes representations of progress or of destruction? Is public activity among the Big Trees to be counted as education about, or desecration of, nature (figure 1-4)? What seems to emerge from such images is an unusually encompassing distance, a tolerance, or, perhaps, an accomodation, which, in the nineteenth-century, was remarkably far from judgmental. One senses that Californians were often too engaged in their varied and discrete activities to consider their relation to one another, too involved in mining or logging to consider the mountains and forests themselves, so intent on loading and unloading ships that they hardly saw the astonishing seascape that contained them.

Calling attention to this circumstance was a task well suited to the early photographer who, by the very nature of his or her work, was often required to relate pictorially an activity and setting of which its denizens were relatively

unaware. Evocative compositions were recorded of mines, mills, and other man-made structures in the larger context of shoreline or forest. Even hydraulic mining, one of the most ruinous of human activities, yielded surprisingly pleasing images from the hands of California's best photographers.

Themes of man in nature appear in later pictorialism in the very different key of literal union (the nude among the rocks; the young woman dressed as an Indian), while modernism tends to relate them from the stance of alienation—as an unattainable goal, or from the philosophical or artistic distance of contemplation.

Diversity of resources, the activities of exploration, settlement, and harvest, and the beauty of the land itself underlie much of what California is; nineteenth-century photographers embraced these themes, as did other early citizens of the state, in a spirit of scrutiny and definition whose overall outlines are still familiar to us today.

## CALIFORNIA PICTORIAL

In Sacramento, between the state library and courthouse, just opposite the capitol, under towering palms and edged by well-trimmed plantings, is a small circle. Its formal setting of opposing steps, columns, and facades and the gravity of its stone construction, draw attention to four carved figures nearby. These statues, female figures in the heroic style in which our culture once, almost universally, declared its symbolic values, are not in themselves unusual, but their allegorical identities are worth noting: Climatic Wealth, Mineral Wealth, Floral Wealth, and Romantic Wealth.

Economists might quarrel with the appropriateness of these categories, but few would deny that, in their symbolic roles, they constituted (and still constitute) important aspects of

California's identity. Indeed it is their formal, somewhat foreign embodiment here that no longer seems to ring quite true. For, to quote Thomas Carlyle, it is a law of human nature "that what a man feels intensely, he struggles to speak out of him, to see represented before him in visual shape, and as if with a kind of life and historical reality in it."[9] Such needs inform the art of any region; in the case of California, this was a mission difficult to accomplish using only traditional means.

One need only look at the two volumes of photographs taken by Carleton Watkins of Thurlow Lodge, the palatial manor of California Senator Milton Latham (p. 52, 53), or at the similar commissions that produced images of Darius Mills' peninsula estate Millbrae and of the San Francisco and Palo Alto homes of Governor Leland Stanford to see that in California during the second half of the nineteenth century a pitched battle was being waged regarding the appropriate form and scale of architectural and artistic representation. These buildings and estates, private and public expressions of wealth and purpose, were monuments to accomplishment in the past and present, and to hope for the future. The strong European neoclassical or Victorian leanings of the architecture and art of the time indicate a striving to match universally acknowledged benchmarks of progress.

It is not difficult to see, however, that between the moral obligations of beauty and the practical demands of improvement, between the nurturing of myth and the need for survival, existed a lively tension for which conventional modes of representation might have been inadequate. In California today, one is constantly confronted with the uneasy peace that has settled among these diverse elements. Just as Italianate sculpture graced estates hacked from the scrubby brush of sand hills, or which rose in comfort above squalid cities, oil rigs now pump slowly in fields of artichoke and

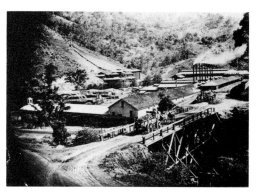

**Figure 1-5.** Edward Vischer, *Vischer's Pictorial of California, New Almaden Quicksilver Mine—The Works,* c. 1870, albumen print. Courtesy of the Everett D. Graff Collection, the Newberry Library.

broccoli or dot broad ocean bays, rockets stand poised beside freeways amid grazing cattle, and comfortable buildings exist in constant peril from fire, earth, and sea.

In light of such novelty and contrast, the state has been a pioneer in imagining itself, and from early on one of its principal trades was in images themselves. But how was one to represent appropriately something so diverse? This question was posed by Edward Vischer, compiler of *Vischer's Pictorial of California* (1870), a volume that attempted to set out, as ambitiously as any of its day, a relatively balanced image of California. Vischer's multifaceted approach is apparent from his preface: "In the accompanying book we present to our subscribers, some of whom are living in California, a work of predilection and perseverance— the result of years of assiduous exertions, guided by the impressions of 20 years' residence and half a lifetime's acquaintance with this country, which has become the land of our adoption."[10] He continues with a sentence whose length and internal complexity are perhaps as indicative of his subject as of the rhetorical style of the time:

The aim and purpose of this collection of views, selected from several hundred of our own sketches in every part of California, has been to represent, as truthfully as lay within our power, the natural characteristics of this favored country, so long secluded from the rest of the world; so suddenly, and under such exceptional inducements, thrown open to the influx of people of every nationality; and by its geographical situation, the vastness of its natural resources, and the rapid development of its diversified elements, called to a well-recognized, important cosmopolitan and financial position, which, with the indomitable spirit of enterprise of its present inhabitants, and the advent of new-comers, will soon have obliterated the land-marks of the California of olden times.[11]

To accomplish this ambitious aim, notable in 1870 for its reference to preservation, Vischer assembled a variety of materials: text, drawings reproduced by photographic means, photographs of drawings taken from other photographs, and photographs themselves. To some extent these images sort themselves out by subject and use of the individual medium. It is a fascinating mix, appropriate to Vischer's stated high purpose of picturing for the public the image of a varied and changing California (figure 1-5).

After describing the land, some of its history, and the many changes it had recently undergone—including a broad, almost radical range of activities, even the damage caused by mining—Vischer continued:

In the midst of these kaleidoscopic workings of a nervous activity, our main object has been to represent the leading characteristics of the *natural conditions of the country;* the Sierra Nevada and its foothills; the Coast Range; and the valley lands, in which the rural wealth and charm of cultivated California is concentrated.[12]

In fact he described more than rural wealth. A chapter entitled "Early Industrial Progress in California" covers the Mechanics Fair of 1864 in San Francisco and is illustrated

with original photographs by Carleton Watkins. It gives a broad sampling of the diversity of industry and commerce of the time. Among the displays illustrated are those featuring furs, fireworks, sugar, glass, wire cables, macaroni, wine, fruit, silk, paintings, and sculpture. Clearly, the San Francisco of this era was a place of considerable activity. Vischer's effort is notable for its attempt to present an evenhanded and varied picture of a complex subject. While he did not perfect a new method of presentation, he used photographs as part of a creditable effort to represent California that in many ways matched the state's own protean nature.

*Vischer's Pictorial* also offers abstracts from *The Yosemite Book*, a volume by Josiah Whitney published only shortly before, in 1868. Of more than passing interest, this inclusion indicates a good deal about Vischer's ideas concerning both visual and verbal presentation. *The Yosemite Book*, drawn from Whitney's work with the Geological Survey and published with the approval of the legislature, is an important progenitor of one of the two major approaches often taken in describing and visualizing California for the public.[13]

Whitney was a geologist, scholar, teacher, and writer whose professional interest in the state was focused largely on its mineral wealth. But his Eastern background and education gave him an overall view of California which was far broader and allowed appreciation of many of its other resources. In opening his book, whose purpose was "to call the attention of the public to the scenery of California, and to furnish a reliable guide to some of its most interesting features," the reader sees that Whitney's emphasis was on veracity and an enlightened sense of just what the state's most interesting feature might be. Much had already been published on California, he noted, but "little of accuracy, almost nothing

of permanent value." *The Yosemite Book* set out to correct this deficiency. Its attitude is respectful but not distant, learned yet accessible. Whitney was clearer than most other writers on California scenery about what he saw. He traced the topographical features of the land to their formation and differentiated between important subtleties of descriptive terminology, noting, for example, that "sublimity and grandeur, rather than beauty and variety" were the primary qualities of Yosemite. He appealed to the mountaineer and serious traveler to come to California and to others to preserve it for them to see.[14]

This was an active, patrician view of nature; how many people, after all, were likely to take the months off from work necessary to explore and name mountains, as Whitney encouraged them to do? Still his work represents an important point of view in regard to landscape. *The Yosemite Book* is really an early "coffee-table" art book whose attitudes were later confirmed in the movement for preservation it helped to found. It is no coincidence, as we will see, that the illustrations chosen by Whitney were carefully produced original photographs by Watkins.

A very different view is presented in another book published in the same year. J. S. Hittell's *Yosemite: Its Wonders and Its Beauties* is a pocket guidebook offering "advice in regard to the most impressive views" and methods of travel that uses as illustrations small, rather indistinct photographs by Muybridge. These are included, the author says, "so the reader can see the mirror held up to nature." "The great attraction of Yosemite," he continues "is the crowding of a great multitude of romantic, peculiar, and grand scenes within a very small space." His praise is often couched in chauvinistic terms (the highest waterfall in the Old World, he notes, is only some nine hundred feet, while Yosemite Falls approaches half a

mile). His helpful advice is set out in practical but simplified chapters on how to spend ten days in Yosemite, a history of the valley, a list of eminent visitors, and "Hints to Tourists."[15]

A comparison of Whitney's book with Hittell's reveals the world of difference between them. The latter is a keepsake filled with vague expressions, such as "romantic," "impressive" and "grand," and images, such as "the mirror held up to nature," that are stylized and derivative. There is little original thought. The former is a paragon of expression and style directed at the serious reader in which the author's commitment to his subject is evident on every page. Naturally, the view of the mountaineer, explorer, or scientist will differ from that of the leisured traveler content to view mountains from afar or from the roadside to which he has been conveyed at his ease in a carriage, and the view of the preservationist will differ from that of the proponent of tourism. Yosemite today, with its parking below and hiking above, reveals that this dichotomy is still very much in evidence. The difference in approach between these two writers, pioneers in the image-making of California, is reminiscent of the recent remark of the economist John Kenneth Galbraith that it is impossible to describe with any precision something you do not entirely understand. The view of Hittell, while clearly adulatory, lacks the fiber of support available to Whitney.

These two views affected photography itself in the nineteenth century and up to the modern era. Other photographic presentations of California generally fall into one camp or the other, most frequently that of Hittell. The photographer Alfred A. Hart's *Traveler's Own Book*, published in 1870, the same year as *Vischer's Pictorial*, lays out the voyage, via six connected railroads, from Chicago to San Francisco. This work, which announces itself as a "Souvenir of Overland Travel via the

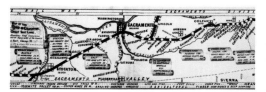

Great and Attractive Route," is illustrated by "fine photo-chromo views," of which the preponderance depict California subjects, among them Yosemite, the American River, and the Big Trees. It is a unique mix of graphic design, text, and illustration. The principal text, an essay entitled "Panoramic Description of the Great Overland Route," is literally enacted on the book's pages, each of which comprises one section of a continuous map stretching from Illinois to California. The line of the railroad runs horizontally across the page, with towns and stops marked on it; below it is a verbal description of the route. Additional notes about hotels, the train schedule, and other matters of interest to travelers are added in as necessary (figure 1-6)[16]. Hart's is by its nature a travel book, and his selection of illustrations leans heavily toward the picturesque. One curious feature is that the text reads, as it must, from left to right, while the map, as it must for a trip from Chicago to San Francisco, reads from right to left. It is perhaps characteristically American to be able to solve the problems of building a railroad more easily than those of describing a trip on one.

A final related work is William R. Bentley's *Handbook of the Pacific Coast*, published in Oakland in 1884. In the manner of Hittell and Hart, Bentley "endeavored to direct the tourist and the traveler to those places where the sky is brightest, the air balmiest, and where pleasure may be found freest from disagreeable surroundings." He provided both original

photographs by Watkins and wood engravings based on other images from the photographer's work.[17] The latter are presented in a manner very popular at the time, the collage technique seen in the mounting of photographs in Eadweard Muybridge's *Brandenburg Album* (figure 1-7). This style of presentation is indicative of the contemporary inclination toward the picturesque, on the one hand, and the need, on the other hand, to serve tourism and the publicist whose audience was an increasingly mobile but often unsophisticated public.

Muybridge and Carleton Watkins, the two principal photographers of this period, stand as exemplars of these two very different attitudes. In many ways the work of each parallels that of the other; in some cases they are virtually indistinguishable. But to say that because of this they are alike would be like saying that a copy of a painting is almost as good as the original: From the beginning Watkins displayed in his work a recognition of the underlying qualities of landscape and was able to portray accurately in a variety of situations the relationships between the land itself and the human activity through which it was explored, harvested, or civilized. Watkins' view of California derived from the same source as Whitney's, with whom he worked. Others were part of this group—something of an informal, nomadic Western salon—among them Clarence King, whose own book on this era in California is significantly titled *Mountaineering in the Sierra Nevada*. King shared the respectful view of California land and culture which motivated Watkins and Whitney. Indeed this view was more than simply respectful. It was, at a fundamental level, worshipful, a platonic stance in which the concrete and the actual were seen as representative of the ideal and the spiritual, thus inspiring a quest for visual purity that presaged photographic modernism.

Muybridge put his prodigious abilities to

**Figure 1-7.** Unknown, illustration from *Bentley's Handbook of the Pacific Coast*, 1884. Collection of The J. Paul Getty Museum.

very different use. While his landscape, urban, and documentary photographs are often striking and beautiful, his career as a photographer depicting landscape and culture in California is but one facet of an extraordinary and highly varied life. Watkins sought out imagery through which to realize his artistic vision. His artistic personality emerged in his works from a pure depiction of the magnificent shapes and volumes of the land and the characteristic forms and patterns of human settlement. He led a life entirely beholden to his subjects and his art, traveling doggedly even to the detriment of his marriage and health. Muybridge was far more adaptable. Willing to apply his art to the subjects he found and to adjust his images, as he did his life, to some predetermined aesthetic or need, he showed many of the propensities toward embellishment, fantasy, manipulation, and experimentation that

**Figure 1-8.** Eadweard Muybridge, *Great Geyser Springs, The Witches' Cauldron—Macbeth, Act IV, Scene 1,* c. 1870, albumen stereo print. The Bancroft Library, University of California, Berkeley.

characterized the later pictorialist movement. Muybridge was a product of, and continued to represent, a tradition based on the subjective, decorative, picturesque, and even anecdotal (figure 1-8), while Watkins represented an aesthetic that prized the abstract, the elemental, and the pure. To borrow an analogy from the world of architecture and prints: in his manner of appropriating and using visual elements, Watkins was palladian in his respectful restraint, while Muybridge was comfortable with the freer, more romantic, and personal approach of a Piranesi.

This difference characterized other areas of American cultural life at the time. In landscape and architectural design, the precious cottages and parks of A. J. Downing were giving way to the magnificent vision of Frederick Law Olmsted, itself sharpened in part in California during this era. In painting, Thomas Eakins was exploring a more demanding realism; in literature writers were beginning to portray America as it had actually developed rather than merely as a set of ideals.

Much of this vast, complex panorama could best be pictured through photography. As Robert Louis Stevenson had noted, the ambitious undertakings of the middle and late nineteenth century, including the exploration and settlement of California, were epic in scope, affording material to fill canvases of

vast proportion (p. 29, top). Speaking as an artist, however, he also suggested that quantity of incident and variety of scene were not enough. "If it be romance, if it be contrast, if it be heroism that we require, what was Troy town to this? But, alas!" he concluded drily, "it is not these things that are necessary—it is only Homer."[18]

In the case of California in the nineteenth century, it was only the photographer who could supply the vision large enough to encompass the new and changing panorama of events (pp. 34, 35). While the image of a seaside mill, forest flume, spacious orchard, or stately mansion with ornamental landscaping and statuary might in itself represent an individual person, a lumbering corporation, or the fruits of settlement, as part of a photographic image it became a piece of something larger, a single episode in the new epic of its time.

Perhaps the most startling development in the photography of nineteenth-century California was the invention, at least in part, of one of the important components of an epic to come: the world of film. While Muybridge was an acknowledged landscape master, he is most widely known for his work with motion. His technical innovations, begun in 1872 under the auspices of Leland Stanford and continued intermittently for the next ten years, produced images of horses and men in motion which are among the first icons of the modern age. While his later work in Philadelphia, where he produced the monumental volumes of *Animal Locomotion*, is better known (figure 1-9), his work with Stanford, from which the 1878 *Attitudes of Animals in Motion* derives, is in many ways more original and exciting, exemplifying as it does an area of vision and art never before seen (p. 36).[19]

Oddly, California's connection with the film industry today has little to do with

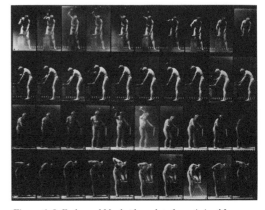

**Figure 1-9.** Eadweard Muybridge, plate from *Animal Locomotion: A. Hammering at Anvil, B. Hammering at Anvil, C. Using Hatchet, D. Sawing a Board,* c. 1985, collotype. Williams College Museum of Art.

Muybridge directly, but there is a continuity of spirit between the two which makes his inventiveness and persistence relevant to that medium. What was most characteristic of Muybridge's time, when he moved from the relatively staid world of California photography to the cosmopolitan position of an Eastern- and European-based researcher, lecturer, and author, was the changing nature of global culture itself, which he himself was perhaps one of the first to understand and use. The California Muybridge left behind soon became sharply divided between the progress he represented and a nostalgic view of the past he had witnessed. Sentimental images by Woods and Fiske (pp. 57, bottom; 28) serve as reminders of the attachment devoted photographers still had to California subjects at century's end, though they speak more clearly of memory than of the spirit of exploration. Such images, while reminiscent of those of the masters of the sixties and seventies, seem more to augur the coming of pictorialism (figure 1-10) and the more self-conscious art that was to be characteristic of the turn of the century.

**Figure 1-10.** Carleton Watkins, *View in the Grounds of Col. Rogers*, c. 1890, albumen print. The Bancroft Library, University of California, Berkeley.

# Notes

1. The wet-plate process, which had been invented by the Englishman F. Scott Archer by 1851, revolutionized photography. Its use of a photosensitive emulsion on glass allowed the production of extremely detailed negatives of virtually any size which, once developed, could be printed as often as needed. While the process enabled photographers to undertake more ambitious work than had generally been possible with the daguerreotype, it was also cumbersome, and its success required considerable planning and expertise. The details of the process are described in all thorough histories of the medium.

2. Vance's views are supposed to have numbered three hundred; see Peter E. Palmquist, *Carleton E. Watkins* (Albuquerque, 1983), p. 8.

3. Robert Louis Stevenson, *Travels and Essays of Robert Louis Stevenson: The Amateur Immigrant; Across the Plains; The Silverado Squatters* (New York, 1895), pp. 108, 129.

4. Stevenson's description of Monterey reads as follows: "The Bay of Monterey has been compared by no less a person than General Sherman to a bent fishing-hook; and the comparison, if less important than the march through Georgia, still shows the eye of a soldier for topography. Santa Cruz sits exposed at the shank; the mouth of the Salinas River is at the middle of the bend; and Monterey itself is cosily ensconced beside the barb. Thus the ancient capital of California faces across the bay, while the Pacific Ocean, though hidden by low hills and forests, bombards her left flank and rear with never-dying surf. In front of the town, the long line of sea-beach tends north and northwest, and then westward to enclose the bay. The waves which lap so quietly about the jetties of Monterey grow louder and larger in the distance; you can see the breakers leaping high and white by day; at night, the outline of the shore is traced in transparent silver by moonlight and the flying foam; and from all around, even in quiet weather, the low, distant, thrilling roar of the Pacific hangs over the coast and the adjacent country like smoke above a battle." (Ibid., p. 149)

5. Contrary to Watkins' crisp image, Stevenson describes South Vallejo as dreary and damp, and the Frisbee House as "a place of fallen fortunes...a two-bit house...given up to laborers...and... rough coatless men" (Ibid., pp. 316-317).

6. Ibid., pp. 320-24.

7. Ibid., p. 87.

8. King was in Yosemite in 1864 and 1866, in the latter year with Watkins. See Josiah Whitney, *The Yosemite Book*, (New York, 1868), pp. 10-12; Palmquist, pp. 199-200.

9. Thomas Carlyle, *On Heroes, Hero-Worship and the Heroic in History* (New York, 1891), p. 6.

10. Edward Vischer, *Vischer's Pictorial of California* (San Francisco, 1870), introduction.

11. Ibid.

12. Ibid.

13. Whitney, pp. 10-12.

14. Quotes are from ibid., introduction.

15. Quotes are from J. S. Hittell, *Yosemite: Its Wonders and Its Beauties* (San Francisco, 1868). The discussion of Muybridge's illustrations in Hittell is not intended to imply that they are characteristic examples of the photographer's work.

16. Alfred A. Hart, *The Traveler's Own Book* (Chicago, 1870).

17. William R. Bentley, *Bentley's Handbook of the Pacific Coast* (Oakland, 1884).

18. Stevenson, pp. 130-131.

19. For discussions of Muybridge's innovations in the context of his life and times, see Robert Bartlett Haas, *Muybridge, Man in Motion* (Berkeley, 1976); Thomas Weston Fels, *Eadweard Muybridge: Animal Locomotion* (Albany, 1985).

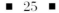

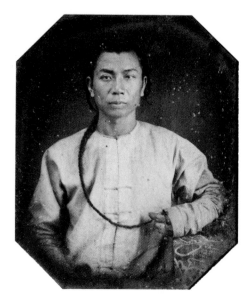

Isaac Wallace Baker (1810-?)
*Portrait of a Chinese Man*, c. 1851
Daguerreotype, sixth plate
The Oakland Museum

George R. Fardon (1807-1886)
*Merchant's Exchange on Battery
Street, No. 3*, from *The San Francisco
Album*, 1850-1856
Mat albumen print
The J. Paul Getty Museum

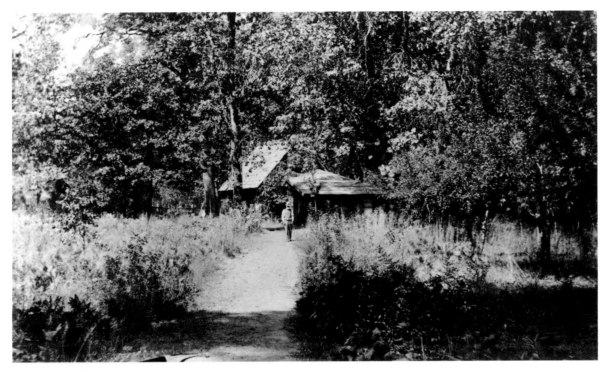

George Fiske (1835-1918)
*Mr. Hutchings' Cabin, Yosemite,* c. 1881
Albumen print
The Oakland Museum

George Fiske (1835-1918)
*Portrait of Galen Clark,* c. 1888
Albumen print (cabinet card)
The Oakland Museum

George Fiske (1835-1918)
*Azaleas, Yosemite,* c. 1880s
Albumen print
The Oakland Museum

George Fiske (1835-1918)
*Nevada Fall, Yosemite,* 1887
Albumen print
The Oakland Museum

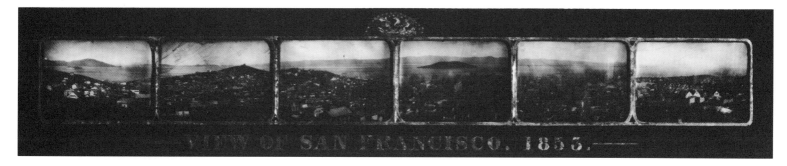

Unknown
*View of San Francisco*, 1853
Five-part panorama of half plates
The Oakland Museum

Unknown
*Portrait of General John C. Fremont*, c. 1854
Whole plate daguerreotype
The Oakland Museum
Founders Fund

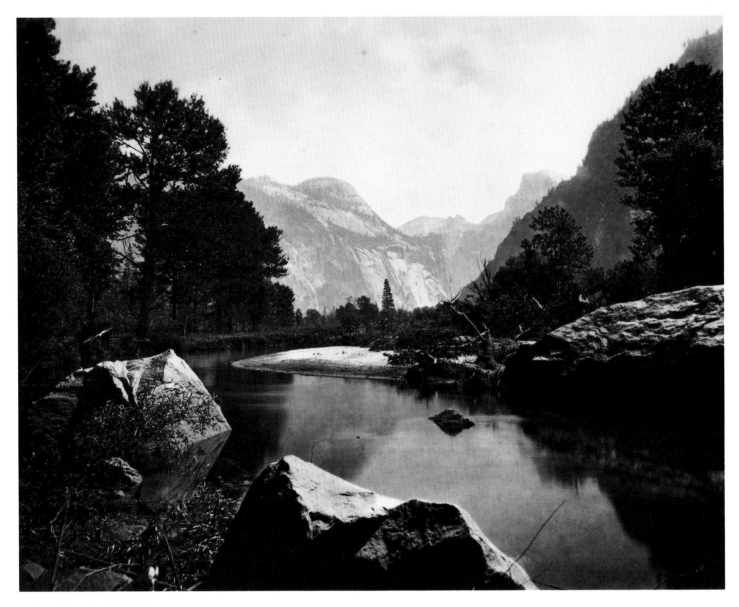

Eadweard Muybridge (1830-1904)
*The Domes, Valley of Yosemite,* 1872
Albumen print
Michael G. Wilson Collection

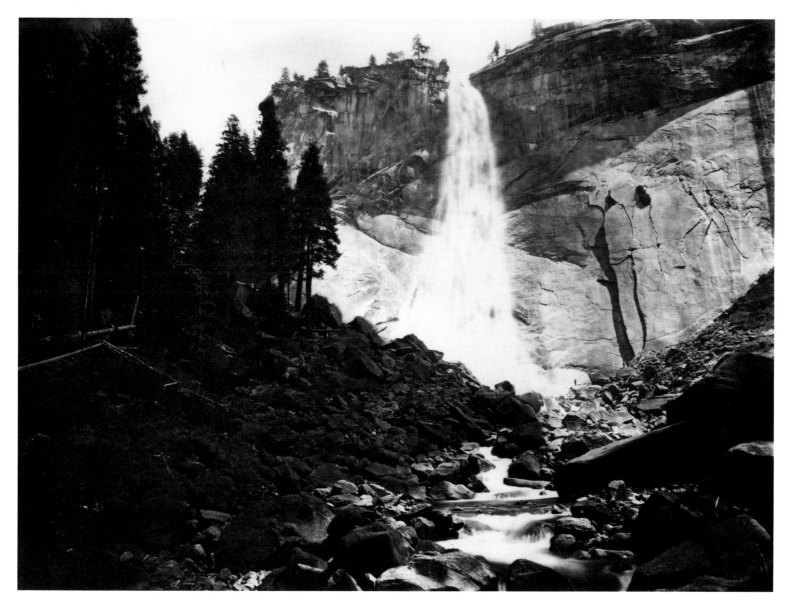

Eadweard Muybridge (1830-1904)
*Nevada Falls, Yosemite,* 1882
Albumen print
Michael G. Wilson Collection

Eadweard Muybridge (1830-1904)
Untitled from *The Brandenberg Album*
(page 116), 1867-1875
Mounted albumen prints
Stanford University Museum of Art
Muybridge Collection

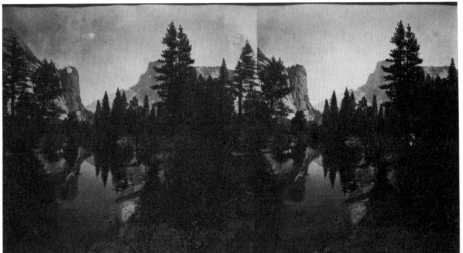

Eadweard Muybridge (1830-1904)
Untitled from *The Brandenberg Album*
(page 35), 1867-1875
Mounted albumen prints
Stanford University Museum of Art
Muybridge Collection

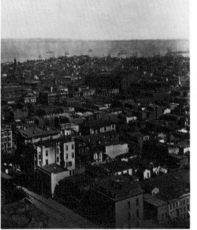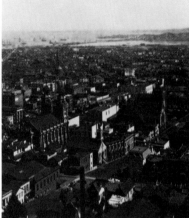

Eadweard Muybridge (1830-1904)
*San Francisco Panorama*, 1877
Thirteen albumen prints
Stanford University Library
Special Collections

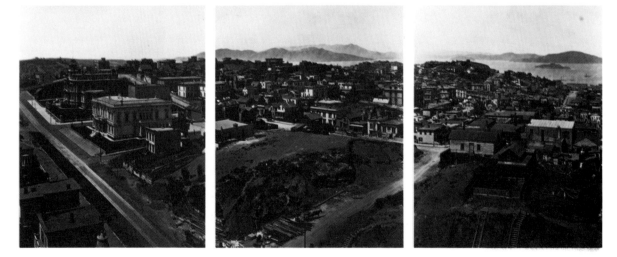

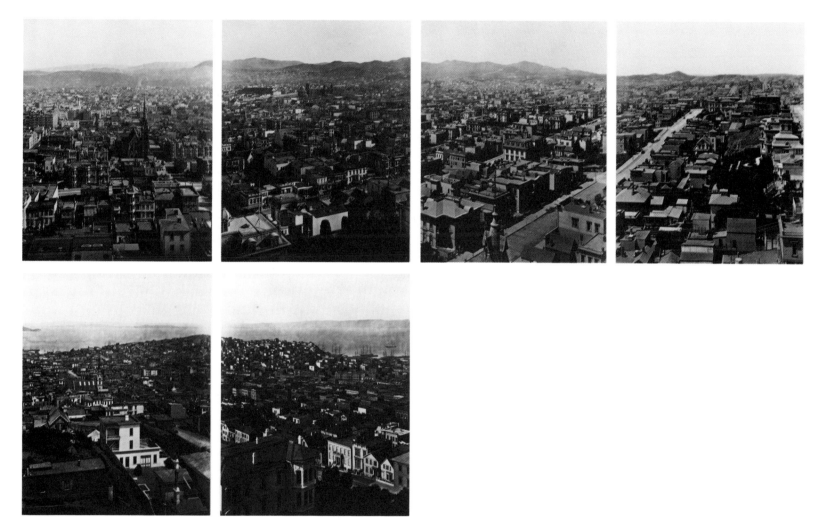

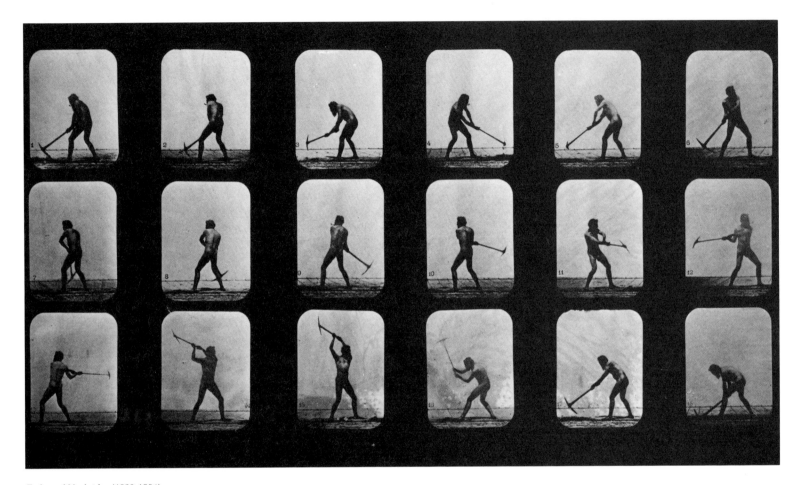

Eadweard Muybridge (1830-1904)
*Pick Swinging*, from *The Attitudes of Animals in Motion*, c. 1878-1879
Brown-toned cyanotype
The J. Paul Getty Museum

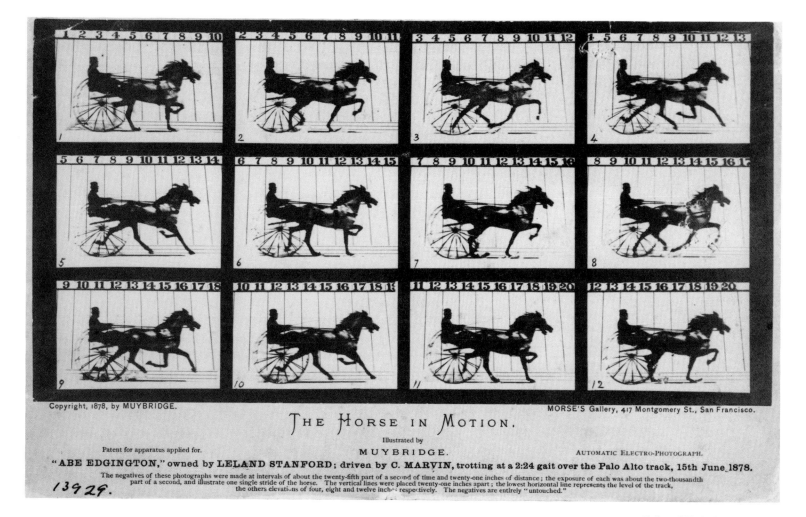

THE HORSE IN MOTION.

Copyright, 1878, by MUYBRIDGE.

MORSE'S Gallery, 417 Montgomery St., San Francisco.

Illustrated by

Patent for apparatus applied for.

MUYBRIDGE.

AUTOMATIC ELECTRO-PHOTOGRAPH.

"ABE EDGINGTON," owned by LELAND STANFORD; driven by C. MARVIN, trotting at a 2:24 gait over the Palo Alto track, 15th June 1878.

The negatives of these photographs were made at intervals of about the twenty-fifth part of a second of time and twenty-one inches of distance; the exposure of each was about the two-thousandth part of a second, and illustrate one single stride of the horse. The vertical lines were placed twenty-one inches apart; the lowest horizontal line represents the level of the track, the others elevations of four, eight and twelve inches respectively. The negatives are entirely "untouched."

Eadweard Muybridge (1830-1904)
*Abe Edgington*, from *The Horse in Motion*, 1878
Albumen print mounted on printed card
Stanford University Museum of Art
Muybridge Collection

Isaiah Taber (1830-1912)
*The Opera French Millinery*
from *The Taber Photographic Album*, c. 1880
Gelatin silver print
The J. Paul Getty Museum

Isaiah Taber (1830-1910)
*I.W. Taber Photographing the Solar Eclipse*, January 1889
Albumen print mounted on large cabinet card
California State Library Photograph Collection

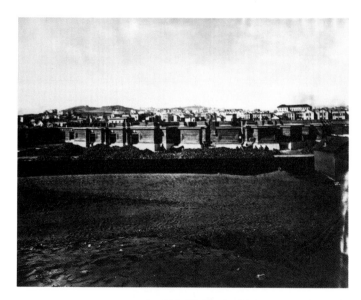

Eadweard Muybridge (1830-1904)
*View of New City Hall Under Construction*
*San Francisco,* 1873
Albumen print
California State Library Photograph Collection

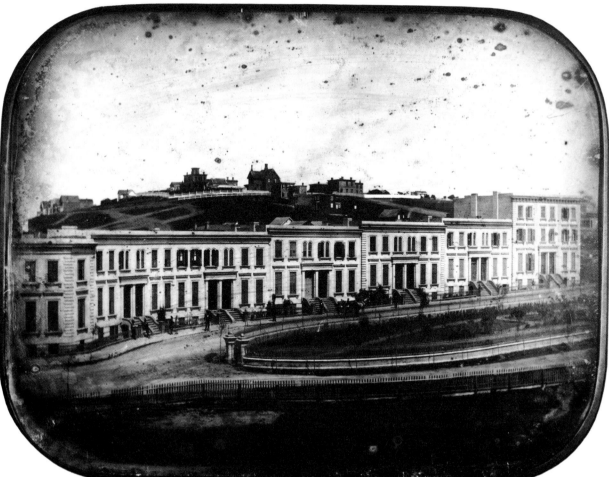

Unknown
*South Park, San Francisco,* c. 1855
Whole plate daguerreotype
The Oakland Museum

Unknown
*View of Ship Building, Navy Yard, Mare Island,* 1875
Albumen print
California State Library Photograph Collection

Unknown
*Vallejo from Mare Island*, 1875
Albumen print
California State Library Photograph Collection

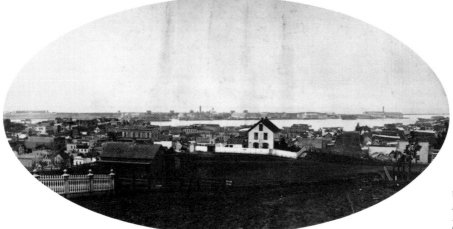

Unknown
*Mare Island from Vallejo*, 1875
Albumen print
California State Library Photograph Collection

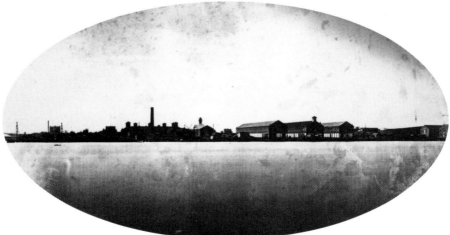

Unknown
*View of Ship Building, Navy Yard, Mare Island*, 1875
Albumen print
California State Library Photograph Collection

Carleton Watkins (1829-1916)
*Bridgeport-East*, from *The Mariposa Series*, 1860
Salt print
The J. Paul Getty Museum

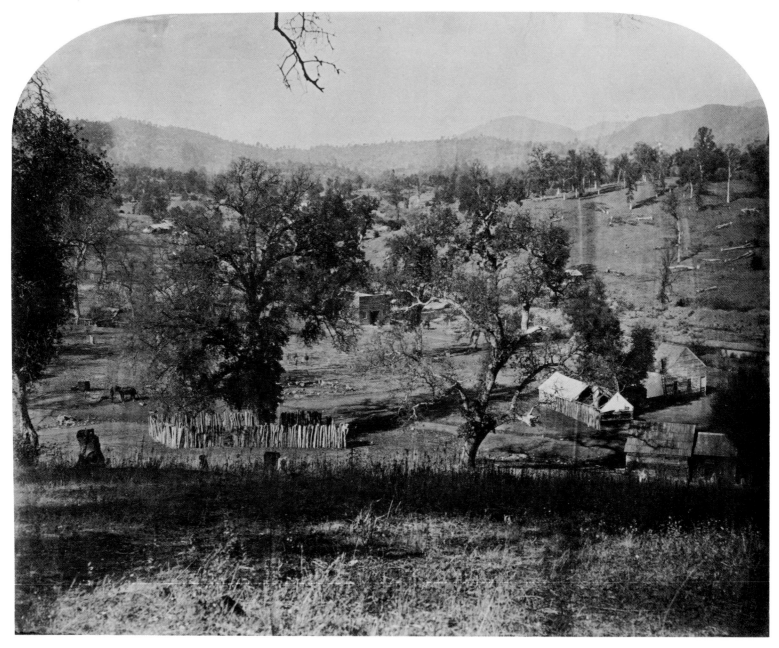

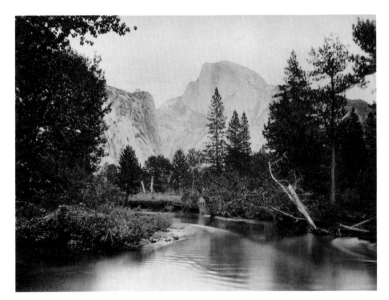

Carleton Watkins (1829-1916)
*Tacoye, Half Dome, Yosemite*, 1861
Albumen print
The Oakland Museum

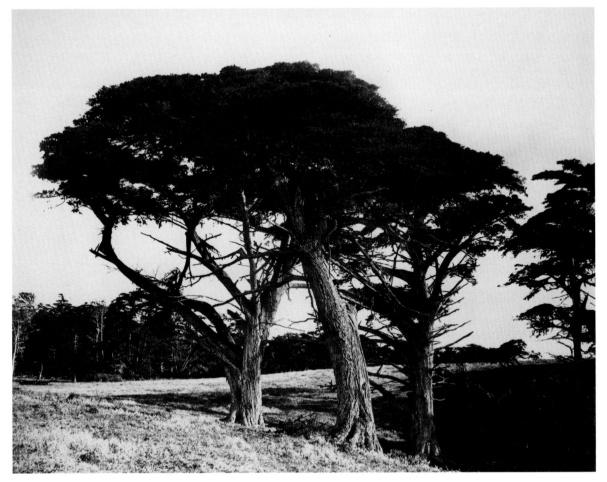

Carleton Watkins (1829-1916)
*Cypress, Cypress Point, Monterey*, 1885
Albumen print
Collection of Harvard University
Gray Herbarium Archives

Carleton Watkins (1829-1916)
*Albion Lumber Company Mill, Mendocino County*, 1863
Albumen print
California State Library Photograph Collection

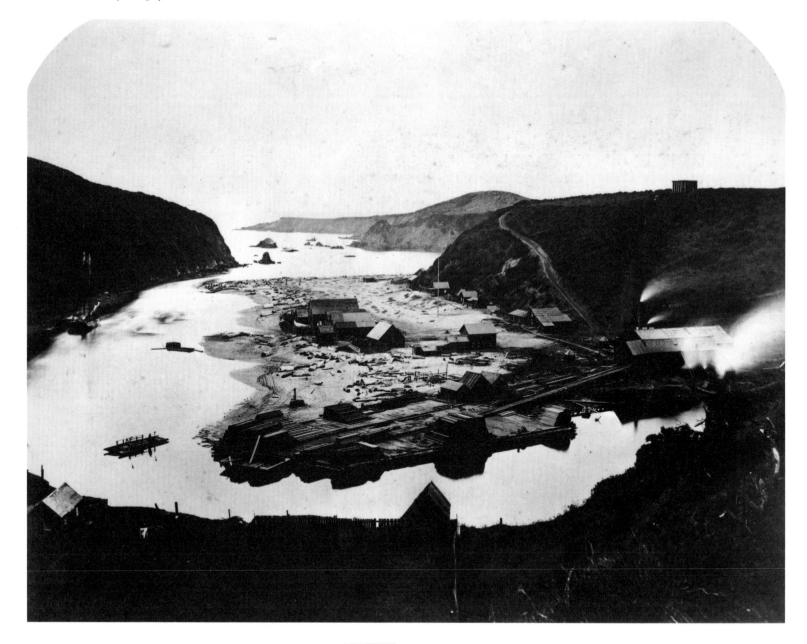

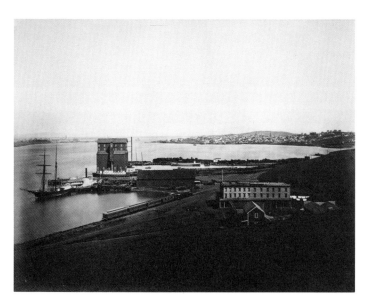

Carleton Watkins (1829-1916)
*City of Vallejo, from South Vallejo,* 1870
Albumen print
The J. Paul Getty Museum

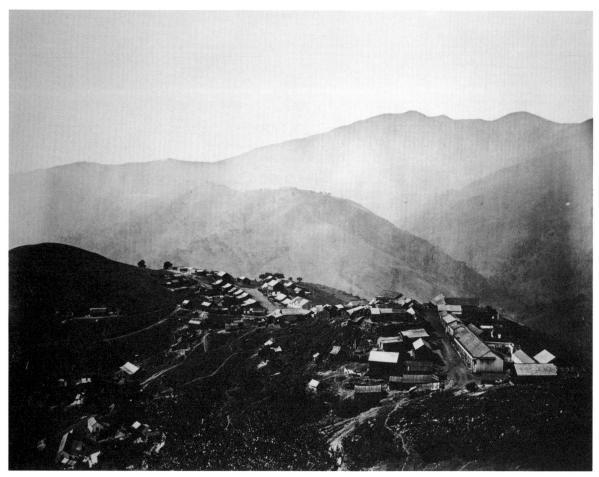

Carleton Watkins (1829-1916)
*The Town on the Hill, New Almaden*
from *The New Almaden Series,* 1863
Albumen print
The J. Paul Getty Museum

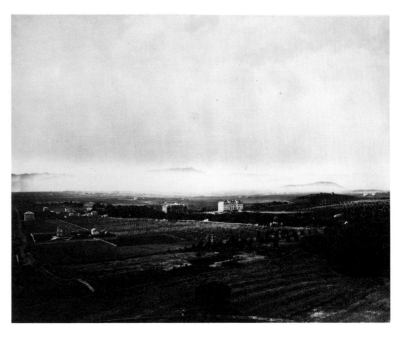

Carleton Watkins (1829-1916)
*View of Berkeley and San Francisco Bay*, c. 1870
Albumen print
California State Library Photograph Collection

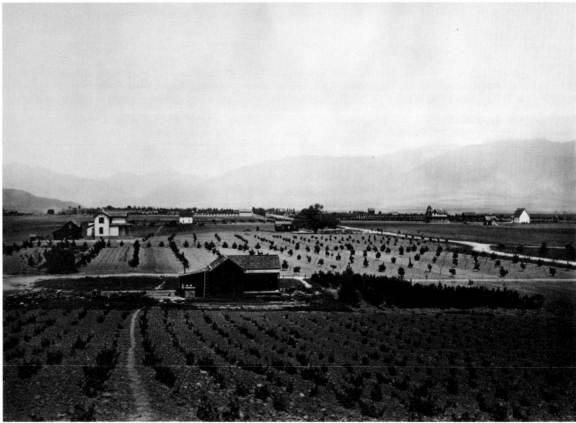

Carleton Watkins (1829-1916)
*Pasadena: Indiana Colony*, c. 1880
Albumen print
California State Library Photograph Collection

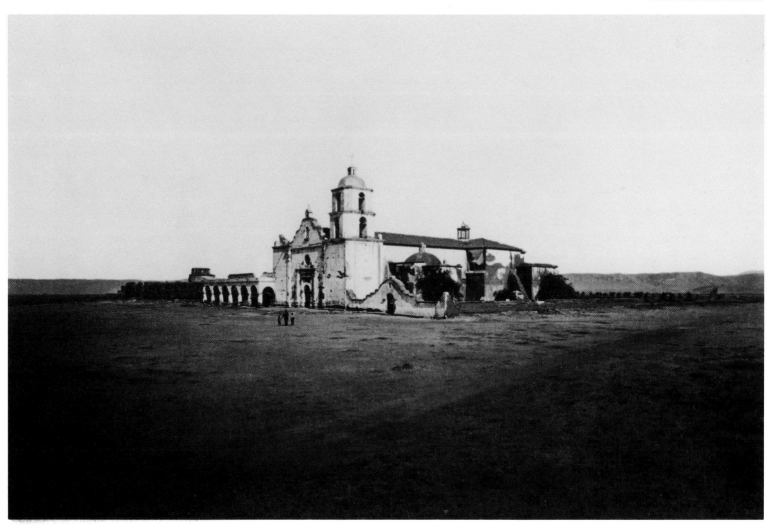

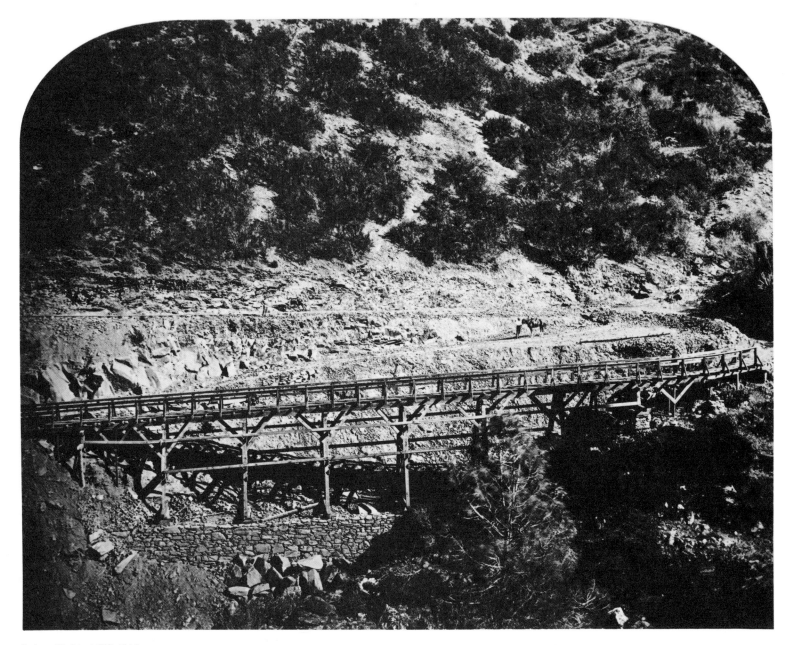

Carleton Watkins (1829-1916)
*Railroad Bridge, Cape Horn,* 1860
Salt print
The J. Paul Getty Museum

Carleton Watkins (1829-1916)
*Trout Pond, Thurlow Lodge, Menlo Park, California*
from the first of two albums, *Views of Thurlow Lodge*, 1874
Albumen print
Collection Canadian Centre for Architecture, Montreal

Charles L. Weed (attributed to) (1824-1903)
*Vernal Fall, 350 Ft., Yo Semite Valley, Cal.*, 1864
Albumen print
The J. Paul Getty Museum

Charles L. Weed (attributed to) (1824-1903)
*Cascade—Little Yosemite Valley*, 1864
Albumen print
Miriam and Ira D. Wallach Division of Art
Prints and Photographs,
The New York Public Library
Astor, Lenox and Tilden Foundations

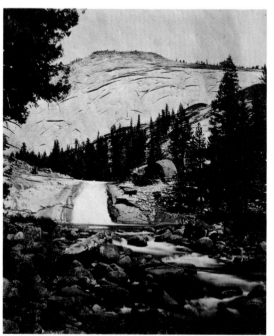

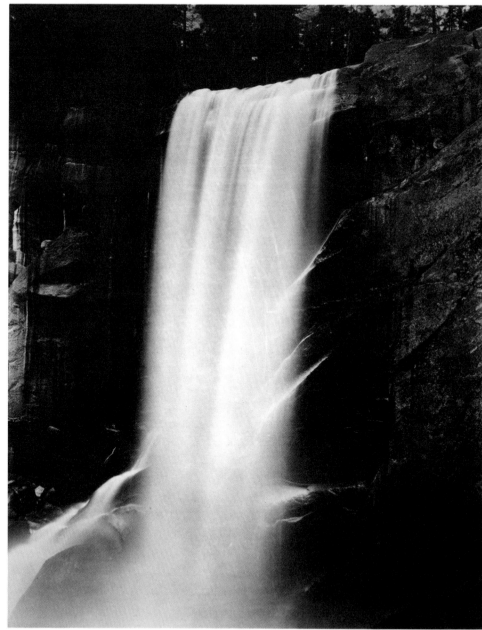

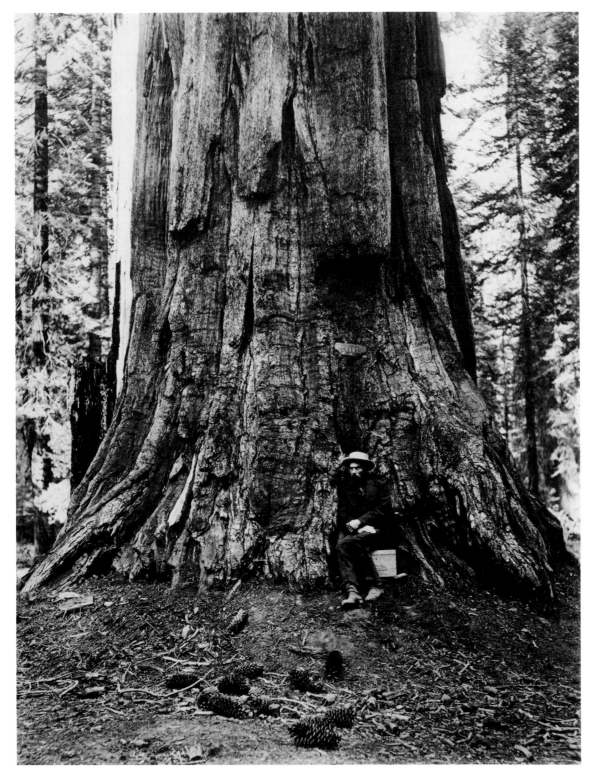

Charles L. Weed (attributed to) (1824-1903)
*U.S. Grant 71 Ft. circ., Mariposa Grove*
*California,* c. 1864
Albumen print
The J. Paul Getty Museum

Edward L. Woods, active in Calif. in 1880s
*Roadside Store in Northern California*, c. 1880
Salt print
The J. Paul Getty Museum

Charles Weed (attributed to) (1824-1903)
*Little Yosemite Valley*, 1864
Albumen print
Miriam and Ira D. Wallach Division of Art
Prints and Photographs,
The New York Public Library
Astor, Lenox and Tilden Foundations

Edward L. Woods
(active in California in 1880s)
*Ore Tracks near Santa Cruz, California*
c. 1880
Salt print
The J. Paul Getty Museum

## I. AIM FOR ART, NOT MACHINE TECHNOLOGY

MANY WRITERS have described the years between 1890 and the 1920s as a period of fine-art photography temporarily stalled at a romantic moment on its way to the proper, progressive, "straight vision" of the 1930s. From this outdated vantage point, the second generation of California photographers appears diminished, as if seen through the wrong end of a telescope.

Yet the many accomplishments, innovations, and challenges the pictorialist photographers defined and met remain potent today. We should remember, for instance, that as the California pictorialists practiced this new, uniquely democratic technology of picture-making, they encountered the classical, intellectual, philosophical, and aesthetic conflicts that had long existed (and still exist) between the elite and the demos: What was art? What were its values? Who codified those values? Did photography's scientific, mechanical, and rational method categorically exclude it from achieving art? What were the role of authority and the value of invention? By what means should one articulate issues of representation and factual recording as opposed to issues of manipulation and effect? Who was an artist? A connoisseur? A professional? An amateur? A hack?

# Encouraging the Artistic Impulse: The Second Generation: 1890–1925

■ *Therese Heyman*

Out of these early arguments—which were often articulate, voluble, and acrimonious—the California photographers gained their sense of direction. Even as the technology of picture-making became simpler and more accessible, the act and study of photography became more compelling to those driven to employ the camera as the artist's eye.

In this exhibition pictorialism is presented from the point of view of its participants in California—in the north, those leaders who joined major pictorial exhibitions, and in the south, a selection of the men and women who initiated new visions. Pictorialism affected the tone and technique of Western photographers as diverse as the academically advanced Arnold Genthe, the self-taught Adelaide Hanscom, and the self-improving Edward Weston. What brought these photographers to make pictorial prints were not pictorial values as they appear to us today—romantic, often contrived, allegorical—but the new spirit of freedom, associated with life in California, toward which they pointed. Very little is known about this second generation of photographers. This seems remarkable inasmuch as the San Francisco Bay area produced three members of the famed Photo-Secession based in New York: Oscar Maurer, Francis

Bruguière, and Anne Brigman.

The Bay Area was explosively populated from the 1850s on. By the 1890s, some three hundred thousand people were living in San Francisco and communities around the bay—a startling rate of growth in the forty years following the Gold Rush. By 1890, the California Camera Club, itself an amateur group, had been formed, attracting several hundred members by its second year.

The second generation of photography in California developed just when the hand-held Kodak I camera became available, with its famous slogan, "You push the button, we do the rest." At the same moment in New York, photography's most noted Eastern spokesman, Alfred Stieglitz, was forming the Photo-Secession, a group, that devoted itself, as we shall see, to a very particular view of picture-making (p. 94). As the techniques of photography were changing, becoming simpler, new opportunities arose. The celebrated scenery of California remained a prime subject for both professional and amateur, but now the motif was often the fragment, the intimate scene—a single, gnarled tree, for example. The heroic views of the mammoth-plate photographers gave way to renderings of protected places. Earlier, in much the same way, the vast paintings of California

landscape by such leading artists as Thomas Hill and Albert Bierstadt had given way to works by a generation of artists like William Keith who were satisfied to paint the character and mood of a glade. The turn-of-the-century photographers who made these intimate pictures, no longer explorers in the pay of government surveys, were most often amateurs (soon to be hobbyists) and occasionally professionals who wanted to participate in the activities of a group.

Many of the leading fine-art workers in the Bay Area began as amateurs who taught themselves photography; Arnold Genthe, Anne Brigman, and Laura Adams Armer came from cultured and artistic families. Although Genthe and others had considered becoming painters, they all reported being caught up in the new, exciting art-photography medium, a means to interpret life "in terms of light and shade." Whether they attended art school—as Armer did at the California School of Design (now San Francisco Art Institute), where she photographed her teacher, Arthur Mathews (figure 2-1)—or whether they studied on their own, the photographic means of expression had a strong appeal.

The California Camera Club flourished. In 1900 it launched a journal, *Camera Craft*. In the opening paragraphs of the first issue the

**Figure 2-1.** Laura A. Armer, *Portrait of Arthur F. Mathews*, c. 1910. The Oakland Museum Collection.

editors were pleased to announce that "The very atmosphere of the Far West encourages the artistic impulse of its people. With such great natural advantage it is small wonder that when the western photographer has seen fit to cross the continent to compete with the eastern brotherhood he returns with laurels on his

brow. Not less wonderful is the existence of the largest Camera Club in the world in the City of the Golden Gate."[1] The editors were claiming, as Californians have regularly done since, that photography of the state's splendid scenery succeeded in special ways because of the subject itself. Whether the size of the club was true or magnified to match the mountains is not certain; at the time such comparisons were probably difficult to disprove.

*Camera Craft* articles of the first years are full of information covering technical news. The publication was produced by offset lithography and illustrated throughout; quality of photographic reproduction does not seem to have been a noticeable criterion, although fine images by William Dassonville and Oscar Maurer appeared on a regular basis. Because many of the members experimented with different photographic processes, their prints were done by a mix of methods. As Dassonville, William Worden, and later, others were accomplished in these sometimes arcane techniques, the articles were helpful if not entertaining. There was a continuous stream of news stories about the club's mild and mannerly social events and parties as well as advice on the uses of photography, always necessary to bolster the many leisure-time camera users who turned to

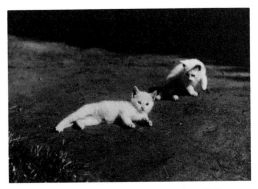

**Figure 2-2.** Oscar Maurer, Untitled (two cats), c. 1910, platinum print. Gift of the artist, The Oakland Museum Collection.

allegories, family moments, and inevitably, their pets (figure 2-2).

In its first years *Camera Craft* was not seen by other journals in the manner in which it viewed itself. When *The Wave*, an innovative and irreverent literary publication, later reviewed in its lively, critical-magazine style the Camera Club's first San Francisco exhibition in 1892, it concluded that there was "little, a very little promising amateur work" and much that was "crude, ill-schemed and timid, and dozens on dozens of snap-shots and posed portraits which desecrated art to the limit and beyond."[2]

Photography was only one cultural area that *Camera Craft* treated; its articles on painters and writers were also taken seriously and discussed by the relatively small Bay Area arts community. *The Wave* and other West Coast publications such as *Pictorial California*, an important art compendium concerned with literary and other cultural matters, were remarkable for their illustrations. To print photographic images along with blocks of text on the same page posed technical problems for printers of the time. With the introduction of the halftone printing plate in the 1880s, it became possible, through use of the dot screen, to translate the continuous tone of

photographs into printers' ink. Yet even after this process was commercially viable, only a few magazines and books—including *The Wave*—employed it; most retained the traditional printing techniques of etching, engraving, and woodblock instead.[3]

Perhaps *The Wave*'s willingness to experiment, to welcome and eagerly use the most up-to-date technology, existed because—like many other California institutions—it was an enterprise with little history in a land of newly formed audiences who believed in the possibilities and advantages of change. When *The Wave* reviewed the 1894 Camera Club exhibition, it noted,

> The development of two years has been remarkable and given great encouragement for the future.... Oscar Maurer has two excellent portraits, together with a Mexican view 'The Storm'... which verges on the great.... Dr. Genthe's two superb portraits, one called simply 'A Study,' is of a handsome woman in diaphanous drapery, and is full of poetic feeling. Dr. Genthe needs only handcraft to be a great painter; except this alone, the portrait in question has all the quality of work of the best portrait painters.[4]

Recognition for outstanding photography was not limited to the local area. There was an active network of California camera clubs from San Diego to Vallejo, while most major cities across the country could claim that they too had a mania for photography that was showing no sign of calming down. In 1900 the Chicago Camera Club held its first salon exhibition in an august location, the Art Institute of Chicago. The importance of this venue suggested what the club members were pleased to proclaim, that the "exhibition [was] designed to demonstrate the artistic possibilities of photography as a means of giving expression to the individual appreciation of and feeling for that which is pictorially beautiful."[5] In this landmark show, the sole entrant from California, Oscar Maurer (who was not a Camera Club member but was active in the club

**Figure 2-3.** Cover of an issue of *Camera Craft*, November 1922. Oakland Public Library.

interchange), fared very well.[6]

While the later issues of *Camera Craft*, particularly those of the 1930s, convey the impassioned, often hostile ideological statements of photographic greats fighting in words over pictorial issues, these first years of the journal lack the dedication and singular focus of that other and most extraordinary publication, *Camera Work* (figures 2-3, 2-4). When Alfred Stieglitz, the most noted advocate for photography as a fine art, began his magazine for the rebelliously styled Photo-Secession in 1903, he set about presenting photographs in the most elegant manner. The precious character of the expensive papers, the tipped-in format that presented only one image on a page, showed the value Stieglitz attached to each. It was frequently observed that the photographic reproductions in *Camera Work* had the unforeseen but highly desired effect of improving the original. Stieglitz, with European training in craft method, dictated the standard he expected.

Figure 2-4. Cover of an issue of *Camera Work*, 1911. Burden Fund for Photography, The Oakland Museum Collection.

By contrast many turn-of-the-century camera clubs in California typically stated their ideas about themselves, photographic processes, and publications in more democratic terms, including all manner of pictures and accepting far less demanding standards of reproduction than Stieglitz'. The committee of the first California Salon assured its viewers, "The policy adopted by the committee in compiling the rules governing the exhibition leaves no possible avenue for criticism. The rigid lines of the Eastern exhibitions have been modified."[7] The entries were all to be on equal footing, quite the opposite of the approach taken by the Photo-Secession, identified by its commitment to fine art. At the turn of the century in California, any photograph made with aesthetic intent was classified as "pictorial photography," a sweeping term usually used to describe a picture made in the style of the popular painters, especially tonalists such as Xavier Martinez, and the late style of William Keith

and Jules Tavernier.[8] These photographers and the painters they admired generally chose subjects consisting of landscapes, often mist-covered fields and forests; portraits of pretty women, often veiled and draped in flowing gowns; and, occasionally, daring nudes. The titles of pictorial pictures usually contain poetic suggestions to indicate the mood or allegory of the image. *The Cleft of the Rock* (figure 2-5), as Brigman called one work, or *Homeless* (figure 2-6), as Maurer entitled his scene of a couple walking in the ruins of an earthquake, carry a universal rather than a specific quality.

Unclothed women and men were studied as rightful objects of art, but in pictures made for public view they were "clothed" in allegory and classical allusions. Anne Brigman wrote to Stieglitz, for example, to advise him that some negatives he was going to reproduce in *Camera Work* had to be handled with great care to insure that the figures would be seen as hamadryads and nymphs photographed in classical poses.[9] Nudes by women in the 1920s were presented with strikingly different objectives than the nudes photographed by men. Arthur F. Kales, in *Arched Colonnade with Seven Figures* (p. 93, bottom), for example, was aiming for the erotic Hollywood shot of nudes posed to stimulate a response. Brigman, in *Heart of the Storm* (p. 76, right) portrayed the nude as fragile, close to nature, suggestive of classical youthful innocence.[10] In the small selection of pictorialist works included in this volume, the sensuous character of the female nude is evident in the pictures taken by males. A self-conscious sexual humor was suggested by Roger Sturtevant in his 1925 photograph of a buxom nude supported by a wall on which a framed picture is easily identified as Johan Hagemeyer's photograph of a tall columnar tower, *Tile Factory* (p. 96). To be certain that his intent was noted, Sturtevant titled his work *Freudian Composition* (p. 108).

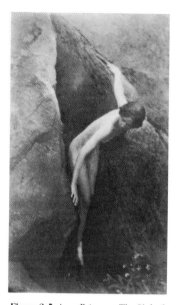

Figure 2-5. Anne Brigman, *The Cleft of the Rock*, 1905. Gift of Mr. and Mrs. W. Nott, The Oakland Museum Collection.

The more painterly photographers depended on diffused light, which produced softened edges and a lack of detail. Their work was often characterized as impressions. These photographers also found lenses that produced "fuzzy" images, as their detractors called them; their effects could be further manipulated by covering the lens with lace or smearing it with oil. The precocious Ansel Adams explained these pursuits in a brilliant 1920 letter.

I am more than ever convinced that the only possible way to interpret the scenes hereabout is through an impressionistic vision. A cold material representation gives one no conception whatever of the great size and distances of these mountains. Even in portraying the character of and spirit of a little cascade one must rely solely upon line and tone. Form, in a material sense is not only unnecessary but useless and undesirable....I want you to see what I am trying to do in pictorial photography—suggestive and impressionistic—you may call it either—it is representation of material things in the abstract or purely imaginative way.[11]

**Figure 2-6.** Oscar Maurer, *Homeless*, 1906, modern gelatin print. Gift of the artist, The Oakland Museum Collection.

Whether this was all in the service of a new art was debated, but from the outset of photography on the West Coast, there were a few professional studio operators who thought about how their pictures ranked with the works of painters and printers around them. An amusing local daguerreian, William Shew, implied that if this new medium was an art, it was because California did not have a surpassing excellence in any other one. Photography was the American and (in his view) West Coast art by default.[12] Arguments about whether and in what way photography could be considered an art continued, with the emphasis changing from Shew's view to one that depended on creating boundaries for a special kind of photography which could then be separated from other types of functional images. This particular kind of photography, which was the basis for a definition of photographic art, was called "pictorial."

While the photographic salons of New York and the East continued to accept many kinds of photographs, Alfred Stieglitz saw the need for still more exclusive art-photography exhibitions. Even his Camera Club of New York, established in 1896, was not the single-minded group devoted to the pure art he advocated. The Photo-Secession, however, was dedicated to pictorial art. Stieglitz invited and limited membership, held members to what was agreed to be a high standard, carefully

advanced photographers from Associate to Fellow status, and exercised tight control over all aesthetic issues. *Camera Work*, for all its authority and call for standards was most widely read in its first years. Its subscription list reached a thousand, eventually including California Camera Club members Brigman, Bruguière, and Maurer. A measure of Stieglitz' influence during these years was Brigman's reaction to a few months' study with him in New York and the well-remembered audiences he gave to Imogen Cunningham, Johan Hagemeyer, and Edward Weston between 1910 and 1924. These visits were often in the nature of pilgrimages. When Cunningham saw Weston's print *Ramiel in His Attic* (p. 109) she commented in her usual acerbic way on Stieglitz' "star" artists, "If that doesn't make old near-sighted Stieglitz sit up and look around...at some one beside the seven constellations...I don't know what would."[13]

West Coast converts were free to find their own "salvation," while Stieglitz continued to propagate his ideas wherever possible. As a juror at many regional exhibitions, he gave recognition to those who met his refined sense of photography. The exclusivity and authority he demanded and exercised also extended to his control of national and international salons. However, he was not called to aid the California Camera Club until its third salon, in 1903. The catalogue lists Armer, Brigman, Bruguière, Dassonville, Louis Fleckenstein, Hanscom, and Maurer.[14]

As important as Stieglitz and the Photo-Secession were to the development of a lively, aesthetically directed California Camera Club, other more democratic and public exhibitions also were significant. To prove to the world that San Francisco could recover from the earthquake and fire of 1906, the city became the site of an international exposition in 1915.

The spirit of the Panama-Pacific International Exposition was optimistic. One critic noted that it was a chance for those living at the edge of the New World to see something of the spirit of the masterpieces of the Old World, "It's a long way to the Acropolis, and what we need here is something of the godlike simplicity of the Athens of Pericles before our eyes, and something of the monumental and massive dignity of Imperial Rome."[15]

During the twenty-four months the exposition was open, photographers and the estimated nineteen million people who attended were able to see the innovative sculpture and avant-garde modernist paintings loaned for its duration. Like the Armory Show two years earlier, the exhibition included often incomprehensible work by Vincent Van Gogh, Odilon Redon, Paul Cézanne, and the futurists, but in the main, it did not overlap with the New York show. (After the exposition, in 1916, there was an additional, smaller fine-art exposition consisting largely of prints and etchings.) Despite the war in Europe the fair secured loans of significant French impressionist works not previously seen in Northern California. Entire rooms were devoted to less celebrated contemporary artists whose work was more immediately influential. (A gallery of sixty-three works by Whistler, for example, was probably the impetus for a revival of etching.)[16]

The exposition remained open for over a year. Ansel Adams recalled being allowed to drop out of school for months in order to attend daily.[17] Some critics have noted the generally conservative intent of the jury for the fine arts. The situation was quite different in photography, for which the fair was not only teacher but model. Bruguière, Maurer, Genthe, and many others found in the fantastic Victorian buildings an "evocation of a past that never was," a delightful, ever-changing subject.

Weston and Hagemeyer visited from Southern California and argued about the art they saw, though their style of pictorialism seemed to depend more on the information and illustrations in *Camera Craft, Camera Work*, and what were called the "little magazines."[18]

Traveling photographic exhibitions were frequent in this period. As early as 1903, works of the Photo-Secession were seen in the San Francisco Bay area, and the manner in which photographic style was communicated made for fairly immediate response. There was no need to retrain the hand; improving techniques and equipment more than kept pace with the desire of a large public that wanted to make pictures. However, as the prime leader in the aesthetic battle announced in the pages of *Camera Work*, it was Stieglitz and his publication advisor and assistant, Charles Caffin, who inspired dedication and high purpose. In an important book, *Photography as Fine Art* (1901), which states the ideas he would contribute to *Camera Work*, Caffin puts this sense of high art into an admirably clear context, "There are two distinct roads in photography—the utilitarian and the aesthetic: the goal of the one being a record of facts, and of the other an expression of beauty."[19] For Caffin the "utilitarian" included photographs of daily incidents, buildings, engineering works used in illustrated newspapers, geological investigations, and mining scenes. These subjects and their factual context made them useful throughout the decades of California's exploration from 1850 to 1890 and also from 1890 to 1923 as cities changed and expanded.

It is ironic that one of the most ambitious and extensive photographic studies undertaken at this time was not a record of the new California but a romantic effort to save a past already out of view. Edward Curtis raised funds to create what might be considered another of America's great surveys, *The North American Indian* (p. 78, left); no project of this magnitude would be tried again until the 1930s. Changes in the majority population and the loss of Indian lands coupled with the growth and settlement of new cities prompted Curtis to attempt to defy the passing of time. His massive series, published between 1907 and the 1920s, is a tribute to his faith in the camera and the picture maker as cultural historian. As photographer he exercised some of the license which movies would assume as they recreated a dead past using imagined, then found props and settings.[20]

Given its ambiguous use of appropriated information, Curtis' series lay neither clearly within nor outside Caffin's definition of photography's "two distinct roads." Photographs in his purely aesthetic category, Caffin noted, recorded facts but "not as facts." This seeming contradiction was explained in different words by one of the three West Coast Photo-Secessionists, Anne Brigman.

> [I]t began in summer camping in the high Sierras far from the beaten trail. Trees at high altitudes are squat giants twisted and torn with the sweep of the prevailing winds.... One day during the gathering of a thunder storm when the air was hot and still and a strange yellow light was over everything, something happened almost too deep for me to be able to relate.
>
> New dimensions revealed themselves in the visualization of the human form as a part of tree and rock rhythms and I turned full force to the medium at hand and the beloved Thing [her camera] gave to me a power and abandon that I could not have had otherwise.[21]

Anne Brigman was to make a record of feelings and spirit, what many at the time described as indications of "soul." She put her feelings in service to a still higher motive—as she put it, "art with a capital A"—that could be appreciated in part because the particular, the specific, were not detailed (figures 2-7, 2-8).[22] One writer noted

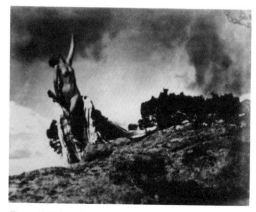

**Figure 2-7.** Anne Brigman, *The Soul of the Blasted Pine*, 1907, modern gelatin print. Gift of Mr. and Mrs. W. Nott, The Oakland Museum.

that in Brigman's works like *The Soul of the Blasted Pine*, "the human is not an alien, has not yet become divorced by sophistication from the elemental grandeur of nature."[23] This appears to contradict what had been one of the most appreciated aspects of photography, its truthfulness to detail. Brigman's trees are quite precise, yet it is not the particular tree that she calls to our attention but the composition of the tree taken in and modified by human form. Human figures are made "universal;" their features are softened and unrecognizable.

In Alfred Stieglitz' view and in his personal collection, Brigman's photographs were given high value and a prominent place. From what she called her "early middle humanhood," when she came to photography, Brigman's images, combining strange aspects of the California landscape with the anguished poses of nude figures, were surprisingly mysterious and seductively beautiful. Stieglitz recognized the individual and exotic vision in her ideas. He encouraged her with advice and the promise of an album of pictures reproduced in *Camera Work*.[24] When she later set the photographs to poetry, she wrote about the intense feelings

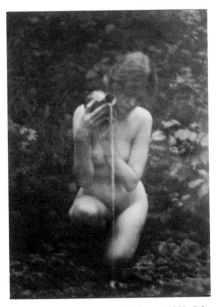

**Figure 2-8.** Anne Brigman, *The Source*, 1908. Gift of Mr. and Mrs. W. M. Nott, The Oakland Museum.

that inspired them. There is about these posed pictures a sense of what we recognize now as "performance," as the cast—her sisters and friends—enters into the pagan spirit of romantic situations; the photographs are documents of that display. Her series of wild outdoor scenes proclaim the necessity of freedom for Brigman, a theme central to her writing as well. "My pictures tell of my freedom of soul, of my emancipation from fear. Why should I seek the artificial atmosphere of a court to secure a legal freedom...when my soul is free without that relief."[25]

Brigman's photography was always personal and her printing methods equally so. One young photographer who assisted her remarked, "Photography for Annie was not the result of certain predictable chemical and physical reactions; it was a mystic rite that some people had learned from the gods." Thus tales of her sensuous paganism, although probably apocryphal, suited her perfectly.[26]

Freedom to pursue a life different from the expected, traditional patterns is a thread that runs through the biographies of other California pictorialists. Genthe and Weston referred to their struggles to become free, a desire also crucial to Laura Adams Armer and Hanscom, with whom Brigman worked. Stieglitz may be considered to have spoken for them all.

The struggle for true liberation of self and so of others had become more and more conscious within me and before I realized it I was editing magazines, arranging exhibitions (demonstrations), discovering photographers and fighting for them.... In short, trying to establish for myself an America in which I could breathe as a free man.[27]

Harmony, another pictorial theme, is the hallmark of many of Oscar Maurer's photographs. His soft-focus, romantic work induces a mood of reverie and celebrates something everlasting. It might be difficult to know where one is in a Maurer view, as he derives much of the impact from the universal. In *Eucalyptus Grove Silhouetted Against Cloudy Sky* (p. 106, right), the refractions and mist on the trees indicate Maurer's acceptance of the California tonalists' aesthetic and, possibly, the work of local painters Arthur and Lucia Mathews. Like tonalist paintings, these photographs lack definition and, when reproduced in color, could be versions of the same medium.[28] In fact in the pages of *Camera Craft* the photographers' prints often resemble painted works, an effect likely to be just what the pictorial photographers wanted from their prints.

How did West Coast photographers manage to make the usually sharp-focus, detailed prints of traditional photography into toned, imprecise images? In most cases they adopted the printing techniques of other media, mixing and manipulating them to convert photography from a largely

machine-made process into a handcrafted art. Camera Club members practiced these inky procedures in their club darkrooms at the Academy of Science, which had materials for the manipulation of plates and an enlarger that used artificial light. Training and knowledge gained in other fields may have helped certain photographers understand the sometimes complex steps in ink-printing processes. (Brigman and Maurer had relatives expert in the graphic arts.)[29] Brigman justified darkroom manipulation as follows:

The lens can be a medium of individual expression. There are those who cry 'faked' when other means are used with it, but are we not living in an age in which we are free reasonably so to do as we please? Who is going to limit himself to one tool when two or three will make his workmanship more beautiful? I claim the right to run the gamut from a lens to a shoe-brush to gain a desired effect. For a general word, Photography is probably a necessary one, for, like the rain it falls alike on the just and unjust.[30]

Although Oscar Maurer was a founding member of the Photo-Secession, his exhibition experience and opinions began to develop in San Francisco, where he was listed in the 1900 salon (figure 2-9). Having been in San Francisco since 1886, he soon was recognized as a leader in Bay Area photographic circles. He was listed as a juror in later pictorial salons, and his work was illustrated often. Maurer's portraits of Brigman and fellow Photo-Secession members document the friendships among the active Bay Area photographers despite frequent moves (figure 2-10).

In an article for *Camera Craft* Maurer makes the case for photography as art.

Not until the present day has the camera been recognized as a legitimate means for the production

of pictures that may be termed works of art.... That a higher ideal is being established is well attended by the splendid examples that recently have been exhibited both in Philadelphia and in Chicago. The art associations of these two cities have so far recognized the photographer's productions that they have granted certain photographic societies the privilege of regular exhibitions within the art associations' halls.... My own observation convinces me that among the vast amount of good material that professional and amateur photographers have produced on this coast, enough may be secured to make a very creditable display.[31]

When Maurer's own work was accepted in the Chicago salon of 1900,[32] Stieglitz, one of the three jurors, commented on his print *The Storm*:

> While the Chicago Salon is honored by the presence of much of the best work by the acknowledged leaders, it is also distinguished by exceptionally fine work bearing names that we will certainly hear more of in the future. One of these names is Oscar Maurer of San Francisco. He sends 'The Storm,' and it is one of the big things of the exhibition. The picture possesses rare feeling, exquisite tones, and the best of composition. All visitors seem to notice it.[33]

Maurer and his colleagues were committed to photography's possibilities as an art, but how could they define its other, more useful modes? Joseph Keily, an active and prolific critic, expressed the dichotomy between art and science that had haunted photography since its inception. "It is the result of an agitation in this direction awakened in the world of photography by a small group of men, who having beheld drowsing in the frozen clasp of science the beautiful spirit of art, strove to awaken it from its icy slumber to add new beauty to the world."[34]

This continued to be a major issue for the second generation of California photographers. The matter was not resolved, but by

**Figure 2-9.** Arnold Genthe, *Portrait of Oscar Maurer*, c. 1905, platinum print. The Oakland Museum Collection.

appropriating the techniques of other arts to formerly precise surfaces, photographers expanded their medium to include many chemical and optical strategies. Clearly, this freedom like others, appealed to the pictorialists.

The importance of the machine and corresponding relative unimportance of the photographer were very much a matter of concern. As the picture-taking process became easier, almost automatic, fine-art photographers sought ways to distinguish their methods and art from those of the button pushers. As Alvin Langdon Coburn complained in his essay "The Future of Pictorial Photography": "[Now] every 'nipper' has a Brownie, and a photograph is as common as a box of matches.... Photography is too easy in a superficial way, and in consequence is treated slightingly!"[35] Arnold Genthe took average, uninspired professionals to task for the sad state of their portrait galleries, listing their tired but standard props: "painted backgrounds, representing some picturesque subject as towering mountains, a library or castle, an immense spider web, a garden gate, the sad, sea waves, peaceful meadows, a staircase, the base of some massive column."[36]

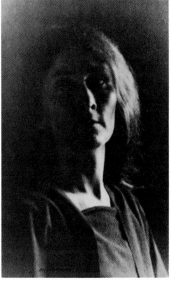

**Figure 2-10.** Oscar Maurer, *Portrait of Anne Brigman*, c. 1910. Gift of the artist, The Oakland Museum Collection.

Another sensitive issue for the California Camera Club was whether one followed photography for the "love of it." If not, could one accept commissions and be artful? As one response to this question, the leading pictorialist portraitists interpreted their sitters' lives and interests instead of using the arbitrary props favored by portrait studios. When in the 1920s Dorothea Lange, Imogen Cunningham (figure 2-11), and Genthe made portraits, they combined the universal ideals of grace and harmony with signs of their individual sitters. In her portrait of Harry St. John Dixon (p. 99), Lange clearly stated his craft as a metalworker (the image was used by Dixon for a catalogue) and suggested a pictorial sensibility of timelessness. This sensibility is often apparent in her many family portraits of wealthy Jewish clients from whom she sought commissions in the 1920s. Genthe, among the most literate of the West Coast group (he completed two books and wrote numerous

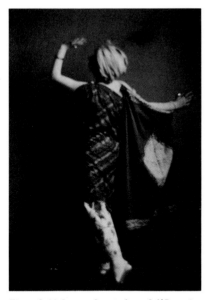

**Figure 2-11.** Imogen Cunningham, *Self Portrait in Javanese Costume*, c. 1910. The J. Paul Getty Museum.

articles), went so far as to propose a "rebellion in photography," including "a fundamental change…brought about in professional portrait photography."[37]

## II. Southern California Still Pictures

Perhaps the most serious obstacle to approaching a history of fine-art photography and culture in Southern California is the commonly held opinion that there has been little of lasting value. Photographic historians may be aware of the aims of the Pictorialists in the Los Angeles area between the turn of the century and 1920, and some readers may know the names of a few of the photographers associated with Edward Weston. But even specialists in California collections are rarely able to see a group of prints from this extraordinarily rich period in one place.

The photographic art of Southern

California was created in an environment of constant growth and unpredictable change. Hollywood, or the movie industry (which may be said to have begun with the 1908 production of *The Count of Monte Cristo*), attracted an array of outstanding and often sophisticated writers, musicians, architects, and painters, many of them immigrants from Europe. These film industry workers felt themselves to be in a cultural wasteland. Whether seen from this perspective or from that of Native American tradition,[38] Southern California was characterized by a sense of opportunity. San Francisco's rich families collected art and had their portraits made. This worldly city was in the news for banking, growth, and after 1906, the speed and energy of its recovery from the earthquake and fire. But after the boom of the 1880s, Los Angeles' population grew sixfold in about thirty years, thus offering infinite possibilities for expansion at once metropolitan and suburban.[39]

The climate of Los Angeles was not only a magnet; it was a financial incentive for early filmmakers and photographers, who could make pictures out-of-doors most of the year.[40] By 1910 Hollywood, incorporated into Los Angeles, had become the location for such movies as *In Old California* by D. W. Griffith. The pace of filmmaking, the energy, and the cluster of professional photographers both provided a challenge and confirmed Southern California's reputation as a land of opportunity.

Photographers, dependent on the sense of place, created an environment for further growth, as picturing the wonder and beauty of the state led inevitably to greater opportunities and, in the arts, a growing clientele and a market for images.

Edward Weston and Johan Hagemeyer were enthusiasts of the medium as well as

portrait photographers for financial gain. In Tropico (now Glendale) and his other Southern California studios, Weston pursued a life in photography which, before 1923, was heavily influenced by the pictorial aesthetic. Most of his work between 1920 and 1923 consisted of portraits, nudes, and studies in geometric form. "His chosen environment," a curator of Weston's archive has written, "was his studio, where he made portraits for a living."[41] The compositions include posed torsos, nudes, and heads seen against abstract walls of light. In the seductively beautiful print *Bathing Pool* (p. 110), Weston set young male figures in a play of soft light reflected by the shimmer of the water. In *Ramiel in His Attic* (p. 109), light again encloses and centers attention on the abstract forms of the walls. This is equally a portrait of light as of Ramiel. In an earlier work, *Wake! For the Sun Behind Yon Eastern Height / Has Chased the Session of the Stars From Night* (a work similar to *Ted Shawn, Dancer and Choreographer* (p. 111, left), light is the controlling agent. In a review of this startling work when it was shown at the London Salon, Antony Guest praised it "for the simple dignity of the figure in the soft light of dawn, the breadth of treatment…and the discriminating sense of tone."[42] Weston orchestrated the distinctiveness of California light. Even though he later repudiated his pictorial stage, it is possible to see these works as essential and lasting.

Weston went east in October 1922. By this time he had read most of the significant literature of the new photography in publications such as *The Dial*, *The Broom* and *The New Republic*.[43] But it was the personal contacts with Alfred Stieglitz and Georgia O'Keeffe (who was living with him at the time), Charles Sheeler, and Paul Strand that marked a turning point in his thinking. Importantly, he was able to see their original works (many of the

major articles he had read were not illustrated). Of course, he was also eager to show his own work to these leaders of the Eastern photographic community, but the viewings did not go particularly well. Stieglitz talked to Weston for four hours with Weston saying a half-dozen words. Years later, Weston admitted to a critic and friend, Nilsen Laurvik, that he was disappointed that his attic pictures had not appealed to Stieglitz.[44] However, Stieglitz' work, particularly his reductive, sharp linear images, impressed Weston with their absolute mastery.

Weston and his friends among the Los Angeles modernist painters indulged a primitive sense of what might be termed a bohemian life. Photographs of him sporting a cane and knickers suggest a delicious sense of life without restraints. Peter Krasnow's painting of Weston is sympathetic to the aspiring artist (figure 2-12). Perhaps the most influential of his associates in Tropico was Johan Hagemeyer, a pictorialist who, with his cape and walking stick, brought a flamboyant sense of the high arts to photography. More substantial was his expert knowledge of horticulture and evident desire to enjoy the good life. Like Genthe, he brought a European notion of culture to what was essentially a regional community.

Together Weston and Hagemeyer "played off of each other's boyish sensibilities," enjoying wine and women, traveling to San Francisco to the international expositions, opening a commercial studio for a few months, and visiting Anne Brigman's studio.[45] Parties, visits, and all-night discussions of photography occupied them as they made their way to evenings with Imogen Cunningham and her husband, etcher Roi Partridge.[46] Another fascinating member of this circle was Margrethe Mather, photographer and Weston's assistant, whose early pictorial work shows a distinctive love of pattern and Oriental touches. Politics, affairs, and visits to San Francisco and the Bay Area salons joined photographers to each other. For Hagemeyer in particular San Francisco offered subjects of industrial and built environments that suggested the dark, threatening side of what most other pictorialists took for their sunny arcadian pictures.

Happenings in Carmel-by-the-Sea also were of interest to this group. Down the coast from San Francisco, Carmel had become a magnet for California bohemians who were attracted there to live, make portraits, and enjoy each other's society and ideas. Located on a strikingly beautiful site in an area of beautiful landscapes, the village had been purchased by and developed for writers. George Sterling, Jack London, and Robinson Jeffers lived there at one time. Painters J. E. Partington and Arthur Mathews made extended visits. Arnold Genthe, unlike most of the artists who moved there after the San Francisco fire of 1906, was an early settler. John Paul Edwards, an amateur pictorialist who would later turn to straight photography with the Group f/64, was drawn to beach scenes with foggy atmosphere. His photograph *William Ritschel Painting by the Ocean* (p. 84, right) reveals the pictorialist preference for the partially seen. This portrait of painter William Ritschel is but one view of what must have been a common sight: someone sketching California's splendid coast. Side by side with pictorialism, a form of California impressionism developed in these seaside towns, as the sunlit paintings of E. Charlton Fortune reveal (figure 2-13). By 1922 a portrait photographer in Carmel could count on a meager living from locals and visitors, but, as always, artistic work rarely paid, and Weston, Hagemeyer, and most of the pictorialists depended on commercial jobs to pay their bills.

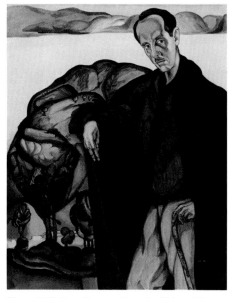

**Figure 2-12.** Peter Krasnow, *Portrait of Edward Weston*, 1925, oil on paper. National Portrait Gallery, Smithsonian Institution.

## III. NEW DIMENSIONS AND DIVERSITY

San Francisco's population in the 1920s had proportionally more immigrants than other American cities. Evidence of this in photography is seen most clearly in the work of Japanese-American photographers. In the Bay Area the largest club, the Japanese Camera Club of San Francisco, was formed quite late (1930), after Japanese newspapers had been holding photography contests for many years. In Los Angeles the group Shakudo-Sha[47] provided support and training for its own members, writers, and other artists and, most notably, held four exhibitions of the work of Edward Weston, beginning in 1921. The work of the more than eighty Japanese-American photographers in Los Angeles at this time is striking for its highly finished quality and, in the matter of style, the sophisticated use of

abstract composition and an expert handling of pattern and shadow. The larger Japanese-American photographic club of Los Angeles, established in the late 1920s, reflected a growing interest in photography on the part of its mostly amateur members. As in other clubs, the realities of finding professional positions were few, and members struggled to find a balance between their daily, often routine jobs and their devotion to amateur photography.

Although the geographically based camera clubs offered membership to all, they did not provide entirely comfortable social gatherings for the fast-growing numbers of Japanese photographers. As Kentaro Nakamura and Shigemi Uyeda pursued their amateur activity, for example, they sent pictures to many salons yet contributed most often to Japanese club exhibitions. Although very accomplished in balancing space and mass, their interest in the play of light on water and glass is often where one can see a unifying approach in the works of these Japanese-American photographers.

The exotic areas of Chinatown and Hollywood drew photographers to them. Genthe and Maurer each explored the Chinatown area near their studio in San Francisco. In the book *In Old Chinatown*, Genthe outlines his desire to photograph in his own manner.[48] The newly available hand-held camera was essential, as he knew he had to be "invisible" on crowded streets. Research confirms the extent to which he edited his view, selecting Chinese subjects but dodging out Caucasians. Cropping and manipulating negatives permitted him to concentrate the compositions of final prints on the closed, narrow streets. He was after "the spell of a self-contained, mythical Cathay."[49] Portraits of Chinese by Henry Hussey and Maurer suggest that many pictorialist hobbyists also visited this distinct section

**Figure 2-13.** E. Charlton Fortune, *Monterey Bay*, 1916, oil on canvas. The Oakland Museum Collection.

of the city. For a time it seemed that every photographer wanted to include Chinese props in his pictures.

It seems obvious today that in picturing the "other" community, Caucasian photographers often misunderstood real cultural signs, fastening instead on superficial details of pigtails and angled roofs. The point of view in these photographs is naturally the idea of the Chinese which Genthe or Maurer brought to Chinatown as visitors to a non-American, "exotic" locale. They did not and could not see the Chinese as they would have seen themselves. Perhaps there is no clearer evidence that photographs are the product of cultural bias, a way of thinking, and, often—as in Untitled (figures in doorway) and Untitled (Chinese market)—an enthusiasm for what is out of the ordinary. While there may have been a tourist market for these photographs, it was often the amateur who had the time and funds to create extensive series of them. Professionals usually stayed close to their studios awaiting portrait clients.

Portraiture was the genre that permitted women to take to photography from its beginnings. Why this singular occurrence came about cannot be explained by looking to the

other arts in California, in which women were unwelcome and rarely included in exhibitions.[50] But for many women at the turn of the century, photography was accessible. As Laura Adams Armer explained it, "Anyone of ordinary intelligence can manufacture a photograph."[51] She, Emily Pitchford, Cunningham, and, later, Dorothea Lange began their careers believing that photography would be a way to both be expressive and earn a living.[52]

By 1902 *Camera Craft* was carrying an effusively partisan article on women in photography, the tone of which is both encouraging and congratulatory. The writer, Helen L. Davie, stated as a certainty that photography was being advanced to the status of an "art" because of the influence of women,[53] something that may have been news to some of the readers of *Camera Craft*. She went on to assess the advantages of the career in the florid style of the day:

> Woman, the conservative, the copyist, as many are pleased to term her, has in this instance been the pioneer, leading the way in pictorial portrait photography, a way her brothers have found pleasant and are making haste to follow....[A] very large percentage of the women who have taken it up earnestly are famous.[54]

The reason for this success is suggestive of stereotypes of the day: women were inherently possessed of beauty, and for that reason they recognized it in art. Davie identified other important qualities of women's nature which are also descriptive of the best of pictorial methods. She believed women had "vivid imaginations" and an "idealism of the commonplace in life." To women's "exquisite sense of harmony" she attributed their success in portraiture; it was assumed that women would be better able to put sitters at ease before the camera. But when the writer

explained why she thought so many women turned to photography, she listed the obvious advantages: "Photography can be learned and practiced at home, with only a small amount of capital, a good lens, a moderate-priced camera, a substantial tripod, developing tray, a few graduates, and the outfit is complete." No long years of training were required, and apparently by this time, directions for the different processes were so plainly stated that only courage was needed. Among the many nationally known women cited for their success, were Laura Adams Armer. Davie reminded her readers that portraits were not the only lucrative trade. Magazines, newspapers, and books required and paid for pictures. Davie thus recognized the beginning of a new career, that of the professional photo editor who could place pictures. In the lives of many women, "picture-taking" was their only chance to be visually creative and independent. One person could handle the camera, take the picture, develop the film. Of course women took it up.

Not all women had the unique situation of Laura Adams Armer who, having married and raised her children, traveled to Navajo villages. Very few women had the "wild" sense of freedom which Anne Brigman recalled from her early Hawaiian home. Few women could attract the leading writers of the day to pose for their pictures of *The Rubáiyát of Omar Khayyam*, as did Adelaide Hanscom. At the outset of their lives in photography, Tina Modotti and Margrethe Mather depended on Edward Weston for his passionate attention to photography and to them, but they soon acquired their own political and professional views. In each of these lives there was an identifiable need for independence.

When Alfred Stieglitz proclaimed that all forms of art should be acceptable in photography without undue regard for past

convention, pictorialist photographers accepted the basic assumption of many turn-of-the-century Americans: art, like life, was evolutionary. Their style of photography was a higher form of achievement—of art—than the earlier, reportorial approach. Art, not machine technology, was indisputably their aim. Although flight from authority characterizes the lives of most of the major California pictorialist photographers, it is important to recognize that their turning away from old forms took its impetus from the desire to encounter the possibilities and exhilarations of the innovative, whether in art or life. Pictorialism in California in this period provided a unique medium of expression as well as uniquely accessible means to realize such goals. The pictorialists' success may appear to have been overshadowed by that of the generation of photographers that followed them. But in a longer view of photography, it may be that manipulation, hand-coloring, and collage will come to be seen as basic to photographers' artistic expression.

## NOTES

1. *Camera Craft* 1:1 (May 1900), editorial.

2. "The California Camera Club," *The Wave* 20:23 (December 1899), p. 5.

3. For a full discussion of the process of translating photographic illustrations into printed reproductions, see John Szarkowski, *Photography Until Now* (New York, 1989), pp. 147-248.

4. "The California Camera Club," p. 5.

5. Joseph Keily, *Introduction to Chicago Photographic Salon of 1900* (The Art Institute of Chicago, 1900), unpaginated.

6. Ibid.

7. "The Salon Officials," *Camera Craft* 1:6 (October 1900), p. 11.

8. See Wanda Corn, *The Color of Mood: American Tonalism, 1880-1910* (San Francisco, 1972).

9. Correspondence between Brigman and Stieglitz is held by the Alfred Stieglitz Archive, Collection of American Literature, Yale University, New Haven, and in the Oakland Museum Archive from the family of Anne Brigman, Mr. and Mrs. William Nott in microfiche and other copy formats. Brigman to Stieglitz, Oakland Museum Archive, 24 April 1907.

10. Whether the obvious differences between Kales' Hollywood work and Brigman's studies done "for the love of art" are typical of a larger sample is hard to establish, as many photographers are remembered for their more sensuous pictures. Weston is a case of biography overshadowing photographs when it comes to the treatment of women.

11. *Ansel Adams: Letter and Images 1916-1984*, ed. Mary Street Alinder and Andrea Gray Stillman (New York, 1988), pp. 6-7.

12. Wendy Cunkle Calmenson, "'Likenesses Taken in the Most Approved Style:' William Shew, Pioneer Daguerreotypist," *California Historical Quarterly* 56, 1 (Spring 1977), pp. 2-19.

13. Quoted in Amy Conger. "Edward Weston's Early Photography, 1903-1926," Ph.D. diss., University of New Mexico, Albuquerque, 1982, p. 57.

14. See *Catalog of the Third San Francisco Photographic Salon at the Mark Hopkins Institute of Art*, October 8-24, 1903 (San Francisco, 1903).

15. Quoted in Nancy Boas, *The Society of Six: California Colorists* (San Francisco, 1988), p. 55.

16. Specific paintings such as those of Louis Maurer's cousin Alfred Maurer and the works of the American impressionists were mentioned by many local artists. While it is impossible to characterize a show of eleven thousand paintings, it is evident that the Society of Six saw and was deeply influenced by the palette of the American impressionists.

17. Interview with Ansel Adams, Oakland Museum Archives, 15 September 1976.

18. See *Camera Craft* 1:3 (1901-1903). Also Gelett Burgess, *Bayside Bohemia, Fin de Siècle San Francisco and its Little Magazines* (San Francisco, 1954; reprint of 1894 edition).

19. Charles H. Caffin, *Photography as a Fine Art* (New York, 1901), p. 9.

20. Curtis was not alone in his effort to retrieve and native traditions. High regard and a devotion to the

study of California missions and native Indians and their tools came together in Southern California in a movement called Arroyo Culture, led by writer, editor, and booster C. F. Lummis. A. C. Vroman, another equally dedicated believer, photographed the missions (mostly in their ruined, romantic state), Indian encampments, Catalina Island, and Southern California epics such as the Tournament of Roses. In turn these ideals inspired Northern California artists. Maynard Dixon, a close friend of Lummis had an appreciaton for the Indians' way of life and particularly for their unagressive use of land. Like the Indians in Curtis' North American series, the hero of Dixon's images appears to believe in the good of the unspoiled land and to find support in the unifying religious life of native culture. This simpler life was seen in a dramatic contrast to the insistent demands of ego experienced under modernism and in contemporary life.

21. Therese Thau Heyman, *Anne Brigman: Pictorial Photographer/ Pagan/Member of the Photo-Secession* (Oakland, 1974), p. 3.

22. *Camera Work* 25 (January 1909) and 38 (April 1912) contain Brigman's images.

23. J. Nilsen Larvik, "Mrs. Annie Brigman—A Comment," *Camera Work* 25 (January 1909), p. 47.

24. *Camera Work* 21, p. 48.

25. "Fear Retards Woman, Avers Mrs. Brigman," *San Francisco Call*, June 8, 1913, p. 9. In 1910 Brigman separated from her husband, a retired master mariner. Looking back, she said, "He had his way of looking at things and I had mine. We developed along different lines."

26. Autobiography, Willard Van Dyke, unpub. manuscript in family collection, p. 31.

27. William Innes Homer, *Alfred Stieglitz and the Photo-Secession* (Boston, 1983), p. 30.

28. Although atmospheric effects were suggested by softly colored inks in Sigismund Blumann's *Moonlight on the Trail* and many pictorialist photographs, true color, accurate in recording fabric, pattern, and detail, was not possible until the Lumière process of Autochrome became available in California after 1907. As Arnold Genthe remembered it, the miracle of autochrome was its one-step ease, available to the amateur. He noted that color was suspended in a glass plate that required transmitted light to be seen, but it afforded even the most inexperienced operator good results. Despite its ease the Autochrome method proved to be a fragile sideline without a future, as black-and-white photography succeeded

as the preferred system of the modernists, who turned away from the pictorialist aesthetic. It has been suggested that the pattern of change in a new medium as it moves to popular acceptance is from scientific to technological and commercial, to aesthetic. Although the artist is free to enter the process at any point, generally we find him or her at the end, after interest has been shown by the amateur. See Arnold Genthe, *As I Remember* (New York, 1936), p. 106; David Travis, *Photography Rediscovered* (New York, 1979), p. 150, n.1.

29. Granddaughter of a leading missionary family headed by Lorrin Andrews (1795-1868), Anne Brigman lived in Honolulu from her birth in 1869 until her mother moved to Los Gatos, California, in 1885. Brigman's grandparents taught the native population to employ copper-plate engraving as an element of Christian learning; see *Missionary Album, Hawaiian Mission Children's Society* (Honolulu, 1969), pp. 12-13. They also began a school program for family members and a printing business that, while not financially successful, provided the tools and opportunity for learning engraving just as they had taught it in their first school at Lahina-luna. Lorrin Andrews' son later described this venture at some length; see "Lorrin Andrews and His Relation to Copper-Plate Engraving," *The Friend* 51:1-2 (1903), pp. 12-13. Oscar Maurer's uncle, Louis, was an outstanding American lithographer and long-time employee of Currier and Ives; late in life Oscar acknowledged the importance of his family link with autographic printing processes (Oakland Museum Archive, *Scrapbook Album*). His cousin Alfred Maurer was an active modernist painter regarded as a member of the Stieglitz circle.

30. "Starr King Fraternity Exhibition," *Camera Craft* 10:4 (April 1905), p. 229.

31. Oscar Maurer, "A Plea for Recognition," *Camera Craft* 1:2 (June 1900), p. 60.

32. William B. Dyer, "The Chicago Salon," *Camera Notes* 4:1 (July 1900), p. 7.

33. Ibid.

34. Keily, *Chicago Photographic Salon of 1900*, foreword.

35. Nathan Lyons, *Photographers on Photography* (Englewood Cliffs, NJ, 1968), p. 54.

36. Arnold Genthe, "Rebellion in Photography," *Overland Monthly* 33 (August 1901), p. 94.

37. Ibid., p. 95-96.

38. See note 20.

39. Kevin Starr, *Inventing the Dream: California through*

*the Progressive Era* (New York, 1985), p. 64.

40. Ibid., p. 288.

41. James Enyeart, *Edward Weston's California Landscapes* (New York, 1984), p. 7.

42. Conger, "Edward Weston's Early Photography," p. 125.

43. Peter Bunnell, ed., *Edward Weston on Photography* (Salt Lake City, 1963), p. xix.

44. Laurvik and Weston juried the October 1921 Oakland Salon of Photography.

45. Emily Hamilton, who interviewed Brigman in 1907, described her studio: "Her studio at present is in Oakland, California, near the edge of the bay of San Francisco but far enough back from the drifting fogs to be drenched in sunshine and afford the studio a fine north light.... Up in the studio the light is subdued, the walls are hung with natural burlap and the woodwork is dark green...the few pictures are framed in dull wood." "Some Scenic Nature Studies from the Camera of Annie W. Brigman 1907," reprinted in Peter Palmquist, ed., *Camera Fiends and Kodak Girls* (New York, 1989), p. 181.

46. Richard Lorenz, *Johan Hagemeyer: A Lifetime of Camera Portraits* (Tucson, 1982).

47. For information on this accomplished group and other Japanese-American photographers, the invaluable study by Dennis Reed is essential: *Japanese Photography in America, 1920-1940* (Los Angeles, 1985), pp. 35-53. Information on California photographers from minority groups is scant, rarely discussed in the standard references, and in need of further study. There is little to go on in the membership lists of most clubs. The destruction of many prints in the 1906 disaster and in 1941 in the wake of relocation per Executive Order 9066 further complicates the search for information.

48. Arnold Genthe, *Pictures of Old Chinatown* (New York, 1908), introduction.

49. Maxine Hong Kingston, "San Francisco's Chinatown: A View from the Other Side of Arnold Genthe's Camera," *American Heritage* 30 (December 1978), p. 39. See also Jack John Kuo Wei Tchen, *Genthe's Photographs of San Francisco's Old Chinatown* (New York, 1984).

50. There were notable exceptions. Grace Carpenter Hudson made portraiture the dominant subject of her work and children a major theme. Lucia Mathews, first as her husband's student and then as his partner, had the opportunity to hand-color decorative invitations and to

follow the traditionally female practice of learning and painting charming, light-filled watercolors. What was unusual for a woman of the time was that Mathews also supervised much of the design and manufacture of the Arts-and-Crafts style furniture she and her husband made for their shop, a business they began after the 1906 earthquake. It is likely that she was able to accomplish this because, as the wife of a great painter who was also an influential arts administrator, she had opportunities that did not depend on her acceptance by local craftspeople. See Harvey L. Jones, *Mathews: Masterpieces of the California Decorative Style* (Oakland, 1972), p. 64.

51. Laverne Mau Dicker, "Laura Adams Armer, California Photographer," *California Historical Quarterly* 56, 2 (Summer 1977), p. 139.

52. As photographic clubs and societies have always included the names of many women, historians have begun to research and describe this impressive group within the commercial and amateur field. By consulting the brief listings in city directories and culling professional identifications, beginning in the Gold Rush years, a sizable number of women have been counted.

53. Helen L. Davie, "Women in Photography," *Camera Craft* 5:4 (August 1902), p. 130.

54. Ibid.

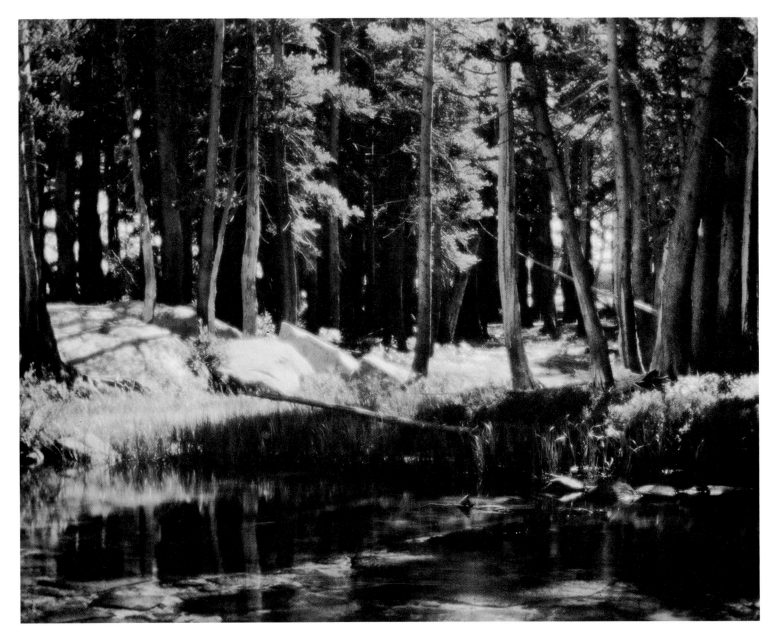

Ansel Easton Adams (1902-1984)
*Lodgepole Pines, Lyell Fork of the Merced River*, c. 1921
Gelatin silver print
Andrea Gray Stillman
© 1992 by the Trustees of the Ansel Adams Publishing Rights Trust

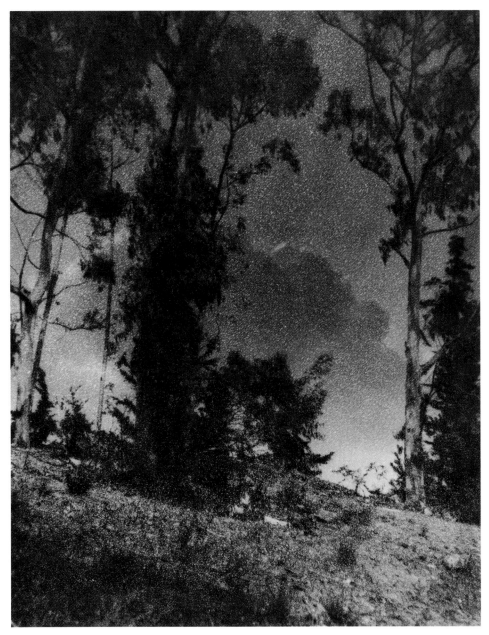

Sigismund Blumann (1872-1956)
*Moonlight on the Trail*, c. 1925
Lithobrome
The Oakland Museum
Gift of Tom and Nancy High

Ansel Easton Adams (1902-1984)
*Black Rock Pass, The High Sierra, Pack Trains in the Snow*, c. 1927
Gelatin silver print
The Oakland Museum
Gift of Francis P. Farquhar
© 1992 by the Trustees of the Ansel Adams Publishing Rights Trust
All rights reserved

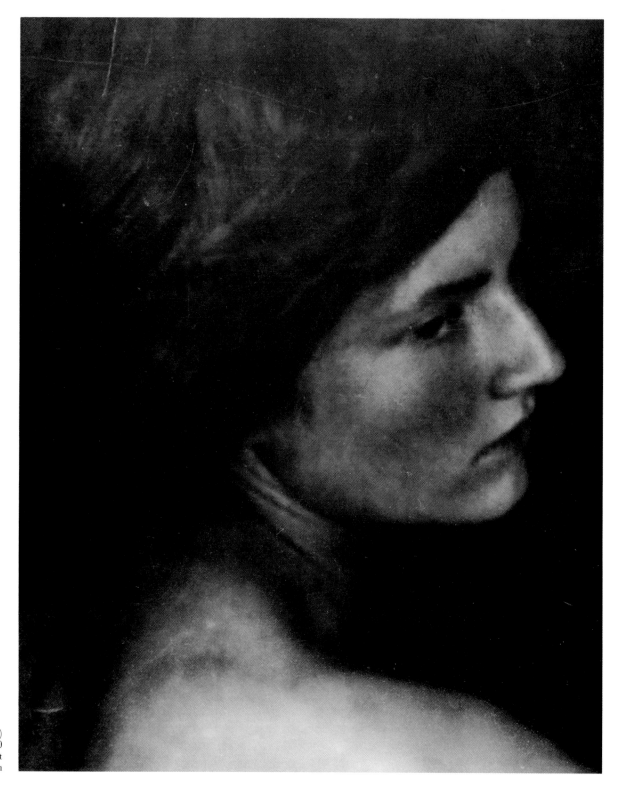

Laura Adams Armer (1874-1960)
*Portrait of a Young Woman*, c. 1900
Toned and lacquered gelatin silver print
Michael G. Wilson Collection

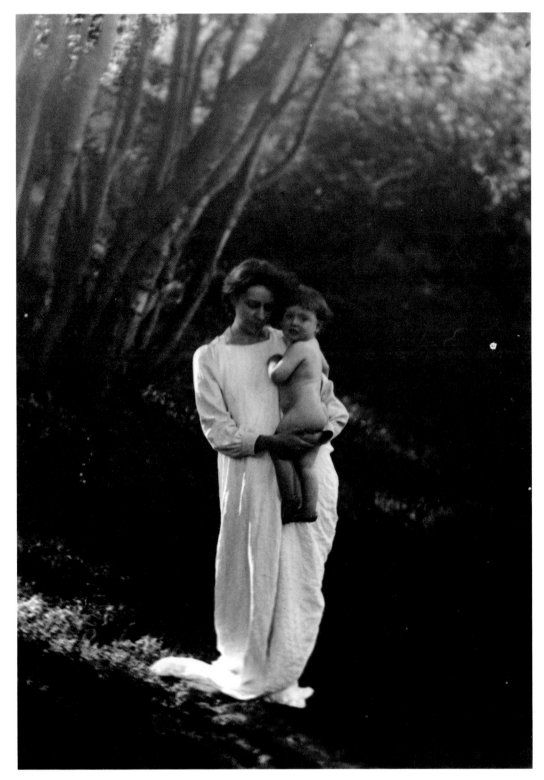

Laura Adams Armer (1874-1963)
Untitled (woman holding child), c. 1903
Toned gelatin silver print
The Oakland Museum

H. Oliver Albrecht (1876-1944)
*Three Girls in White, San Francisco*, 1898
Medium unknown
Collection of J. A. Partridge, Jr.
Courtesy of Mrs. J. A. Partridge, Jr.

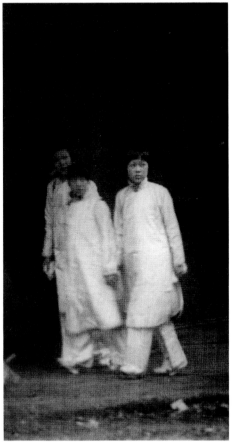

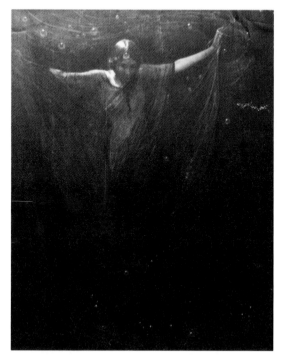

Anne W. Brigman (1869-1950)
*Beneath the Waterfall*, 1908
Toned gelatin silver print
The Oakland Museum
Bequest of Elizabeth Keith Pond

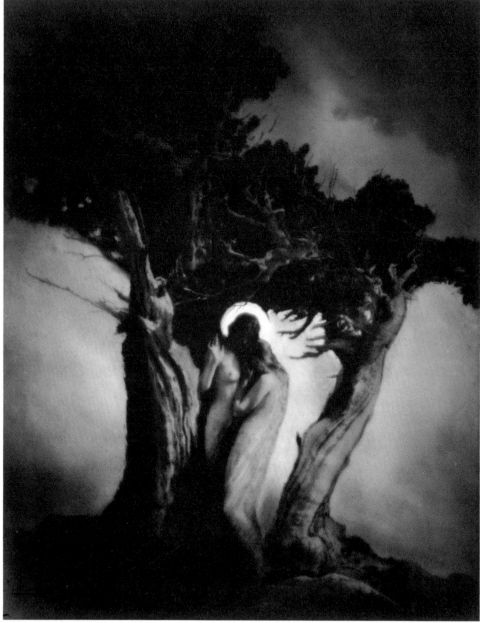

Anne W. Brigman (1869-1950)
*Heart of the Storm*, 1912
Platinum print
Michael G. Wilson Collection

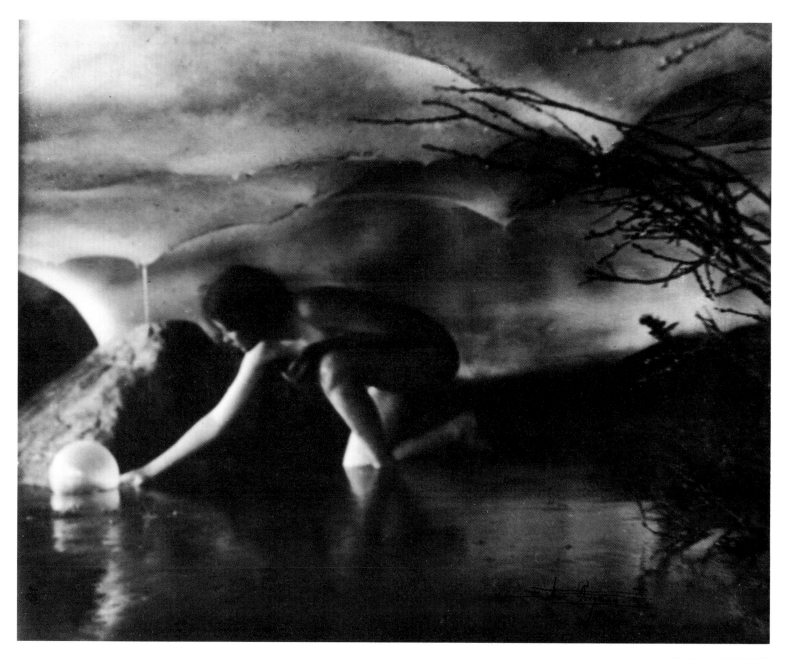

Anne W. Brigman (1869-1950)
*The Bubble*, c. 1910
Gelatin silver print
Michael G. Wilson Collection

Edward Sherriff Curtis (1868-1952)
*Signal Fire to the Mountain God*, 1899
Toned photograph
The Oakland Museum
Gift of Mr. and Mrs. John Fawcett

Edward Sherriff Curtis (1868-1952)
*Before the White Man Came, Palm Canon*, 1924
Photogravure
The Oakland Museum

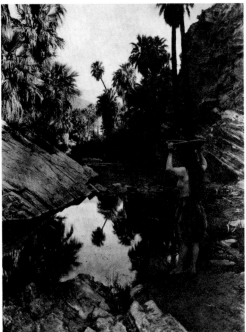

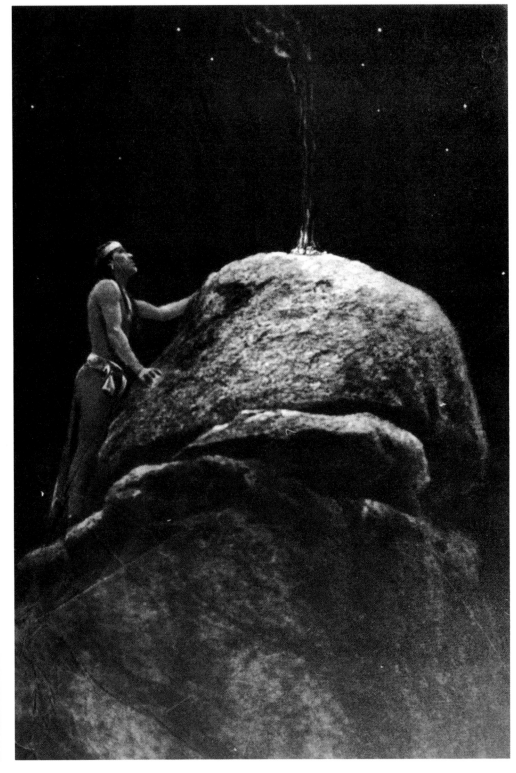

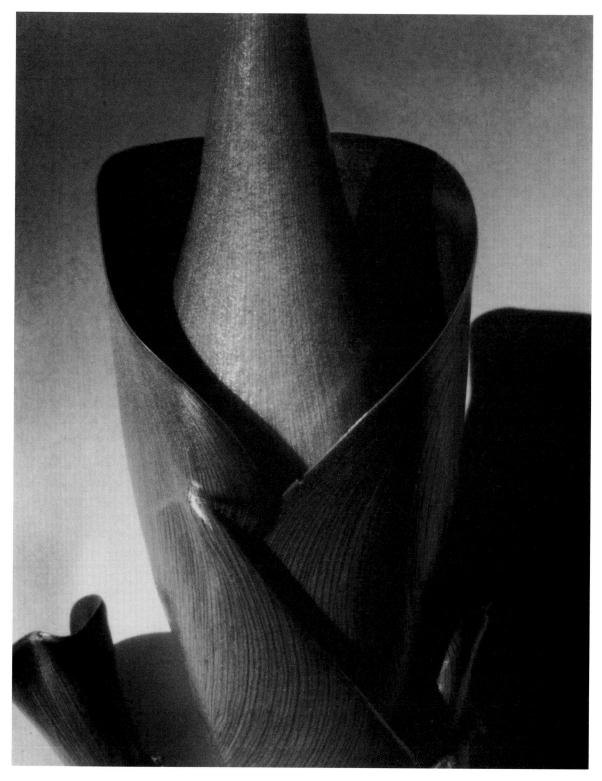

Imogen Cunningham (1883-1976)
*Water Hyacinth*, c. 1920
Gelatin silver print
The Oakland Museum
Gift of Mrs. Matt Wahrhaftig
© The Imogen Cunningham Trust

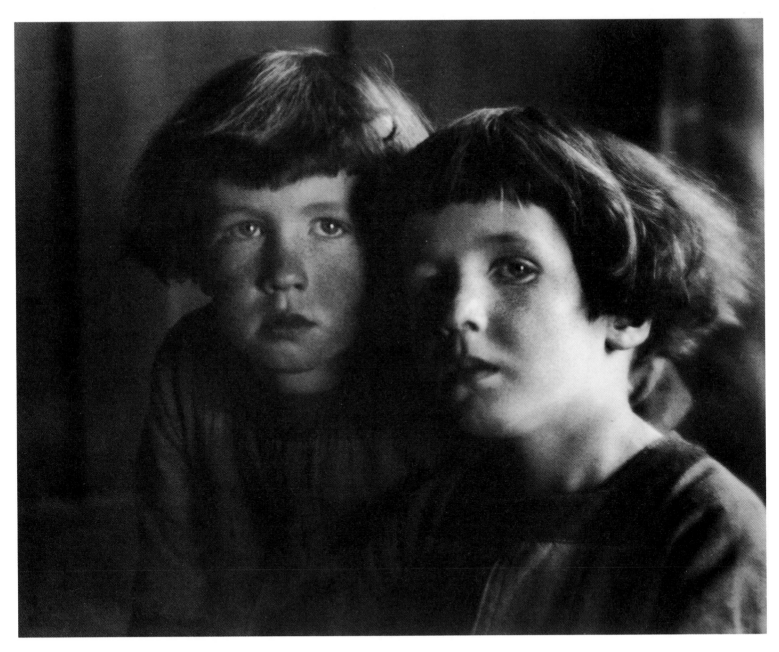

Imogen Cunningham (1883-1976)
*Twins*, 1921
Toned silver gelatin print
Imogen Cunningham Trust
© The Imogen Cunningham Trust

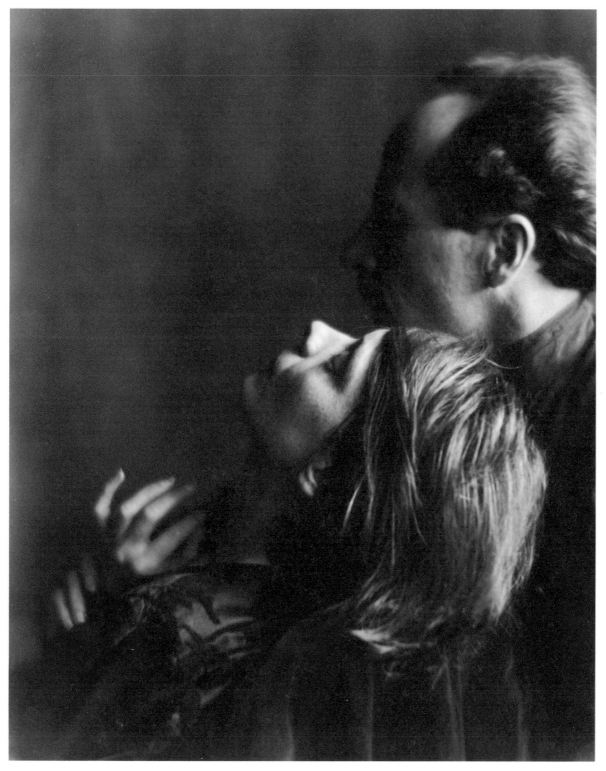

Imogen Cunningham (1883-1976)
*Edward Weston and Margrethe Mather,*
1923
Platinum print
The Oakland Museum
The Dudley P. Bell Fund.
© The Imogen Cunningham Trust

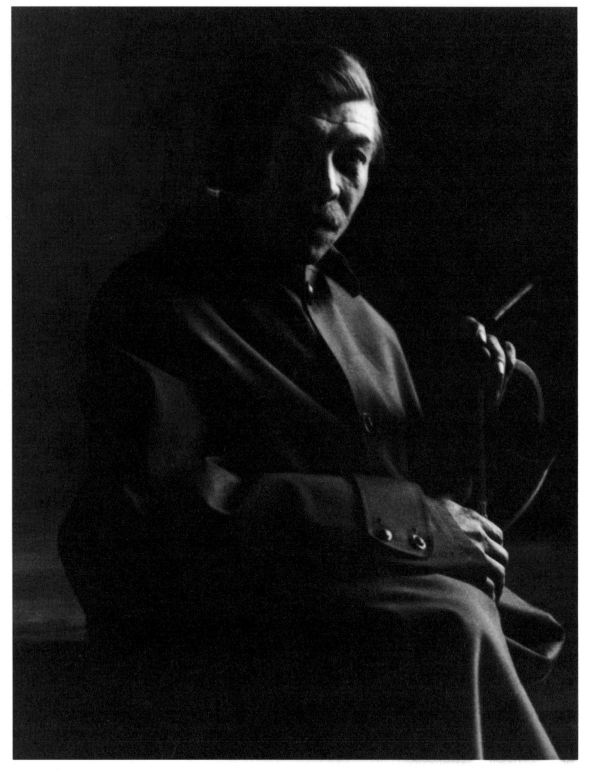

Francis Bruguière (1879-1945)
*Portrait of Xavier Martinez,* 1915
Toned silver gelatin print
Paul M. Hertzmann, Inc., San Francisco

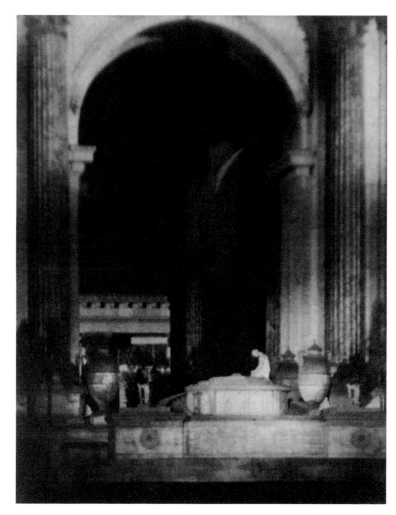

Francis Bruguière (1879-1945)
*Altar Before Rotunda, Palace of the Fine Arts*
*Panama Pacific International Exposition, San Francisco*, 1915
Hand-colored gelatin silver print
The Oakland Museum
Museum Donors Acquisition Fund

Arnold Genthe (1869-1942)
Untitled (figures in doorway), c. 1906
Gelatin silver print
The Oakland Museum
Gift of anonymous donor

John Paul Edwards (1884-1968)
*A Pause for Breakfast*, c. 1915
Bromide silver print
Paul M. Hertzmann, Inc., San Francisco

John Paul Edwards (1884-1968)
*William Ritschel Painting by the Ocean*, c. 1920
Bromoil print
The Oakland Museum
Gift of Mrs. John Paul Edwards

Louis Fleckenstein (1866-1943)
*Hoxey-at-Domingus Field*, n.d.
Bromide print
Marjorie and Leonard Vernon Collection

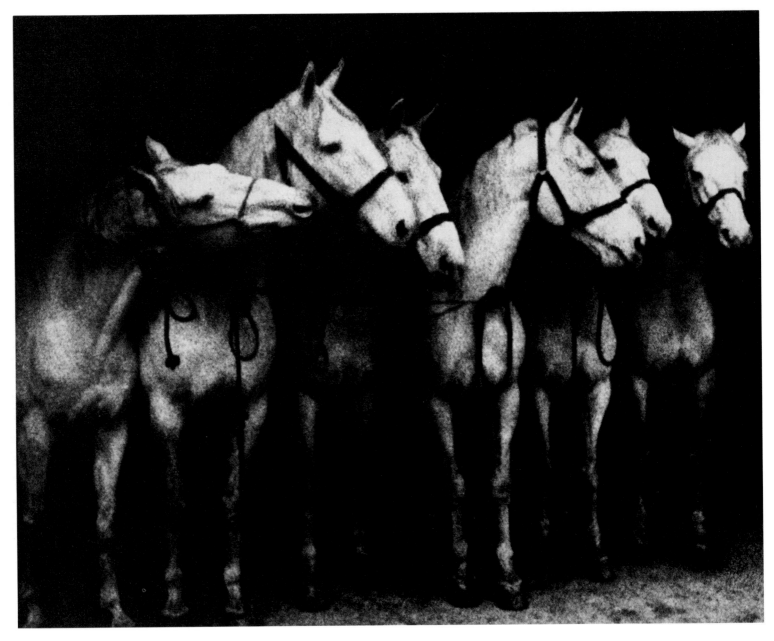

Louis Fleckenstein (1866-1943)
*Thoroughbreds*, c. 1900
Gelatin silver print
Michael G. Wilson Collection

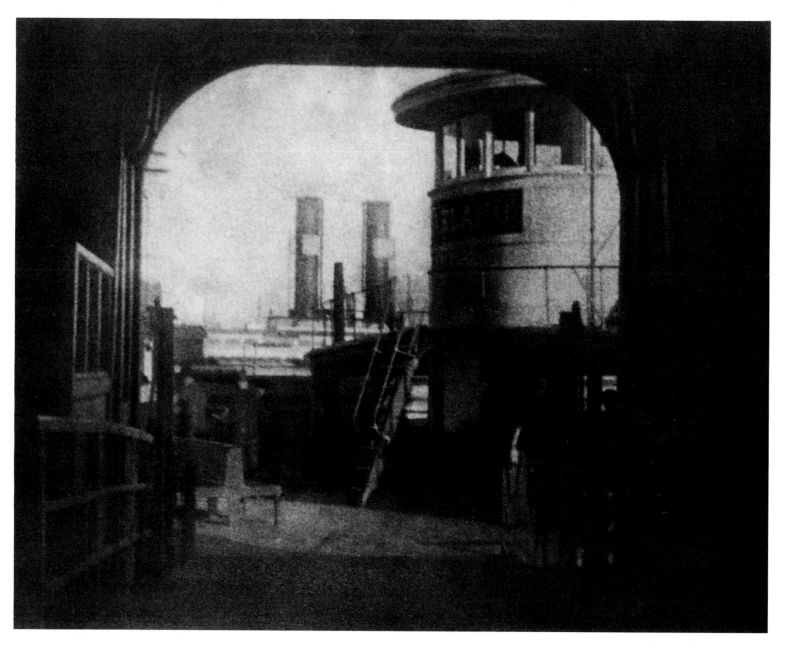

Henry A. Hussey (1887-1959)
*Ferry Boat*, 1923
Bromoil print
The Oakland Museum
Gift of Mrs. Henry A. Hussey

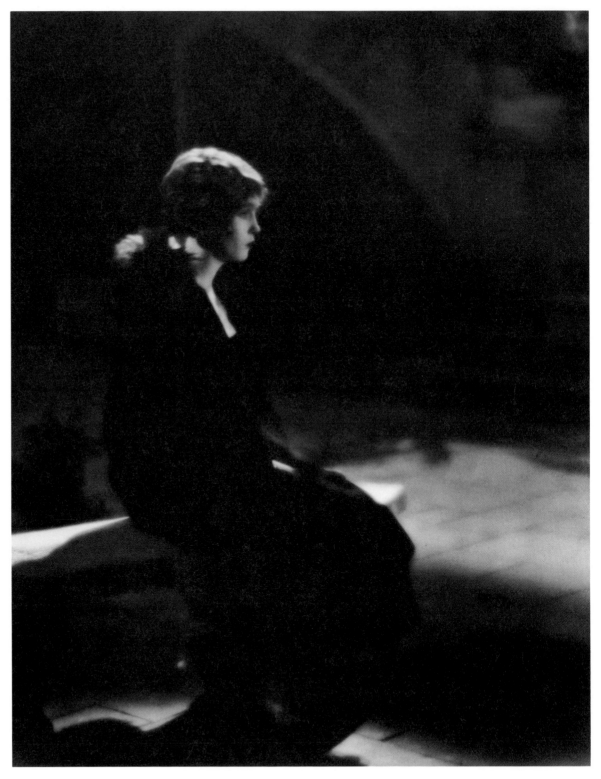

Arthur F. Kales (1882-1936)
*Waiting*, c. 1915
Gelatin silver print
Michael G. Wilson Collection

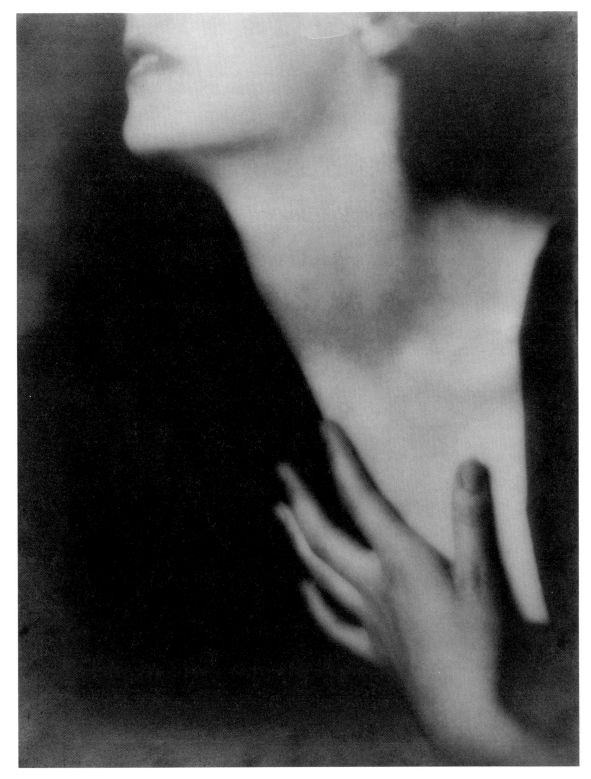

Arnold Genthe (1869-1942)
*Greta Garbo*, n.d.
Gelatin silver print
Marjorie and Leonard Vernon Collection

Henry A. Hussey (1887-1959)
*Orientale*, c. 1920
Bromide print
The Oakland Museum

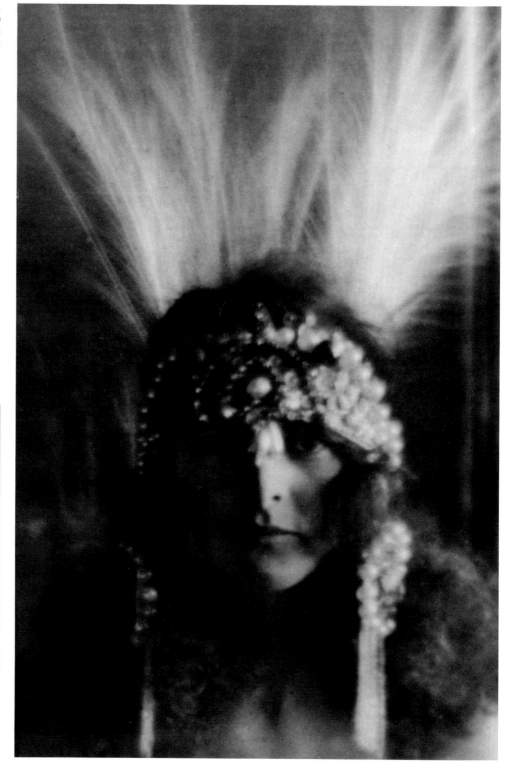

Arnold Genthe (1869-1942)
*Nora May French*, c. 1903
Platinum print
The Oakland Museum
Gift of anonymous donor

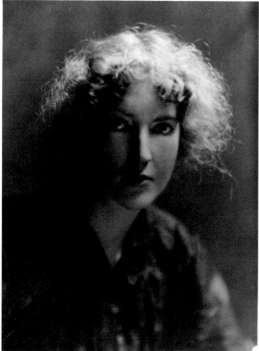

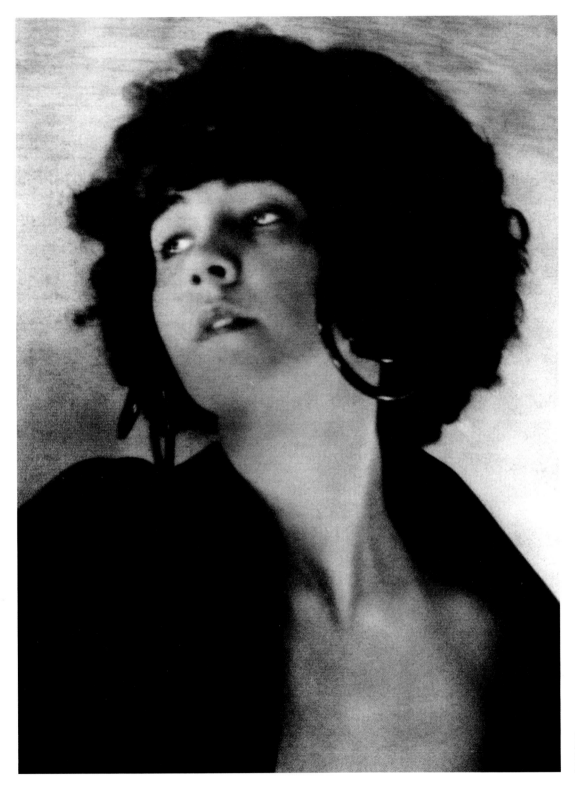

Arthur F. Kales (1882-1936)
*Miss Julanne Johnston,* c. 1920s
Bromoil transfer print
Michael G. Wilson Collection

Arthur F. Kales (1882-1936)
*Woman with Bottles*, c. 1927
Bromide transfer print
The J. Paul Getty Museum

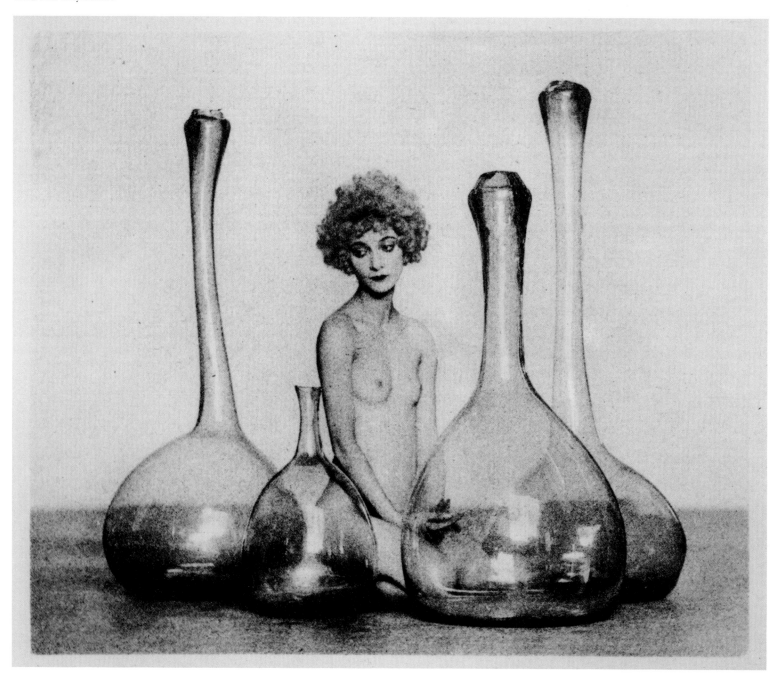

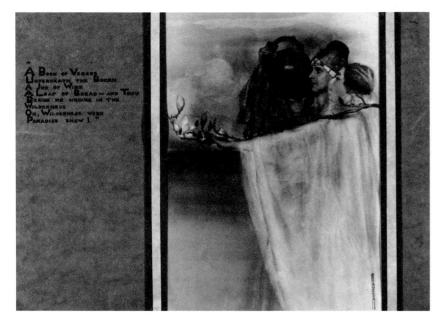

Adelaide Marquand Hanscom (1876-1932)
*Underneath the Bough*, plate from *Rubáiyát
of Omar Khayyam* with printed verse, c. 1910
Gelatin silver print
Michael G. Wilson Collection

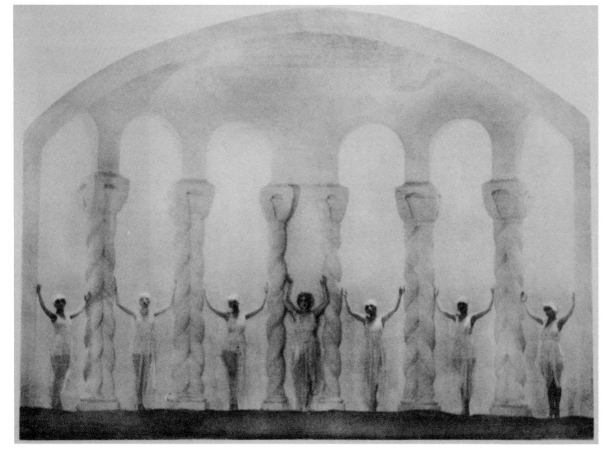

Arthur F. Kales (1882-1936)
*Arched Colonnade with Seven Figures*,
c. 1920-1927
Bromide transfer print
The J. Paul Getty Museum

Johan Hagemeyer (1884-1962)
*Pedestrians*, 1922
Gelatin silver print
The Oakland Museum
Gift of Mrs. Mabel T. Bjorge
in memory of Mrs. Horton Denny

William E. Dassonville (1879-1957)
Untitled, *c.* 1920
Gelatin silver print
Michael G. Wilson Collection

Johan Hagemeyer (1884-1962)
*Tile Factory*, 1923
Selenium-toned gelatin silver print
The Oakland Museum
Gift of Imogen Cunningham

Florence B. Kemmler (1900-1972)
*The Trapeze Act*, 1928
Chlorobromide print
Dennis and Amy Reed Collection

Florence B. Kemmler (1900-1972)
*Sacred Solitude*, n.d.
Chlorobromide print
Marjorie and Leonard Vernon Collection

Dorothea Lange (1895-1965)
*Portrait of Harry St. John Dixon,* 1922
Gelatin silver print
The Oakland Museum
Gift of Florence Dixon

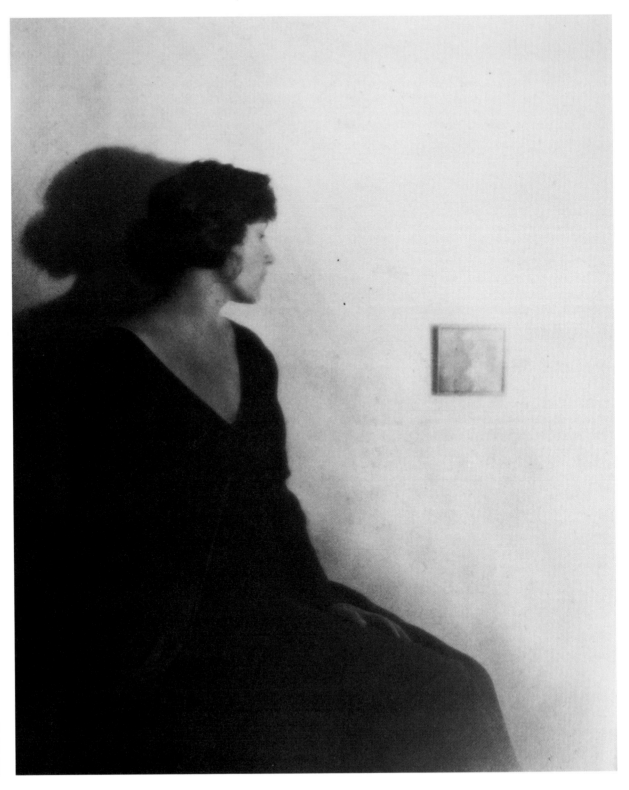

Margrethe Mather (1885-1952)
Untitled (seated woman), n.d.
Toned silver gelatin print
The Oakland Museum
Gift of Dr. and Mrs. Dudley P. Bell

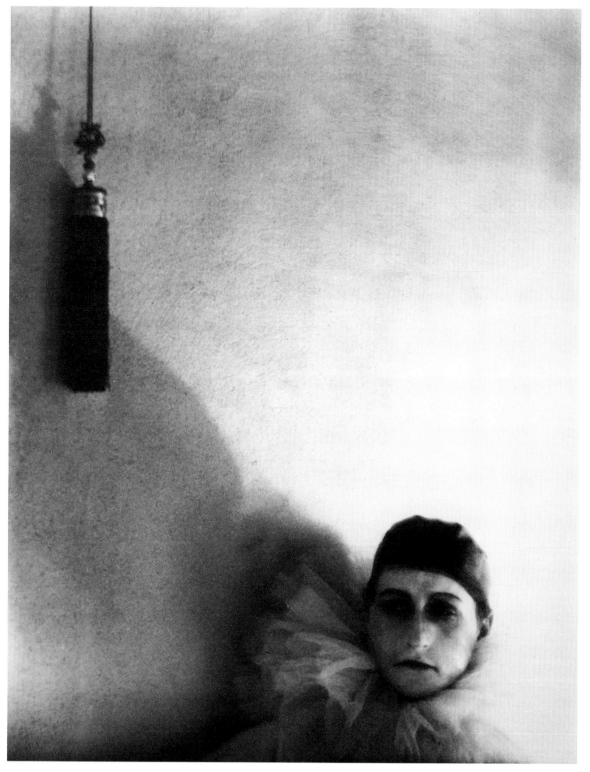

Margrethe Mather (1885-1952)
*Pierrot* (Otto Matiesen), c. 1917
Palladium print
San Francisco Museum of Modern Art
Gift of Elise S. Haas in honor of
Clifford R. Peterson

William Mortenson (1897-1965)
*Inquisition*, c. 1925
Bromoil print
Michael G. Wilson Collection

William Mortenson (1897-1965)
*The Repentant Judas* from the album *King of Kings*, 1924
Silver gelatin print
Michael G. Wilson Collection

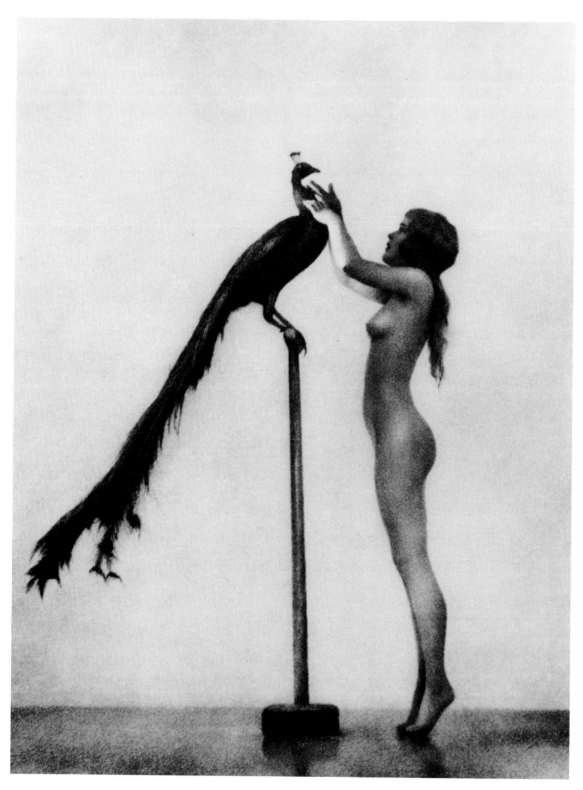

William Mortenson (1897-1965)
*Mutual Admiration*
(alternate title, *Vanities*), 1924
Toned silver gelatin print
Paul M. Hertzmann, Inc., San Francisco

Emily Pitchford (1878-1954)
*Vanity*, c. 1908
Gelatin silver print
Michael G. Wilson Collection

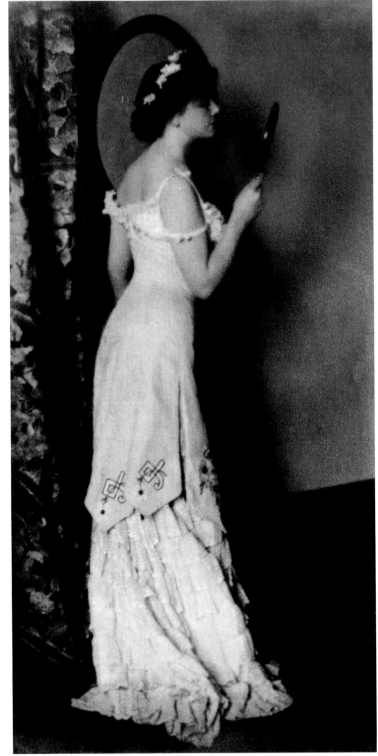

Emily Pitchford (1878-1954)
*Study in Study*, c. 1917
Toned silver gelatin print
The Oakland Museum
Gift of the Knott Fund

Karl Struss (1886-1981)
*La Danseuse*, 1919
Platinum print
The J. Paul Getty Museum

Oscar Maurer (1871-1965)
Untitled (Chinese market), c. 1906
Platinum print
The Oakland Museum
Museum Income Purchase Fund

Oscar Maurer (1871-1965)
*Eucalyptus Grove Silhouetted Against Cloudy Sky
Golden Gate Park, San Francisco*, c. 1915
Gelatin silver print
The Oakland Museum
Gift of the artist

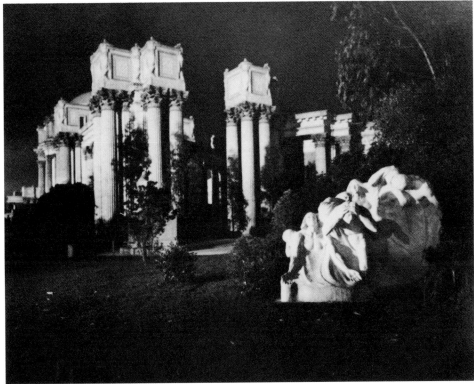

Willard E. Worden (1868-1946)
*Japanese Tea Garden*, c. 1920
Hand-colored bromide print
The Oakland Museum
Gift of Robert Shimshak

Willard E. Worden (1868-1946)
*Statue Group, Panama-Pacific International Exposition*, 1915
Toned gelatin silver print
The Oakland Museum
Gift of Robert Shimshak

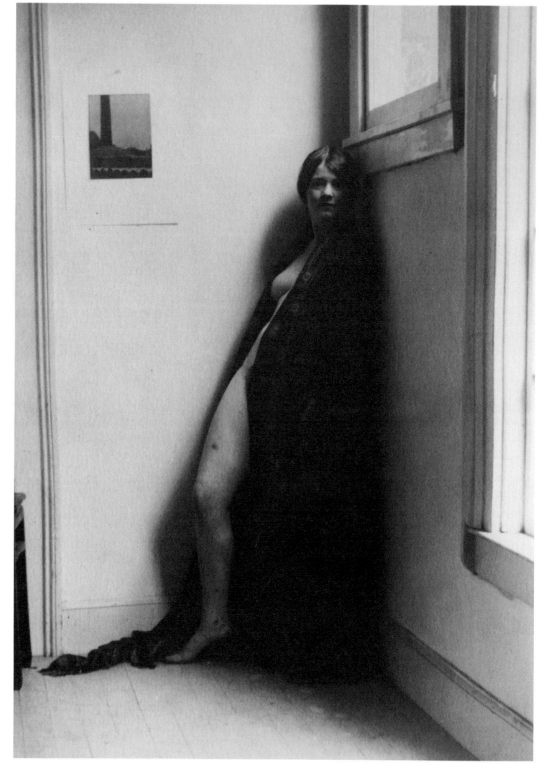

Roger Sturtevant (1903-1982)
*Freudian Composition*, 1925
Toned silver gelatin print
The Oakland Museum
Gift of the artist

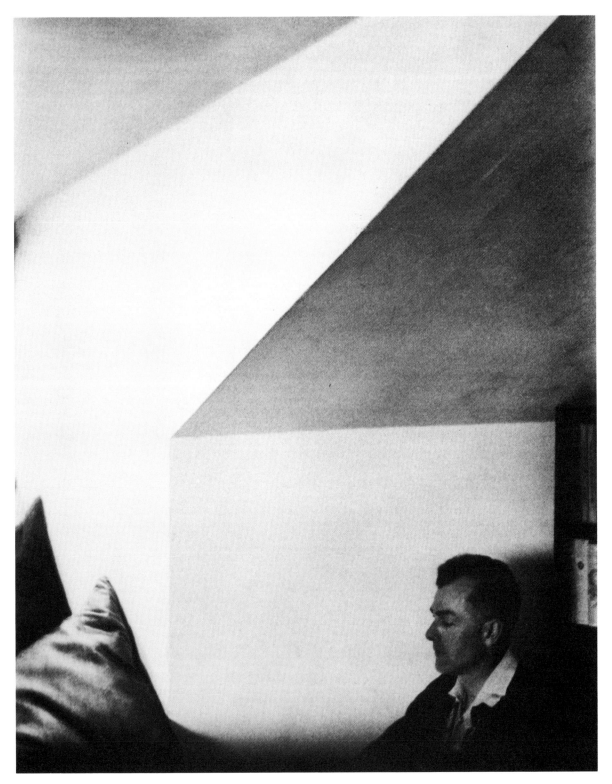

Edward Weston (1886-1958)
*Ramiel in his Attic*, 1920
Platinum print
San Francisco Museum of Modern Art

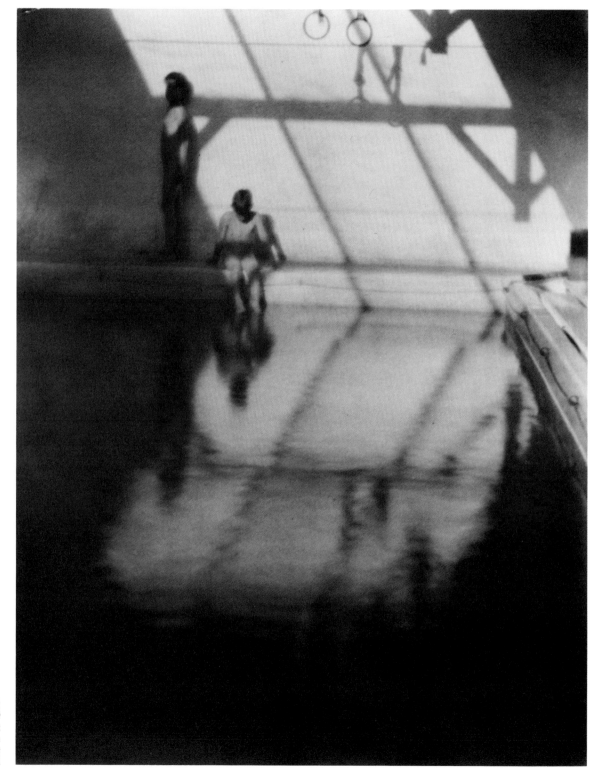

Edward Weston (1886-1958)
*Bathing Pool*, 1919
Platinum print
The Oakland Museum
Puchased with funds donated by
Dr. and Mrs. Dudley Bell

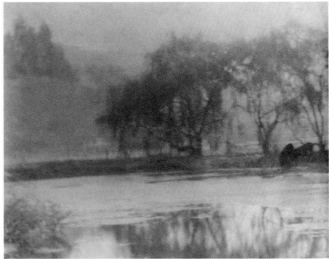

Roger Sturtevant (1903-1982)
*Landscape,* c. 1919
Platinum print
The Oakland Museum
Gift of the artist

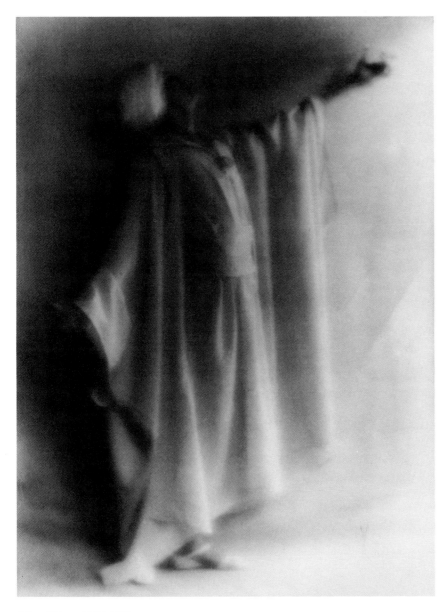

Edward Weston (1886-1958)
*Ted Shawn, Dancer and Choreographer,* 1915
Platinum print
The Gilman Paper Company Collection

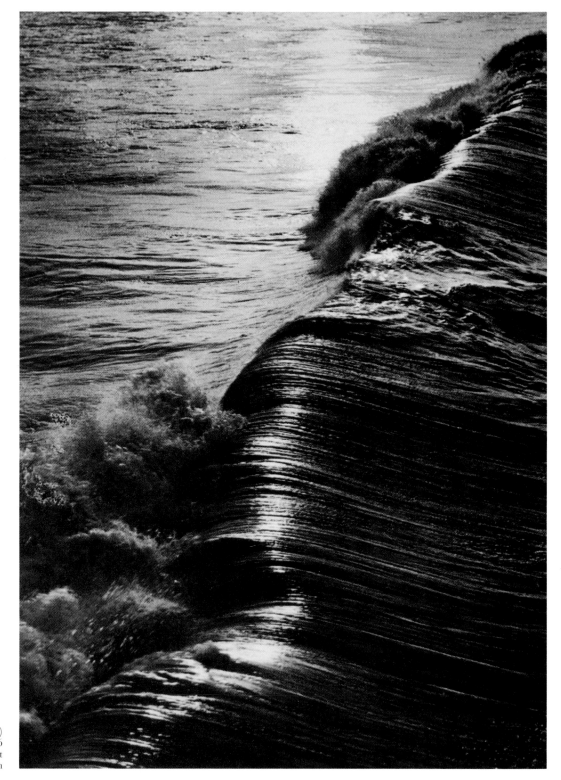

Kentaro Nakamura (dates not known)
*Evening Wave*, c. 1926
Bromide print
Dennis and Amy Reed Collection

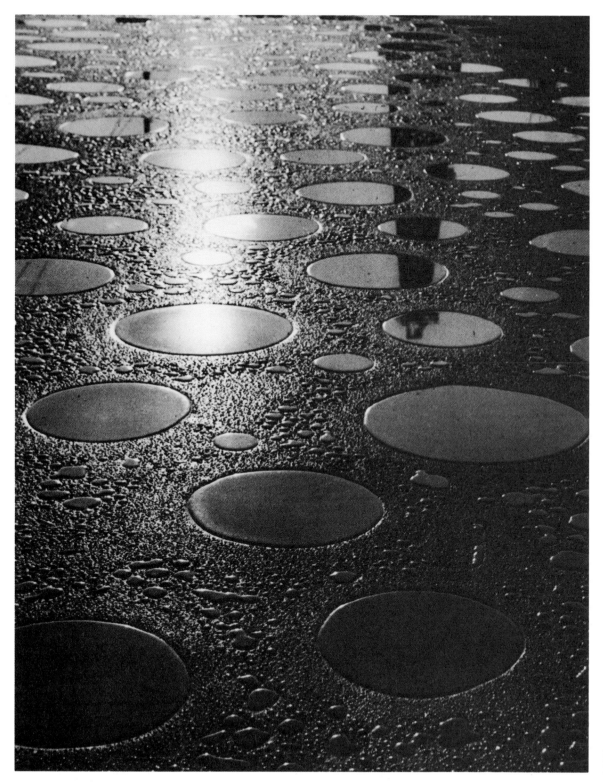

Shigemi Uyeda (1902-1980)
*Reflections on the Oil Ditch*, before 1925
Bromide print
Dennis and Amy Reed Collection

## I. INTRODUCTION

WHEN Edward Weston first saw Point Lobos, it must have been an exhilarating sight: "cloudless and bright, the air still beneath a glittering sun; yet the water of the sea, impelled by some distant and invisible upheaval, surged thundering against the headland rock and swept furies of white foam hissing up the narrow inlets."[1] Or so it was recorded from his memory through the energetic writing of Doty Warren in 1950, thirty-five years after his first visit. But by then much had changed. Weston's last photographs of Lobos, taken in the 1940s, are elegiac in tone rather than cloudless and bright.

His 1915 trip there from his home in the Los Angeles suburbs was made not to tour a magnificent stretch of California coast but to attend the Panama-Pacific International Exposition. Upon returning to Tropico he was full of new ideas garnered from the exposition and from new acquaintances in San Francisco conversant in the latest artistic theories. When he lectured to the College Women's Club of Los Angeles a year later, he accompanied his thoughts with examples of his own "straight" photography, that is, photographs made without any handwork or nonoptical manipulation on the negative or print.[2] Weston may have been inspired in this new approach by the last issues of

# Setting Out from Lobos: 1925–1950

■ *David Travis*

Alfred Stieglitz' *Camera Work* or by Japanese art. Perhaps his approach was reinforced by seeing his own photographs displayed in the Liberal Arts Building of the exposition amid work by other American photographers, especially Karl Struss, Anne Brigman, and Clarence White, all of whom he singled out for commendation to the ladies in Los Angeles. Or perhaps the source of his new ideas was just something in the air. Although new to California, such ideas had been stirring for a quarter of a century, first in Europe and then in New York. We might single out one or more of these influences and feel moderately sure that they explained Weston's change of attitude. But to suggest that in 1915 a stretch of California coast could have had a profound effect on his aesthetic musings would be farfetched.

If we consider the last quarter of Weston's career, however, few subjects were more stimulating, and none more meaningful, than the rocks and ocean at Point Lobos. In his early career nature, landscape, climate, and his immediate outdoor surroundings did not much enter into his photographs; he seldom wandered from his studio with a camera and a serious photographic pursuit in mind. If in his early years the natural environment of California did not supply him with direct inspiration, it still affected him, for it provided, as it did for many others, a climate and an invitation to

freedom of action and thought that allowed any seed to germinate, any idea to flourish. California allowed Weston to distinguish himself in the practice of a medium for which most of the critical ideas had come, like most of its practitioners, from elsewhere.

What developed in California in the period between 1920 and 1950 was a two-part shift away from the established style of pictorialism. The first part involved a shift from subjective, impressionistic rendition to objective, calculated composition. The second part, although not a reversal, brought the photographer's subjective feelings back into play, as a consideration of psychological meaning came to the fore. What may have distinguished these shifts in California from similar shifts elsewhere is that in California they were based on artists' search for the self affected primarily by natural environments or personal relationships rather than by a political, commercial, critical, or philosophical atmosphere.

Before these shifts began, Weston was a quiet, sublimated mix of searching emotions. As a professional portrait photographer he had to justify serving a client's needs, but he also had to maintain the fluidity of his curiosity as if he were still an amateur owing nothing to anyone but himself. He was beginning to feel the constraints and responsibilities of fatherhood, while at the same time he knew

that his restless imagination might throw everything out if the quest for a new idea required it.

This transition period for Weston was also a transition period for photography. One by one, photographers gave up their pictorialist attitudes and techniques as the modernist point of view established itself. Although this history in California could be told in relation to what was happening worldwide, there is a more appropriate way: using the maturing vision of Edward Weston as a metaphor for the growth of photography as an art. There must, however, be a significant break in this explanation for a discussion of documentary photography, photojournalism, and Hollywood portraiture. It is a necessary interruption, for the favorable conditions in California that attracted so many varied talents nurtured them to such stature that they cannot be ignored for rhetorical or stylistic reasons if the history of the period is to have any pretense at being comprehensive. But none of these separate disciplines or isolated talents can serve as well as the example of Weston's influential career as a device for relating all the others.

## II. THE ROAD TO MODERNISM

Southern California, the land of new beginnings for hundreds of thousands of New Englanders and Midwesterners, should, in 1923, still have been full of potential for a photographer like Weston. As he was afflicted by an unsatisfactory marriage, a declining market, and the tedium of modest success, it proved insufferable. Leaving his wife, he went to Mexico with Tina Modotti, one of his mistresses and models, who could live life on an edge that the more reserved Weston would not have dared alone. Not yet an aesthetic juggernaut, he stayed somewhat on the sidelines in the revolutionary atmosphere of Mexico City. Tied to yet another modest portrait studio in the suburbs of another city in another culture, he nevertheless had time to clear his mind, think about things anew, and experiment. Modotti made sure he was never isolated by drawing him into the circle of artists Diego Rivera and Jean Charlot.

When Weston settled in California for good in December 1926, it was not the letdown it had been during his eight-month return in 1925.[3] He felt more secure, having decided that his life would be determined by his will to grow and create and not by what others demanded of him. Although he had new mistresses to pose for him, he had other stimulation through the paintings of Henrietta Shore and her collection of seashells. Having sent a sample of his still lifes of shells to Modotti in Mexico City, Weston received her strong, unequivocal response.

**Figure 3-1.** Edward Weston, *Margarethe Mather, Redondo Beach*, 1924, gelatin silver print. © 1981 Center for Creative Photography, Arizona Board of Regents.

Edward—nothing before in art has affected me like these photographs. I cannot look at them long without feeling exceedingly perturbed, they disturbed me not only mentally but physically. There is something so pure and at the same time so perverse about them. They contain both the innocence of natural things and the morbidity of a sophisticated, distorted mind. They make me think of lilies and embryos. They are mystical and erotic.[4]

Though he was not blind to the power these photographs had, Weston's own terms for them were less emphatic: "spiritual" and "sensual."[5] Diego Rivera characterized them as "biological" and wondered if Weston himself was as sensual as his own photographs.[6]

Weston's photographic expression had

**Figure 3-2.** Imogen Cunningham, *Edward and Margrethe 2*, 1923, platinum print. © The Imogen Cunningham Trust.

moved closer to his personal experience. To him it now seemed more honest than the generalities of his former pictorial style. He had based earlier compositions on a neat geometry of interrelating shapes that were architectonic and planar.[7] These new photographs were organic and volumetric by comparison. Surprised by the strong, uniform reaction of his Mexican friends, Weston insisted that he had pursued the subject not for reasons of erotic urgency but rather, as he phrased it, "with clearer vision of sheer aesthetic form."[8] He did, however, admit that he was recording his inner feelings for life as never before and discovering the life force within form. Objective rendition put a premium on recording a clear visual impression of "the thing itself" and kept him from the self-indulgence of his earlier work. This balance seemed to both release and guide him. It was the challenge of maintaining this balance which made running back to Mexico unnecessary.

The new equilibrium between sensuousness and structure objectively rendered could also be seen in the work of Margrethe Mather, Weston's former model, assistant, and studio partner.[9] She, like Modotti, lived life on the edge. She may have helped to push Weston to extremes and drew upon his reciprocal

inspiration for her own photography. In the spring of 1923, before he left for Mexico, Mather posed for the most blatantly sexual nudes of Weston's career (figure 3-1). His feelings surfaced and crashed, at least pictorially, against the restraint of his well-mannered style. This open emotional release was part of what they both were looking for aesthetically, something jolting, some surging fury direct from the source.

This was not the only effect the outgoing Mather had on Weston at the time. Before she met him, Mather had maintained, with a lesbian companion, a kind of studio/salon with the "uncluttered Japanese atmosphere generally favored in current avant-garde circles."[10] They entertained Margaret Anderson and Jane Heap of *The Little Review*, Carl Sandburg, Alfred Kreymborg, and Emma Goldman. Through her sophisticated companion, Mather had also acquired a sense of good taste in Japanese wood-block prints, which may in turn have affected Weston as it seems to have affected other art photographers at the time.[11] Mather also had connections with the Japanese Pictorial Photographers of Southern California and on occasion acted as a judge for their competitions.[12] In addition, judging from her own work immediately after Weston left for Mexico, it is likely that Mather had been urging him further toward accepting the ideas of "pure" photography which he had encountered in the work of Charles Sheeler, Stieglitz, and Paul Strand during a trip to the East Coast in 1922.[13] Being a kind of upstart who had no allegiances to a particular photographic style, it was easier for Mather to drop the veil of pictorialist sentiment in order to use the medium as a direct transcription of the object of desire. Sometime between 1923 and 1927, inspired by William Justema, a young man nearly fourteen years her junior, she took a series of body studies that are all the more voluptuous for being

sharply focused. As advanced as these photographs were, they had no broad influence, since they were strictly private studies. This is probably also one reason they have none of the dulling overlay of aesthetic pretension.

The third photographer to gain a new equilibrium between sensuousness and structure objectively rendered at this time was Imogen Cunningham. Three years Weston's senior, she had been trained in the scientific aspects of photography in Germany. In 1910, upon returning from a one-year fellowship abroad, she became a professional portrait photographer in Seattle.

Cunningham had already met Weston and Mather sometime before August 1923, when she photographed them together in Weston's Tropico studio (figure 3-2). If knowing them during these decisive years of their careers influenced Cunningham's move toward a modernist approach to photography, it is not clearly evident from the portraits she made of them as a couple. Her style was tied to its pictorial origins. But then so was the portrait Weston had made of Cunningham only a year earlier (figure 3-3).

Having moved to San Francisco in 1917, Cunningham was occupied with raising three young sons and temporarily without a darkroom and studio. Around 1921, having moved to Oakland, she began to take photographs again. Although she visited and probably photographed Point Lobos that year, she was mostly tied to her home and garden. Her photographs of a few years later are not sentimental domestic scenes or allegories of the kind she had admired in the work of Gertrude Kasebier in 1901.[14] They are of plants, close-up studies of garden flowers and succulents. It was not just Cunningham's sense of graphic design which differentiated her new work from pictorial compositions but her abandonment of the soft-focus lens.[15] This was not the only change the new equilibrium caused in her technique.

**Figure 3-3.** Edward Weston, *Imogen Cunningham*, 1922, platinum print. © 1981 Arizona Board of Regents, Center for Creative Photography.

She also adjusted her printing, although not radically. One might say that the prints Cunningham made at this time had a transitional character, for they did not entirely reject the pictorialist appreciation of special materials.[16] They were enlargements on a silver bromide emulsion with an ivory paper base and a matte surface that retained some of the tonality of platinum prints. While not letting go completely of the physical aspect of the print, Cunningham nevertheless moved a step further toward a more objective rendition and less precious presentation of her subjects.

Even with her modernistic approach, the domesticity of Cunningham's garden must have seemed a long way from sophisticated New York, where Edward Steichen was making portraits and fashion photographs of stunning clarity for *Vanity Fair*, and Stieglitz was holding the revelatory 1923 and 1924 exhibitions of his own work. As with her first enthusiasms for art and photography in Seattle, Cunningham would only have known such advanced work through reproductions, for the new coterie of Stieglitz photographers had long since withdrawn from exhibiting in traveling pictorial salons or exhibitions organized by local camera clubs. Whether influenced directly or indirectly by others, Cunningham remained an independent photographer who would respect other masters but not follow them. Consequently, she often unknowingly achieved an aesthetic advance similar to that of others but in her own way. For instance, in finding simple subjects among her immediate surroundings, she paralleled Stieglitz' recent cloud studies jtaken at his family's summer home on Lake George. Of course her works were different. Whereas Stieglitz' studies had both metaphysical tones and titles, Cunningham's plant studies were celebrations of natural beauty abundant in California, less metaphoric and more down to earth.

In 1925, during Weston's four-month stay in San Francisco, one would think that, with Cunningham starting her best work in nearby Oakland, they could have sparked a minor revolution. But Weston was not yet settled, and neither of them was a proselytizer or leader. In addition there were no significant followers. What protégés there were were usually Weston's mistresses. In addition, California cities—whether in the Bay Area or in Los Angeles and its vicinity—had nothing like the concentrations of artists found in New York, Paris, or Berlin. In these cities artists saw each other constantly and exchanged ideas in the process of being formed. San Francisco and Los Angeles provided only occasional exhibitions and opportunities for contact. Without this constant interchange and the influx of new personalities typical of European café society, without culture and history at every turn, and without a high level of critical challenge, artists either withdraw into themselves or make something of their surroundings. Weston, uninspired by Tropico (now called Glendale), kept his work inside his studio, while Cunningham found nature more attractive.

## III. GROUP f/64 AND ITS FOUNDATIONS

The most significant international recognition that anything special was happening in far-off California came through a touring exhibition that began in Stuttgart, Germany, in 1929.[17] A group of California photographs selected by Weston and of East Coast photographs selected by Steichen were sent to represent American avant-garde photography. The exhibition, *Film und Foto*, organized by the Deutsche Werkbund, was the most influential photographic exhibition of the period, because it dealt not with the link between photography and art or sentiment—as pictorialism had tried to do—but with the exploration of photography as a medium of expression distinct from any other. Weston wrote a brief essay for the exhibition catalogue that started out complaining of pictorialists and hobbyists. As an example of what a photographer should be and of what many modernist photographers were becoming, he outlined the attitude he had recently established for himself, mentioning his special practice of previsualization:

> The finished print is previsioned on the ground glass while focusing.... The shutter's release fixes forever these values and forms.... Not to interpret in terms of personal fancy, transitory and superficial moods, but present with utmost exactness, —this is the way of photography.... Vision, sensitive reaction, the knowing of life, all are requisite in those who would direct through the lens forms from out of nature.[18]

Besides his own work, Weston selected photographs by Cunningham (mostly plant studies), his own eighteen-year-old son Brett, Roger Sturtevant, a former pictorialist, Sonya Noskowiak, his current mistress and protégé, and John Paul Edwards, a veteran pictorialist who had recently come around to "straight" photography.

Two of Weston's original sentences are not included in the catalogue text. Perhaps they seemed out of place or too chauvinistic for an

exhibition that was trying to demonstrate a universal view of the medium. "California," he had written, "unhampered by tradition, less bound by convention, more open, free, youthful,—physically, affords untilled soil from which will appear a new feeling for, and manifestation of, life."[19] By 1929 that was exactly how Weston himself was feeling. In a few short years California had become for him what Mexico had been in 1924. He was revitalized. He had moved into photographer Johan Hagemeyer's old studio in Carmel, away from city life, with Sonya Noskowiak. And he had discovered a new subject. His *Daybook* entry for March 21 reads: "Point Lobos! I saw it with different eyes yesterday than those of nearly fifteen years ago. And I worked, how I worked! And I have results! And I shall go again—and again!"[20] Within a year he had yet other revitalizing subjects, peppers and other vegetables, and it was at this time that he resolutely decided to print his photographs on glossy paper and mount them on white boards, as his son Brett had done for some time. Typically, Weston's established technical routine and practices such as previsualization helped to lead him to new ideas about photography. Whatever critical speculation arose in his mind was usually the result of a recent success in the field. Keeping his theorizing in check through experience was yet another challenging balance he maintained.

Within the space of a few years such pure and unencumbered methods, which emphasized seeing rather than fancy printing and special presentation, would become the central tenet of a casual group of Bay Area photographers in revolt against pictorialism.

The instigator of this group—Group f/64—was Willard Van Dyke, a young photographic enthusiast who spent the free time he could afford away from college and his job as one of Weston's private students. Joining Van Dyke with an equal enthusiasm for forming a group

was Ansel Adams, who had adopted "straight" photography after having spent most of the 1920s as a pictorialist landscape photographer associated with the Sierra Club. The new group was formed at a party given by Van Dyke at 683 Brockhurst in Oakland, Anne Brigman's old place and now his studio/gallery residence.[21] The founding members were Van Dyke, Adams, Cunningham, Edward Weston, John Paul Edwards, Noskowiak, and Henry Swift, a wealthy amateur.

It was not long before Group f/64 was in the public eye. Lloyd Rollins, recently appointed director of the M. H. de Young Memorial Museum, had already begun a series of photography exhibitions in 1931-32 at his prestigious institution. Because his first invitations to Stieglitz, Steichen, Strand, and Sheeler had been turned down for various reasons, he concentrated his efforts elsewhere. Exhibitions were organized of photographs by Eugène Atget, Edward Weston, Brett Weston, Adams, Alma Lavenson, and László Moholy-Nagy, among others. At one of the early f/64 meetings, Rollins asked to host the "visual manifesto" the group wanted to present. Added to the show were works by Preston Holder, Consuelo Kanaga, Brett Weston, and Lavenson. The eighty photographs displayed between 15 November and 31 December 1932, as well as the accompanying manifesto handout, caused a stir among the established photographic community of salon exhibitors led by William Mortensen. Adams and Van Dyke defended the new approach to photography against Mortensen's attacks in the pages of *Camera Craft*. In several articles they upheld the "purist's" philosophy of their manifesto, which began:

The name of this Group is derived from a diaphragm number of the photographic lens. It signifies to a large extent the qualities of clearness and definition of the photographic image, which is an important element in the work of members of this Group.... The members of Group f/64 believe that

photography, as an art form, must develop along lines defined by the actualities and limitations of the photographic medium, and must always remain independent of ideological conventions of art and aesthetics that are reminiscent of a period and culture antedating the growth of the medium itself.[22]

Despite its constant mention in books on the history of photography, Group f/64 was never a formal organization, just a loose association of like-minded photographers. In fact only one other group exhibition was held, in 1933 at a gallery Adams had established on Geary Street. When Van Dyke moved to New York in 1935 to become a filmmaker, the photographers remained friends, but the group dissolved.

Despite his enthusiasm in helping to found Group f/64, Ansel Adams was not a photographer with a substantial reputation at the time. It had only been two years since he had met Paul Strand and seen Strand's exquisite photographic negatives in Taos.[23] At that point Adams had decided to make photography, not music, his profession.[24] The concept of "straight" photography that Adams had developed along the lines established by Weston's practice of previsualization fitted Stieglitz' and Strand's mission to reform the medium. Adams later refined both practice and technique while teaching at the California School of Fine Arts in San Francisco.[25] His Zone System of exposure and development was not unlike the measured scales a pianist must practice. He codified the various intensities of light in a subject and related them to the grays on a ten-step scale that made up the tones of the final print. Adams' reputation developed quickly, beginning with *Making a Photograph* (1935) and the many other books that followed as well as his various exhibitions, one of which was held in 1936 at Stieglitz' gallery An American Place.

Bringing this new conception of photography to a California audience in the 1930s and

early forties was accomplished not just in Van Dyke's and Adams' modest galleries or in the pages of *Camera Craft*. In 1940 Adams had the opportunity to broaden his audience through an exhibition covering the history of photography which he prepared for the Palace of Fine Arts on Treasure Island during the Golden Gate International Exposition. The exhibition was truly comprehensive, including not only photography as a medium of artistic expression but, as was the custom at the time, examples of news, aerial, astronomical, X-ray, color, and microscopic photography. An accompanying illustrated catalogue included essays by Adams, Beaumont Newhall, Edward Weston, Moholy-Nagy, and Lange, among others. Also featured was a spread each for California women and men photographers.[26] Weston was celebrated with his own one-person show.

One of the permanent contributions Adams made in this exhibition was his introduction of the work of early Western landscape photography, especially that of Timothy O'Sullivan. As Nancy Newhall noted:

> And what a survey of the work of Western photographers, both early and contemporary; there were many we did not know and were rejoiced to see. Group f/64 had certainly established high standards of vision and technique. The show as a whole, we thought, represented a breadth of mind and heart unusual among creative artists with such strong personal dedications as Adams.[27]

By 1940 photography as a medium of artistic expression had arrived in California. Established first in the work of singular photographers of vision, it had slowly gained acceptance in a few museums and galleries.[28] In addition a few technical, thematic, and monographic books had begun to appear. The predominant aesthetic point of view had become the one proposed by Group f/64, which had established itself on principles and practices evolved by Stieglitz and Weston as they revolted against pictorialism.

## IV. PHOTOGRAPHS WITH A PURPOSE

One of the exhibitors Van Dyke featured in 1934 at his 683 gallery was Dorothea Lange, a professional portrait photographer who had been a founding member of the Pictorial Photography Society of San Francisco in 1920. Her exhibition was of a radically different kind of work: social documentary. In his written review of these photographs for *Camera Craft*, Van Dyke signaled the appreciation members of Group f/64 might have had for photographers with a sense of moral mission:

> Dorothea Lange has turned to the people of the American Scene with the intention of making an adequate photographic record of them. These people are in the midst of great changes—contemporary problems are reflected on their faces, a tremendous drama is unfolding before them, and Dorothea Lange is photographing it through them.[29]

Because most of the photographers in Group f/64 lived a kind of bohemian existence, their lives were not as radically altered by the Depression as those of unskilled laborers or stock investors. But its terrible effects were hard to miss. On the streets near her studio, Lange became a sympathetic witness but with no idea of what she should be doing with the photographic evidence. Her exhibition at 683 was her first step toward finding a larger audience.

One of the visitors to the exhibition was Paul Schuster Taylor, an associate professor of economics and social reformer who had recently written an analysis of the 1933 San Francisco General Strike for *Survey Graphic*. Taylor was pleased to see on the walls photographs of some of the same subjects by an independent photographer completely unknown to him, whose work far surpassed his own modest efforts or those of news agencies. Some months later he met Lange (they were later married) during one of his field outings, which included Van Dyke, Cunningham, Holder, and Mary Jeanette Edwards.[30]

Beyond the general strike and mounting unemployment, California had another enormous problem. In the next five years the state of sunshine and opportunity would become the destination of 350,000 farmers and their families from the Dakotas to Texas, made homeless by the Dust Bowl. The large, commercially run California farms had no facilities for these numbers and were unaccustomed to whole families arriving as migrant workers. Mobilized by the State Emergency Relief Administration, Taylor and Lange went into the field and with their report and photographs helped to initiate the construction of the first decent migrant workers' camps. The photographically illustrated Taylor-Lange report also circulated in high government offices in Washington, D.C., in 1935, reaching Roy Stryker, who was putting together the documentary photography program of the Resettlement Administration, later known as the Farm Security Administration (FSA). He immediately requested that Lange be on the photographic team he was forming with Arthur Rothstein, Carl Mydans, Walker Evans, and Ben Shahn.[31]

The photographs Lange took for the FSA were to be her most famous. Being a portrait photographer and having seen poverty and hardship firsthand as a child in New York, she was able to establish a rapport with her subjects that allowed them to remain naturally posed and at the same time expressive of their plight. Although she profited immensely from Taylor's knowledge and patient persistence, in creating her "documents" she responded to experience from her heart. In doing this, Van Dyke felt, she followed "no preconceived photographic aesthetic," as he expressed it in his *Camera Craft* article. If Lange had a guiding motto, it seemed to be a quote from Francis Bacon that appeared on her 1934 Christmas

**Figure 3-4.** Horace Bristol, *Pea Pickers* (illustration for book *The Grapes of Wrath*), 1938. Courtesy of the artist.

card and that hung over each of her darkroom doors: "The contemplation of things as they are, without substitution or imposture, without error or confusion, is in itself a nobler thing than a whole harvest of invention."[32] This idea was consonant with the "straight" photography of Weston and the objectivity of Group f/64.

Accompanying Taylor and Lange on several of their trips to interview and photograph the migrant workers in the lettuce fields was Horace Bristol. With them he experienced rough handling near Salinas by hastily sworn-in sheriff's deputies and highway patrol officers suspicious of photographers. Such working conditions must have demanded saintly composure and courageous determination. As a commercial freelance photographer, Bristol found that the Depression provided him, as it had Lange, with an opportunity for personal response. He became so involved in the plight of migrant workers that he persuaded John Steinbeck to accompany him in hopes of producing with him a kind of picture/caption book (figure 3-4). After meeting and photographing Oklahoma refugees and spending seven or eight weekends with Bristol, Steinbeck saw the possibility of another novel in the powerful historical moment before him. The picture book was never realized, nor was their hoped-for *Life* magazine article, as Steinbeck turned to writing *The Grapes of Wrath*.[33]

Bristol, a native Californian, was the kind of photographer who was more in evidence on the East Coast and in Europe: a freelance journalist with an innate sense for what a photostory was. The increasing demand for weekly magazines illustrated with topical photographs that had had its beginning in Germany and France in the late 1920s, coupled with the development of excellent hand cameras, created new professional possibilities for photographers who were not portraitists or technicians. Along with Peter Stackpole, who even as a high-school student knew Cunningham and Lange, Bristol became one of the early *Life* photographers and began to travel widely. Stackpole, whose first work was a sensational and often daring study of the construction of the San Francisco Bay Bridge, later became a Hollywood photographer reporting on the stars and the glamour of motion picture life. The German couple Otto Hagel and Hansel Meith started their professional careers in California in freelance photojournalism, working for the WPA. In 1937 they began to travel around the country for *Life* and *Fortune*.

Photojournalism and commercial photography in the 1930s brought photographers into and out of California and the American Southwest more regularly than studio portraiture or landscape work. Bristol and the Hagels were just three of the many photographers now on the move. Lange's FSA assignments took her through the West, South, and northern Great Plains. But life on the road working for assignment editors was not glamorous. For Lange, like other photographers, there was the frustrating problem of exposed but undeveloped film. She wanted to have it developed in her own facilities in Berkeley rather than having it sent to Washington, where Stryker, her boss and editor, sometimes punched holes in negatives he rejected. Unlike commercial photographers, in working for the government Lange felt the lack of funds in constant equipment shortages and insufficient assistance. Finally, there was the clash of personalities to contend with. Having her own inner determination, sense of mission, and long professional experience did not put her in the same category as several of the young, inexperienced photographers Stryker had recently hired, partly because of their ability to follow the orders of his shooting scripts. Government administrators, like assignment editors, need a certain number of willing troops ready to accomplish their objectives. In 1938 and 1939 Lange was on and off the payroll. By the beginning of 1940 her employment had been terminated.

Stryker had problems with Lange's independence and personality just as he had with Walker Evans'. Along with Shahn, Lange and Evans formed the real photographic genius of the team, and it is a wonder that Stryker's patience extended as far as it did with these singular and sometimes perseverant artists. He had no doubts regarding Lange's talent and felt that she would easily find assignments with any number of picture magazines. But such magazines were run not to promote social consciousness or for historical record-keeping but for profit. With darkening war clouds on the horizon, a specialist in rural poverty was not exactly what they were looking for.

A Guggenheim fellowship awarded to Lange in 1941 helped, but she was a photographer who needed a challenging assignment of near-impossible proportions in order to function at her best.[34] Her next opportunity was not far off, for by April 1942 she had begun working for the government's War Relocation Authority (WRA). Executive Order 9066 allowed military commanders to remove anyone to internment camps.

About 110,000 Japanese immigrants, their American-born children, and even their grandchildren were sent off with almost no protest from anyone. Taylor was incensed as soon as the evacuation was announced and joined the Committee on American Principles and Fair Play to help counteract the wave of hostility and "remind people that the evacuees were not convicted, were not found guilty of anything."[35] Lange, ever the sympathetic witness, photographed the round-up and removal with the same heart she had had for the migrant workers.

During the period when the camps were being established under military directors, Lange was only able to document one of them, at Manzanar. After civilian directors were appointed, Ansel Adams was able to gain access there through a Sierra Club friend who was in charge.[36] In 1943 Adams began a series of documentary photographs which lasted over several visits and resulted, incidentally, in two of his best-known landscape photographs: one of the huge boulder in front of Mount Williamson and one of a mountainside during a winter sunrise with the silhouette of a distant horse. In a lesser-known photograph of birds resting on wires suspended over the camp shacks, the overcast sky lends a sad mood to the scene. As with the better-known images, the disturbing beauty of the place and Adams' feelings were better expressed in his landscape photographs than in his portraits and documents. Unlike Lange's, his sympathies worked better at a distance, partly because he understood and revered nature and partly because his "purist" approach to photographic technique and vision were in sympathy with the nonpsychological complications that mountains, architecture, and natural still lifes provided.

Despite Lange's inspiring work, along with that of her former assistant John Collier, social documentary photography was not a California specialty. Even by the late 1940s when Marion Palfi and Lou Stoumen arrived, the field had not fostered the development of another photographer of Lange's stature and attitude. Indicative of the situation was the kind of exhibition of photographs sponsored in California by the Works Projects Administration in the 1930s. Elsewhere in the country the WPA through the Federal Arts Project aided photographers by giving them documentary assignments all over the country. In California, however, the WPA permitted Brett Weston, who was paid as a sculptor, to direct a series of exhibits of art photography by himself, his father, his brother Chandler, Sonya Noskowiak, Sybil Anikeyev, Nacho Bravo, Hy Hirsh, William Abbenseth, and LeRoy Robbins.[37]

Another photographer who developed her talent for photography in California was Consuelo Kanaga. She began working in her early twenties, around 1915, as a reporter and feature writer for the *San Francisco Chronicle* and learned to take photographs as accompanying illustrations. In joining the San Francisco Camera Club she discovered *Camera Work* and was overwhelmed by material reproduced there by Steiglitz, Steichen, Kasebier, Strand, Julia Margaret Cameron, and Clarence White, among others. Although Kanaga was already in and out of California in the early 1930s, her photographs were included in the first Group f/64 exhibition. Many were of African-Americans, who became her special subject. After moving permanently to New York, she found work on newspapers and magazines and joined the Photo League, a cooperative of documentary photographers dedicated to social change and to teaching and exhibiting photography. The Photo League was more than a socially conscious version of Group f/64, for it had leftist leanings and an active documentary component as well as being a forum for critical discussion and supplying facilities for technical instruction. It was at the Photo League that Ansel Adams argued for a distinction between reportage and creative photography. And it was in the league's darkrooms that Kanaga gave professional printing lessons to Max Yavno, a street photographer whose destiny would take him to the California she had left.

Like Lange, Yavno was committed to effecting social change. They had many of the same sympathies. Yavno had the background as well. After earning a degree in social science in 1932 and being a social worker, he served as president of the Photo League between 1938 and 1939. Until he was drafted in 1942, he and Aaron Siskind shared an apartment while photographing in Harlem for a documentary project they called "The Most Crowded Block." It was after discharge from the military in California that Yavno made a name for himself. While freelancing in Los Angeles in 1947, he was commissioned by Houghton Mifflin to illustrate a book on San Francisco. The publisher determined what the book would be like and assigned certain subjects. Even though Yavno was able to include scenes of street life and to hint at life in the poorer neighborhoods, San Francisco still emerged as a scenic city with its harbor, cable cars, hills, and vistas. This publication, *The San Francisco Book* (1948), was followed two years later by *The Los Angeles Book*. The latter included high and low cultural extremes, industrial intrusions, healthy recreation, and sublime pedestrian oddities, all exposed in the balmy surrealism of direct sunlight.

Ironically, John Gutmann, the photographer with the best eye for the coincidence of incompatibles that is California, lived and centered his work not in catch-all Los Angeles but in sophisticated San Francisco. From New Year's Day 1934, when he arrived by freighter in flight from Nazi Germany, he was amazed at California's jazz-beat version of the "man and his world" theme. At twenty-eight, having no

family, Gutmann was ready for adventure. As a student of the German Expressionist Otto Müller, he had gained confidence in his own talents and was conversant in the latest European aesthetic discourses. Only San Francisco and his Rolleiflex were new to him, which was enough to generate an astonishment with "the marvelous extravagance of life" that never ended.[38] To Gutmann's eyes the Great Depression had not extinguished the materialistic, grab-bag culture of America; it had proven it to be permanent. Not only did this American experience stimulate him; it fortunately sold photographs, especially overseas. Working first for the German agency Presse-Foto and then (after 1936) for Alfred Eisenstadt's Pix, Inc., in New York, Gutmann, in addition to teaching painting, was able to maintain himself throughout the 1930s. His identity as an outsider was not compromised by this arrangement, and with this freedom he was better able to maintain his own view of American society rather than that dictated by a publisher or government agency.

By working out of the darkrooms of the California Camera Club, Gutmann did not become acclimated to the style and composition common among amateurs who wanted to explore the world as an escape from it. Nor did his vision match the detached approach of Group f/64. Gutmann wanted to get in as close as he could. He was indeed a stranger in a strange land but one who was not confused either by the new curiosities besieging him or by having to abandon his mother tongue. Any rules he may have discovered came from experience and were like secret agreements he made with his camera and his imagination; they were not the abstract, overarching pronouncements of a manifesto. Consequently, he had no equal, no classification, no proper circle of photographic comrades, and no master. His was a pure talent for seeing let loose in a photographer's paradise.

If Gutmann found a fantasy in reality, the Hollywood photographers of motion picture stars found it in artifice, where it was to be expected. From 1925 to the beginning of the Second World War, the "Golden Age of Movies," Hollywood became a world unto itself financed by the dreams of millions of movie-goers and fans. Because the image of a star could mean big business, the motion picture studios no longer allowed stars to hire their own publicity photographers. By the end of the 1920s they were all under contract to use photographers the studios hired.[39] Such photographers purposely avoided confronting reality in favor of courting allure, for it was the public persona rather than the actual, off-screen character of the sitter which was important to promote.

In establishing their portrait galleries, the motion-picture studios could control publicity and satisfy the censor at the same time. Even with such restrictions, photographers explored an imaginative field and invented styles. For George Hurrell and Clarence Sinclair Bull, this was achieved through artificial lighting, for Robert Coburn through the intricacies of pose or color. These photographers took their work seriously, knowing exactly what their part was in the complicated army of talents it took to produce and publicize movies. Outside photographers were sometimes involved, as when a major magazine like *Vanity Fair* sent Imogen Cunningham to Hollywood in the 1930s to make portraits of actors, or when Condé Nast sent Edward Steichen. Occasionally, photographers like George Hoyningen-Huene and Baron de Meyer, who had established enormous reputations elsewhere, moved onto the Hollywood scene toward the ends of their careers.[40]

One photographer of talent found Hollywood to be the perfect subject not for publicity but for satire. Will Connell, a commercial photographer of enormous versatility and visual wit, made fun of everyone in the business, from editor and prop man to director and producer,

in a 1937 book entitled *In Pictures.* Connell was a self-taught photographer who had at one time been a pharmacist and cartoonist. In 1921 he joined the Camera Pictorialists of Los Angeles.[41] Through this group he came to know the work of a group of Japanese-American photographers and gained an appreciation for their simplified shapes and geometric compositions.[42] His varied background and connection with the pictorialists served him well when he founded the Photography Department at the Los Angeles Art Center School of Design.[43] There students like Horace Bristol, Wynn Bullock, and William Garnett were first exposed to professional photography and its potential. Connell and the Camera Pictorialists were open-minded when it came to appreciating other types of photography. In 1931 (along with James N. Dolittle and Karl Struss) he selected photographs by Edward and Brett Weston, Cunningham, and Willard Van Dyke for inclusion in *The Pictorialist*, a publication of the Camera Pictorialists.

Because of the versatility and commercial nature of his attitude, it is difficult to classify Connell in the larger scheme of photography viewed strictly as artistic expression. Indeed California provided so many opportunities for so many different types of photographers that even when they viewed the medium as aesthetically expressive, we often fail to find adequate ways to describe their talent in relation to that of others. This is true, for example, of the documentary photographs of John Gutmann and the Bauhaus-inspired photograms of Margaret De Patta. It was also true of Man Ray during his Los Angeles years.

Although Man Ray did make excellent photographs during his stay (1940-51) in California, he actually settled in Los Angeles to paint. He came to escape, not only from the war but from the world in general. But it was in Los Angeles that he hoped to reestablish himself. Having left

many canvases in Paris, he set about recreating some of the most prominent of them. In his photography, too, he continued along the lines he had established earlier in his career. In Southern California his innovative use of the medium and his Dada attitude made him seem a complete outsider, and he realized almost no income from several exhibitions. He did manage to meet a few like-minded artists, patrons, and writers, such as Henry Miller, who made him feel closer to his Parisian days and shared the perception of Los Angeles as a "beautiful prison."[44] But despite his marrying there and liking the climate, he never intended to stay.

One influence Man Ray did have during his Los Angeles years was on Edmund Teske, who had also brought an odd variety of techniques to California. Although he had worked for a short time in the photographic stills department of Paramount Studios, Teske's claim to fame was that he was a friend of, and had been a kind of personal photographer to, Frank Lloyd Wright at Taliesin. (After moving to Los Angeles in 1943, Teske lived until 1949 in Residence B of Hollyhock House as an assistant to Aline Barnsdall, who had commissioned the house from Wright.) Teske was not an amateur photographer, however. In 1936 he had met Stieglitz and, two years later, Moholy-Nagy. Although Stieglitz' spiritual approach impressed Teske, his strict idea of "pure" photography did not. Like Moholy-Nagy, Teske loved to experiment. He immediately appreciated Man Ray and his store of darkroom magic, for in the darkroom of a commercial studio in Chicago, Teske had himself stumbled on the technique of solarization, which he had admired in Man Ray's work through reproductions. In Los Angeles Teske's imagination flourished, as he brought his interests in poetry and psychology together with Hindu mythology and symbolism through the Vedantic Center of Southern California. For the first time he began to create images by double-printing old photographs with recent ones, giving form to his developing notions about the movement and indeterminacy of the universe. But even his "straight" photographs have a mystical and poetic mood like those of no other photographer working in California.

It is easy to say that photographers like Teske, Man Ray, and Gutmann were outsiders out of place in California. On the other hand California might be defined, paradoxically, as a place that attracts exactly those who are out of place there.[45]

## V. BEYOND SUBJECT AND OBJECT

In considering the history of photography as an art, California shows itself to have been the fertile ground in which general aesthetic notions planted from the outside sprouted naturally and easily developed their first shoots. If the photographer remained, ideas grew unhampered and bore fruit for others. California artists and photographers received aesthetic notions from outside the state not as restrictive ideologies but as points of departure which, more often than not, valued practice and experiment over critical theory. Because of an open and relaxed artistic climate, the results of such developments were frequently equal or superior to the results achieved closer to the origin of the notion itself. One of the best examples of this can be found in the work of Minor White, who spent his crucial, formative years (1946-53) as a photographer in San Francisco. To understand White and the effect California had on his development, one must understand not only the state of photography as we have sketched it here but also what he brought with him.

Minor White arrived in San Francisco from New York in July 1946, invited by Ansel Adams to teach at the California School of Fine Arts.[46] He was one of the first photographers of major talent to bring with him a wide variety of sophisticated influences from outside photography. Before moving to San Francisco, White had written poetry and been an amateur photographer and local arts center instructor in Oregon, a soldier in the South Pacific during the war, a student in the history and philosophy of art in Columbia University's Extension Division, a colleague of Beaumont Newhall at the Museum of Modern Art, New York, and an admirer of Alfred Stieglitz. Oregon had given White enough of a start in photography that he felt it to be his vocation. The war had deepened his self-awareness and brought about the realization that he was a spiritual being. Study under Meyer Shapiro had created an interest in the psychological approach to art. And working at the Museum of Modern Art had given White access to a circle of active photographers and to ideas about the medium that Beaumont and Nancy Newhall were incorporating into a critical and historical framework. In California White found enough natural stimulation to compliment his broad intellectual approach and enough veteran photographers to challenge his developing ideas. On top of this he found in his first class a remarkable student named Rose Mandel. Mandel had studied psychology with Jean Piaget at the Jean-Jacques Rousseau Institute in Geneva. After moving to California in 1942, she had met Edward Weston through a friend, and photography had become her fascination. Unable to take on any students because of his divorce and declining health, Weston recommended Adams and White. Mandel's nascent ideas about photography matched White's about psychology as student and teacher encouraged each other.

Adams and White, both superb craftsmen, communicated their aesthetic ideas to students first through technique and then through analysis. Although White taught technique by using

Adams' Zone System of exposure and development, his own analysis was less formal. In a letter to Adams dated 8 March 1947, White sketches his approach:

> Carrying out the theme that the photo reveals as much or more of the person than what he photographs to its logical conclusion, leads to analysis of [the] inner person as shown by the things chosen to photograph.... I have been saying that an artist has only one subject—himself.[47]

For Adams nature would have been the primary subject; for Lange, Yavno, and even Gutmann it would have been people. Teske (who also appreciated poetry and psychology but who worked in relative isolation in Los Angeles) and Rose Mandel would have been the only photographers to agree with White completely.[48]

The way White taught expression in photography was by examining three approaches: the "subjective," the "objective," and the "equivalent." Students were taught to see "the subject with regard for either its individuality or its essence [objectivity], or the reaction it causes in the photographer [subjectivity]."[49] After this stage the student might experience an "equivalence," which was not a reaction caused by an exterior object or situation but rather a recognition that the presence of the self could generate an expression of its existing interior state or feeling by finding a symbolic object or situation in the outside world.[50]

To his developing idea of equivalence, initially inspired by Alfred Stieglitz, White had begun to add the notion that his own photographs needed to be presented in formal sequences, similar to the format in which Stieglitz had organized his own cloud photographs. But for White as for Teske and Mandel, the idea of sequence could apply to any of his photographs, not just to a special set. For instance his 1947 sequence *Amputations* integrates his poetry and a variety of recent photographs with portraits he had taken of servicemen during the war.[51] Stieglitz had described the sequence format as musical. For White it was poetic. The metaphorical nature of both conceptions allowed the photographers to lay claim to ideas and feelings that literally could not be recorded by lens and film. For instance *Sequence Four* carries hidden messages not readily apparent without some explanation. Composed of photographs taken at Point Lobos the year before and finished in 1950, *Sequence Four* is the first one White composed entirely of "abstract" photographs. Although nothing as specific as a male figure is shown, the sequence has since been described as "highly erotic and utterly revealing of [White's] personal frustration and inner conflicts regarding his sexuality and his attitudes toward women."[52] Thus the sexual symbols White found constantly in Weston's photographs had been transferred to his own vision but with a different orientation.

While White's philosophical turn toward the inner man rather than the adventurer in the wilderness or the witness to a changing society was initially encouraged by Stieglitz, he was soon encouraged by the vegetables, rocks, nudes, and sand dunes to which Weston had given "sensual" and "spiritual" expression. White at first took this to be a sexual expression. But he also began to see something else. As he observed in a letter to Adams, he felt there was something in Weston's work that went beyond sexual symbols: they "seemed to have disappeared and a tremendous feeling of eternal things was present—a feeling of humility before God."[53]

The introductory text to *Sequence Four* when it was issued as a portfolio expresses much of what White had absorbed from his single visit to Stieglitz in 1946 and his many trips down the coast—alone and with students—to visit Weston. At the time this was probably the most sophisticated statement about what metaphorical photography was.

> A sequence of photographs is like a cinema of stills. The time and space between photographs is filled by the beholder, first of all from himself, then from what he can read in the implication of design, the suggestions springing from treatment, and any symbolism that might grow from within the subject itself.
>
> While rocks were photographed, the subject of the sequence is not rocks: while symbols seem to appear, they are pointers to the significance. The meaning appears in the space between the images, in the mood they raise in the beholder. The flow of the sequence eddies in the river of his associations as he passes from picture to picture. The rocks and the photographs are only objects upon which significance is spread like sheets on the ground to dry.
>
> The spring-tight line between reality and photograph has been stretched relentlessly, but it has not been broken. These abstractions of nature have not left the world of appearances; for to do so is to break the camera's strongest point—its authenticity.
>
> The photographs may be read without reservation. The accidental has been held back. The transformation of the original material to camera reality was used purposefully; the printing was adjusted to influence the statement; and it was anticipated that as the object was revealed, the Self of the beholder would unfold.
>
> For technical data — the camera was faithfully used.[54]

Here we sense the formation of a mystical vision that both Stieglitz and Weston approached without becoming mystics themselves. Here is an open invitation to find and explore the self, something White had developed photographically in California and something California had been providing to artists, photographers, aspiring actors and actresses, cult followers, and social reformers in one way or another since the late nineteenth century.

The nurturing conditions of California's open and relaxed artistic climate is evident in a letter White wrote to Adams in 1954 from his

new home in Rochester, New York:

> Most of it [Rochester] is dull, the rest is quaint.... the paint peals in a characterless way.... Even the wall scrawls are without imagination or daring.... The trees cast a gloom over the grey houses that is a sheer monstrosity of depression. And when...one turns to the skies, even the clouds are messy."[55]

White would not find his bearings in Rochester as quickly as he had found them in San Francisco. For several years his inner vision needed the special exterior California had abundantly provided.

As most of the photographers who developed their photographic eye in California stayed in California, White's responses in leaving it revealed how much its natural environment actually meant, even to a photographer who had come to feel that subject matter was not of the first importance.

## VI. THE SURVIVAL OF MEANING

The idea of "straight" photography that Weston, Mather, Cunningham, Adams, and Lange had molded out of pictorialism was accepted as part of the varied approaches to photography of the next generation. White's interest in landscape, Bristol's in reportage, and Wright Morris' in literary vision each had a foundation on which to build. Others such as Gutmann, Man Ray, Teske, or Ruth Bernhard brought new notions about photography with them from elsewhere. At first "straight" photography seemed an honest enough means of depicting nature or social conditions. In some instances followers of movements based on technique began exercising a consciousness about recording nature by photographic means. This clarified their purposes, making their activities into aesthetic endeavor. But as a guiding principle, like the casual notions of photographic aesthetics voiced by Group f/64,

that attitude could not last long and could certainly not sustain the career of a talented artist. As ideas became technical routines, the question of meaning reasserted itself. Deflecting the question away from the subject of nature or social conditions, some photographers addressed the medium itself, thinking that if a photograph, picture, or some kind of independent image was created instead of a statement directed by nature, they could claim it to be a fair result. In the eyes of the modernist photographers, the medium could speak of itself or of abstract design as well as it could of any other thing it engaged. This departure from the depiction of natural subjects fascinated every photographer of the period including Weston. However, given the variety of natural and social subjects in California, the majority of photographers did not become obsessed with this self-conscious regard of the medium for itself. In fact photographers like Wynn Bullock, who began his career experimenting with solarization and multiple exposures, converted completely in the early 1950s to the kind of photography White had developed out of Weston's example. Outside California, as the new ideas about photography became more critically extended, they often wrapped themselves into a circle of inquiry and experiment, taking off on tangents without dealing with the central issue of the photographers who had generated the images. Too often the character and identity of the photographer was dismissed. Weston pereived this critical oversight. Toward the end of his career he seemed less concerned about the medium than about preserving his identity as an artist.[56] If this was a romantic notion somewhat out of place in a modernistic world, it benefited his greatness to accommodate it. It also underscored his determination to grow and create not through the demands of others but through his own "vision, sensitive reaction, [and] the knowing of life."[57]

**Figure 3-5.** Edward Weston, *Point Lobos*, 1948, silver gelatin print. The Art Institute of Chicago, gift of Max McGraw.

In 1948 Weston took his last photograph, a quiet detail of some scattered rocks and pebbles in the sand (figure 3-5). Appropriately, it was taken at Point Lobos. This last photograph reveals a Lobos radically different in mood than the place he had encountered in 1915. Although viewers can still appreciate the image for its formal qualities, it is a significant step beyond Weston's Lobos details of 1929-1938. The rocks and ocean are more than scenery and more than an exercise of nature's design and patterns. Lobos had come to mean something personal to Weston, something that was inextricably part of his life and character. His photographs of the site in this late period became, in Minor White's opinion, one of the most expressive bodies of work the medium had to offer. White went so far as to compare them to Beethoven's last quartets when he published a selection in *Aperture* in 1953.[58] Around 1938 Weston's photographs of the rocks and ocean at Lobos had started shifting toward a somber mood. If he had a brooding, existential character to express, this is the closest it ever came to the surface. Through a poetic mix of the lyric and the tragic, Weston's last photographs so silently eclipsed the brilliance of his earlier and easier glories that few except

White understood their meaning. For White "a tremendous feeling of eternal things" was present in Weston's photographs of Lobos. However, Weston himself made no such statements. He believed that his photographs would speak for themselves.

White and Weston were not alone in feeling that Lobos had a connection with eternal things. In 1915, when Weston had first visited, Robinson Jeffers and his wife had been living there, happily isolated, in a rented cabin for a year. Jeffers had known at first sight that Lobos was his place in which to work and build a life. For Weston this realization took time and a certain amount of wandering. In 1915 he still had to find himself. That sense of discovery, definition, and change became a parallel theme in the recognition of photography as a form of modernist art not only in California but everywhere.

In his last photographs Weston saw Lobos not as a mere subject for "straight" photographs but as an expression of his own being. Only able to approach nature through the formalism he had carefully developed and personalized over his career, his accumulated habits were now somewhat at odds with his purposes as an artist. His feelings began to outdistance his virtuosity. Yet another challenge arose as the depth of the inner man expressing himself through the surfaces of an exterior world struggled with the nature he revered. A dark peace that had been building since the late 1930s now became permanent in his photographs.

As he aged, Weston's eye grew sober and keen. He no longer sought intrigue for his imagination but meaning. Jeffers had already taken the survival of meaning as a theme in his images of the waters, wildlife, and rocks around Lobos. He put into words what echoes in the late solemnity of Weston, the gentler visual utterances of White, and the work of a few others who celebrated their example up and down the California coast:

I think, here is your emblem
To hang in the future sky;
Not the cross, not the hive,

But this; bright power, dark peace;
Fierce consciousness joined with final
Disinterestedness;

Life with calm death; the falcon's
Realist eyes and act
Married to the massive

Mysticism of stone,
Which failure cannot cast down
Nor success make proud.[59]

## NOTES

1. Doty Warren, introduction to Edward Weston, *My Camera on Point Lobos* (Boston, 1950), unpaginated.

2. The lecture is recorded as "Photography As a Means of Artistic Expression," in Edward Weston, *Edward Weston on Photography*, ed. Peter C. Bunnell (Salt Lake City, 1983), pp. 18-21. It should be noted that at the time of this lecture Weston still used a soft-focus lens for his professional portraits as well as his personal work.

3. During this Mexican period, Weston returned to California for an extended stay between Christmas 1924 and August 1925, living part of this time in San Francisco. His son Chandler accompanied him during the first part of the Mexican sojourn and Brett on the second.

4. Quoted in Edward Weston, *The Daybooks of Edward Weston*, vol. 2: *California*, ed. Nancy Newhall (Millerton, 1973), p. 31.

5. Ibid., p. 32.

6. Ibid., p. 31.

7. Abstract design in pictorial photography was influenced by one or more of several sources: abstract painting, the Japanese idea of *notan*, Jugendstil decoration, and Art Moderne design. Much of this is diagrammed and explained by Arthur Wesley Dow in *Composition, A Series of Exercises Selected from a System of Art Education* (New York, 1900).

8. Weston, p. 32.

9. William Justema, "Margaret, A Memoir," in *Margrethe Mather* (Tucson, 1979), p. 8. According to William Justema, Mather had been a child prostitute in Utah and San Francisco before landing in Southern California. She and Weston first met at a Los Angeles Camera Club meeting in 1912. Moving from model to assistant to partner, she kept the Tropico studio during Weston's absence, much to the displeasure of his wife, Flora, who had an interest in the property.

10. Justema, p. 8.

11. Ibid., p. 11.

12. It should be noted that Weston had an early exhibition at the studio of Toyo Miyatake.

13. Margery Mann reported that Imogen Cunningham's opinion was that it was Mather who convinced Weston to dismiss pictorialism. See Margery Mann, *Imogen Cunningham: Photographs* (Seattle, 1970), unpaginated.

14. Mather also admired Kasebier's work.

15. It might be noted that Johan Hagemeyer also took a close-up study of a calla lily in 1925 but still used a lens of relatively soft focus.

16. Weston did not use untoned glossy papers exclusively until 1930.

17. The exhibition *Film und Foto* traveled through Europe and was sent as well to Tokyo and Osaka.

18. Quoted from Edward Weston, "America and Photography," in Bunnell, ed., *Edward Weston: On Photography*, pp. 55-56.

19. Ibid., p. 56.

20. Weston, *Daybooks*, p. 114.

21. Van Dyke formed the gallery with Mary Jeanette Edwards, daughter of the photographer John Paul Edwards. For Group f/64, see Jean S. Tucker, *Group f/64*, exh. cat. (University of Missouri, St. Louis, 1978); Nancy Newhall, *Ansel Adams: The Eloquent Light* (San Francisco, 1963), pp. 74-80; Ansel Adams with Mary Street Alinder, *Ansel Adams: An Autobiography* (Boston, 1985), pp. 110-115.

22. Adams with Alinder, p. 112. It should be noted that the f/64 aperture was typical of lenses manufactured for view cameras rather than hand-held cameras.

23. At their meeting Strand had no prints of his work to show Adams, who judged him strictly on recent negatives Strand had developed.

24. Had Adams not chosen photography as a profession

after meeting Strand in Taos, there would have been several other opportunities, one of which would have been his visit to Stieglitz in 1933.

25. Since 1961 known as the San Francisco Art Institute. The Department of Photography was launched in the summer of 1946. Students attracted to the school included Pirkle Jones, Rose Mandel, Ruth-Marion Baruch, Oliver Gagliani, and William Heick. Guest lecturers inlcuded Cunningham, Lange, and Weston. For a discussion of the schools of photography in California established just after the Second World War, see Louise Katzman, *Photography in California, 1945-1980* (New York, 1984), pp. 16-23.

26. California photographers included in the exhibition either in the regional section or in solo showings were Ansel Adams, Sybil Anikeyev, Fred Archer, Edgar Bissantz, Will Connell, Imogen Cunningham, William Dassonville, Mary Jeanette Edwards, Rex Hardy, Dorothea Lange, Alma Lavenson, Norman Lindblom, Dr. Paul Naimone, Sonya Noskowiak, Marion Partridge, Roi Partridge, Rondal Partridge, LeRoy Robbins, Peter Stackpole, Willard Van Dyke, Brett Weston, Edward Weston, and Cedric Wright.

27. Quoted in Adams with Alinder, p. 198.

28. The most active museums were the M. H. de Young Memorial Museum, the San Francisco Museum (now the San Francisco Museum of Modern Art), and the Los Angeles Museum of Art (now the Los Angeles County Museum of Art). Occasional exhibitions were held at the Santa Barbara Museum of Art.

29. Quoted in Milton Meltzer, *Dorothea Lange: A Photographer's Life* (New York, 1978), pp. 84-85.

30. Mary Jeanette Edwards worked for Lange in her darkroom and founded the 683 gallery with Van Dyke. For more on this outing to Oroville, California, see ibid., pp. 86-87.

31. Other government-sponsored photography in California was administered by the Federal Art Project (FAP) of the Works Progress (later Work Projects) Administration (WPA). The California project was the only one of the country geared to artistic expression. Brett Weston supervised the producing of several exhibitions (see Merry A. Foresta, "Art and Document: Photography of the Works Progress Administration's Federal Art Project," p. 154). Imogen Cunningham's son Rondal Partridge photographed California adolescents in the spring of 1940 for the National Youth Administration (NYA). See Sally Stein, "Figures of the Future," pp. 103-104.

32. More of the quotation from Bacon, which Lange probably did not know, has to do with light as a photographer would understand it: "And yet (to speak the whole truth), as the uses of light are infinite in enabling us to walk, to ply our arts, to read, to recognize one another—and nevertheless the very beholding of the light is itself a more excellent and fairer thing than all the uses of it—so assuredly the very contemplation of things as they are, without superstition or imposture, error or confusion, is it itself more worthy than all the fruit of inventions." The New Organon, pt. 2, 129, in Sidney Warhaft, ed., *Francis Bacon: A Selection of His Works* (New York, 1985), p. 374.

33. Horace Bristol, "Photographers and Photography in My Life," unpub. manuscript, 1989. See also "Travels with Steinbeck" by Horace Bristol as told to Jack Kelly in *People*, May 1, 1989, pp. 67-73.

34. In 1937, Weston had received the first Guggenheim fellowship awarded to a photographer, which was renewed the following year.

35. Quoted in Meltzer, p. 240.

36. The photographer Toyo Miyatake, who had shown Weston's photographs in his studio, was interned at Manzanar. He was able to smuggle in a lens and shutter and constructed a camera in order to document the camp.

37. For a discussion of WPA/FPA photography projects, see Foresta, pp. 148-156.

38. Quoted in Max Kozloff, "The Extravagent Depression," in John Gutmann, *The Restless Decade: John Gutmann's Photographs of the Thirties* (New York, 1984), p. 11.

39. David Fahey and Linda Rich, *Masters of Starlight* (New York, 1987), p. 15.

40. Paul Outerbridge moved to Laguna Beach in the late 1940s.

41. This group was originally formed by Louis Fleckenstein and Margrethe Mather.

42. This connection to the work of the Japanese-American photographers in Los Angeles is made in Van Deren Coke, *Photographs by Will Connell*, exh. cat. (San Francisco Museum of Modern Art, 1981), p. 4.

43. Other influential teachers were Fred Archer and Edward Kaminski. George Hoyningen-Huene occasionally taught there as well.

44. The quote is from a letter Man Ray wrote to his sister, quoted in Neil Baldwin, *Man Ray: American Artist* (New York, 1988), p. 238.

45. Teske eventually found an official place in the Los Angeles photographic community. At Robert Heinecken's invitation, he taught at UCLA from 1965 to 1970, continuing to teach evening classes until 1974.

46. White learned of the CSFA position through Beaumont and Nancy Newhall.

47. Quoted in Peter C. Bunnell, *Minor White: The Eye That Shapes*, exh. cat. (Princeton, 1989), p. 25.

48. White and Teske did not meet each other until 1960.

49. Minor White, "Photography Is an Art," *Design* 49:4 (December 1947), p. 8.

50. We might remark that these three categories (subjective, objective, equivalent) were three successive phases through which Stieglitz' and Westen's careers had passed and from which White was expecting to proceed.

51. The sequence was completed in 1947 and scheduled for exhibition at the California Palace of the Legion of Honor in August. The exhibition was cancelled because of criticism of the length and quality of the written words that accompanied the photographs. For a personal memoir of White during this period, see Walter Chappell, "The Threshold of Vision: Minor White," in *Minor White: A Living Remembrance* (Millerton, 1984), pp. 18-21.

52. Bunnell, *Minor White*, p. 6.

53. White to Adams, 8 March 1947, quoted in ibid., p. 25.

54. Quoted from Minor White, *Mirrors Messages Manifestations* (Millerton, 1969; 2nd ed., 1982), p. 63.

55. Quoted in Bunnell, *Minor White*, pp. 30-31.

56. Even during his stay in Mexico, Weston rejected the work of Man Ray and Moholy-Nagy.

57. Weston, "America and Photography," in Bunnell, ed., *Edward Weston: On Photography*, p. 56.

58. For Minor White's statement about Weston's 1944-48 Point Lobos photographs, see *Aperture* 1:4 (1953), p. 5. White was careful not to create a sequence out of the Weston photographs of Lobos, reproducing only one full-page photograph per spread.

59. Robinson Jeffers, "Rock and Hawk," in Robert Hass, ed., *Rock and Hawk: A Selection of Shorter Poems by Robinson Jeffers* (New York, 1987).

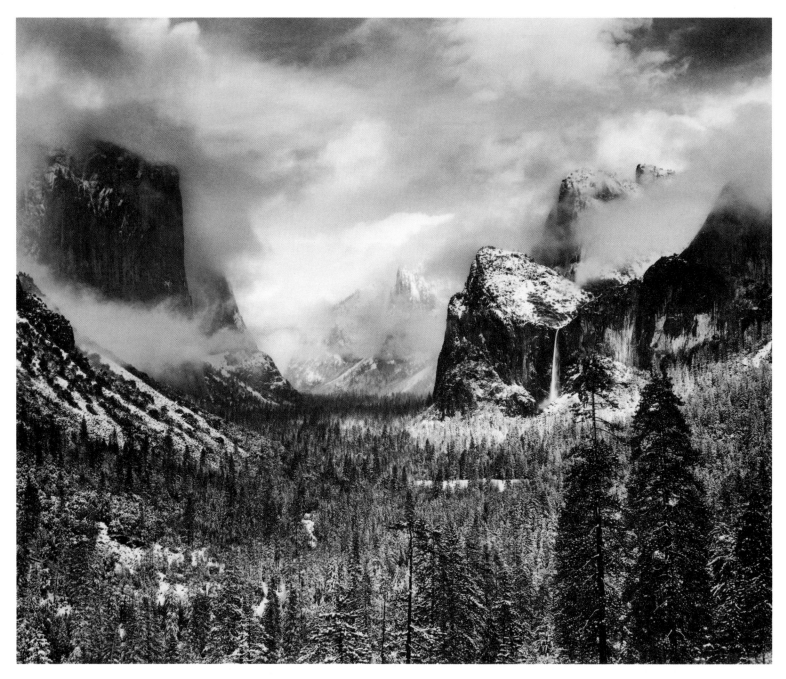

Ansel Easton Adams (1902-1984)
*Clearing Winter Storm, Yosemite National Park, California*, c. 1941
Gelatin silver print
Anonymous loan
© 1992 by the Trustees of the Ansel Adams
Publishing Rights Trust

Ansel Easton Adams (1902-1984)
*Birds on Power Wires (Manzanar)* , c. 1943
Gelatin silver print
Center for Creative Photography

Ansel Easton Adams (1902-1984)
*Ice on Merced River, Yosemite Valley, California*, c. 1950
Gelatin silver print
San Francisco Museum of Modern Art
© 1992 by the Trustees of the Ansel Adams Publishing Rights Trust
All rights reserved

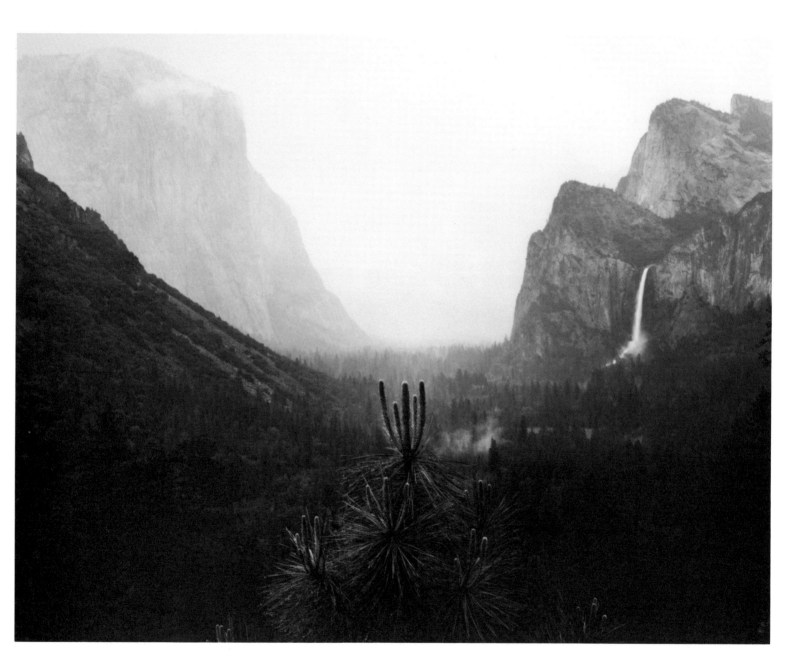

Ansel Easton Adams (1902-1984)
*Yosemite Valley, Rain and Mist, Yosemite National Park, California,* c. 1935
Gelatin silver print
Center for Creative Photography
© 1992 by the Trustees of the Ansel Adams Publishing Rights Trust

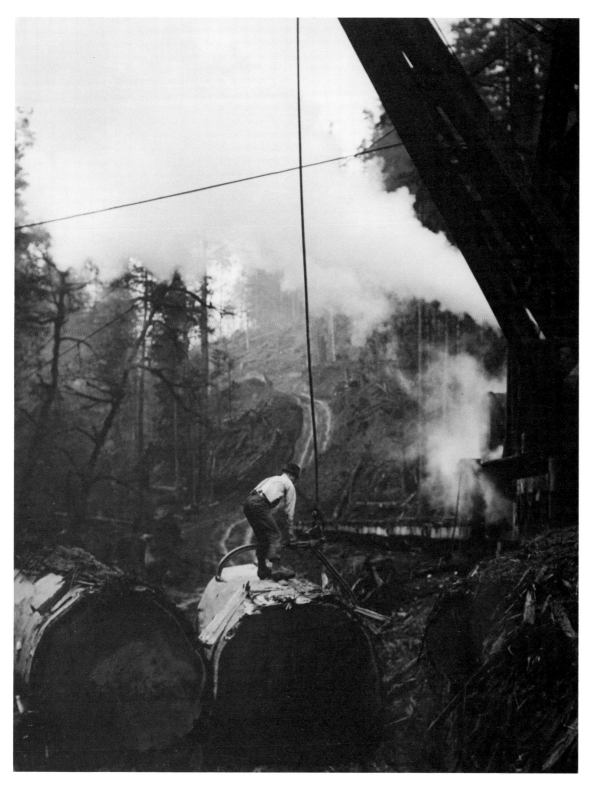

Horace Bristol (b. 1908)
*Redwood Lumbering, Eureka, California,*
1937
Gelatin silver print
Santa Barbara Museum of Art

Will Connell (1898-1961)
*Sodium Lamp*, 1937
Gelatin silver print
Department of Special Collections,
University Research Library, UCLA

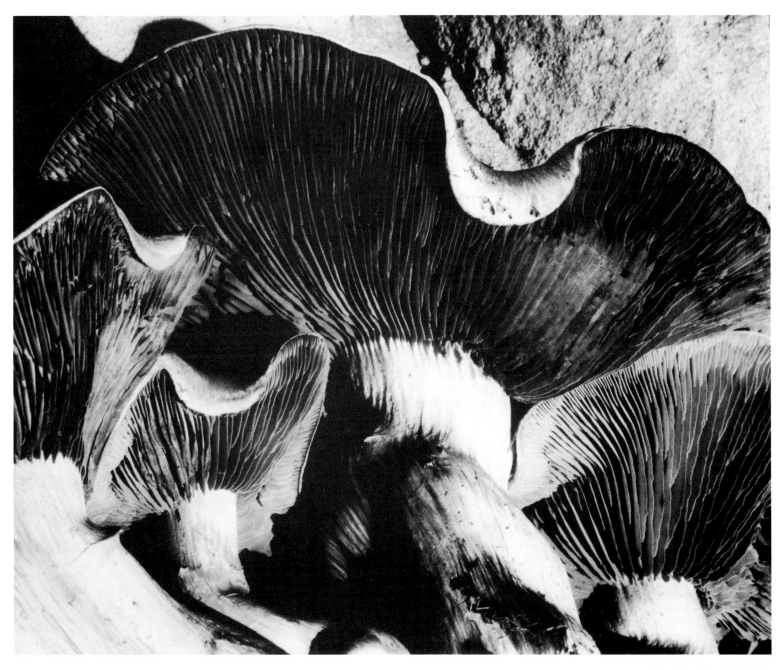

Willard Van Dyke (1906-1986)
Untitled, 1931
Gelatin silver print
Lee Wolcott Collection

Wynn Bullock (1902-1975)
*Solarized Head*, 1949
Gelatin silver print
Center for Creative Photography
© The Wynn and Edna Bullock Trust

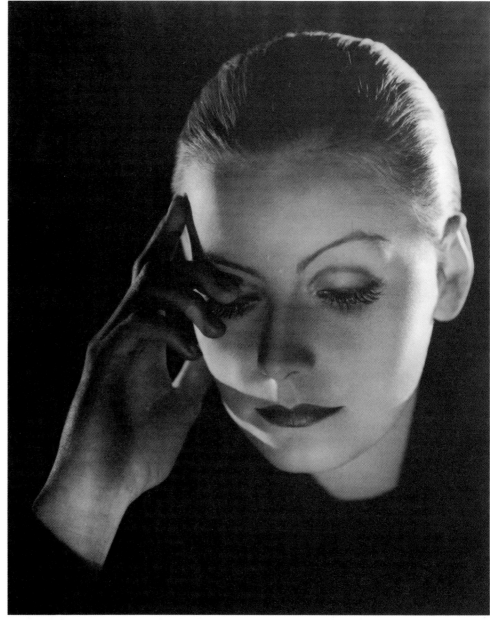

Clarence Sinclair Bull (1896-1979)
*Greta Garbo as Mata Hari*, 1931
Gelatin silver print
Fahey/Klein Gallery, Los Angeles

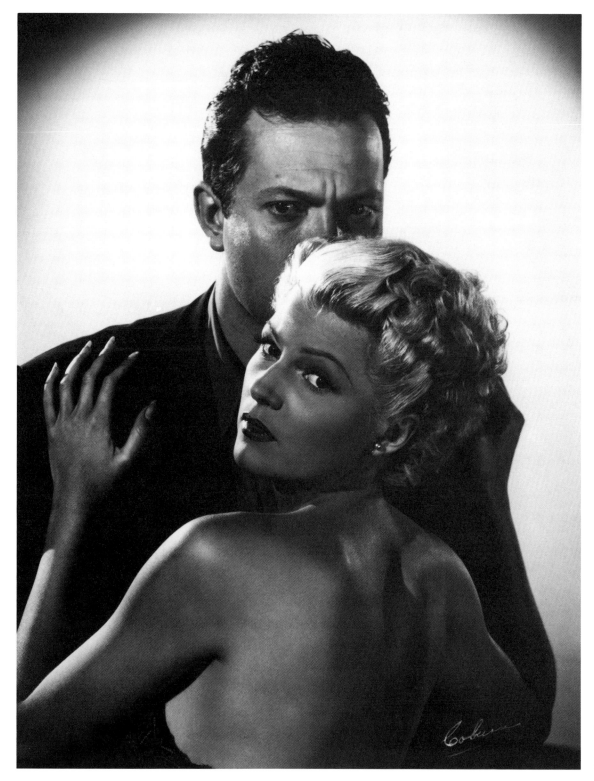

Robert Coburn (1900-1990)
Untitled (Orson Welles with Rita Hayworth)
1947-48
Gelatin silver print
Fahey/Klein Gallery, Los Angeles

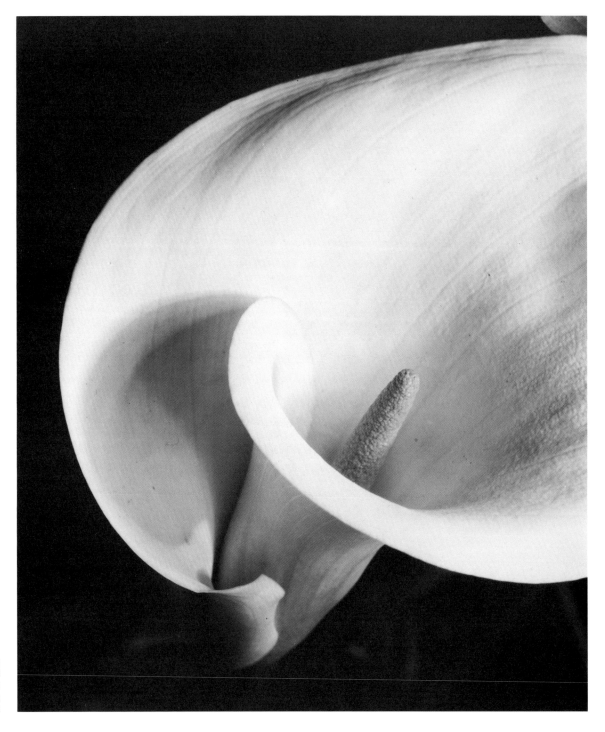

Imogen Cunningham (1883-1976)
*Calla*, c. 1929
Gelatin silver print
Leland Rice and Susan Ehrens Collection
© The Imogen Cunningham Trust

Imogen Cunningham (1883-1976)
*Triangles*, 1926
Gelatin silver print
The J. Paul Getty Museum

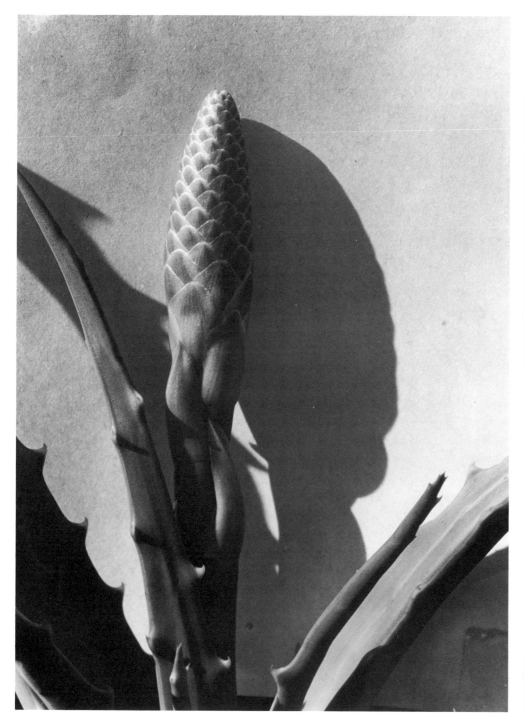

Imogen Cunningham (1883-1976)
*Aloe Bud*, 1930
Gelatin silver print
Los Angeles County Museum of Art
Los Angeles County Funds

Imogen Cunningham (1883-1976)
*Magnolia*, 1925
Gelatin silver print
Marjorie and Leonard Vernon Collection

Imogen Cunningham (1883-1976)
*Snake*, 1929
Gelatin silver print from contact positive
The Art Institue of Chicago,
The Julien Levy Collection
Gift of Jean and Julien Levy

Faurest Davis (1906-1991)
*Banana Blossom, Los Angeles*, 1943
Gelatin silver print
Courtesy of Fraenkel Gallery, San Francisco
© Faurest Davis

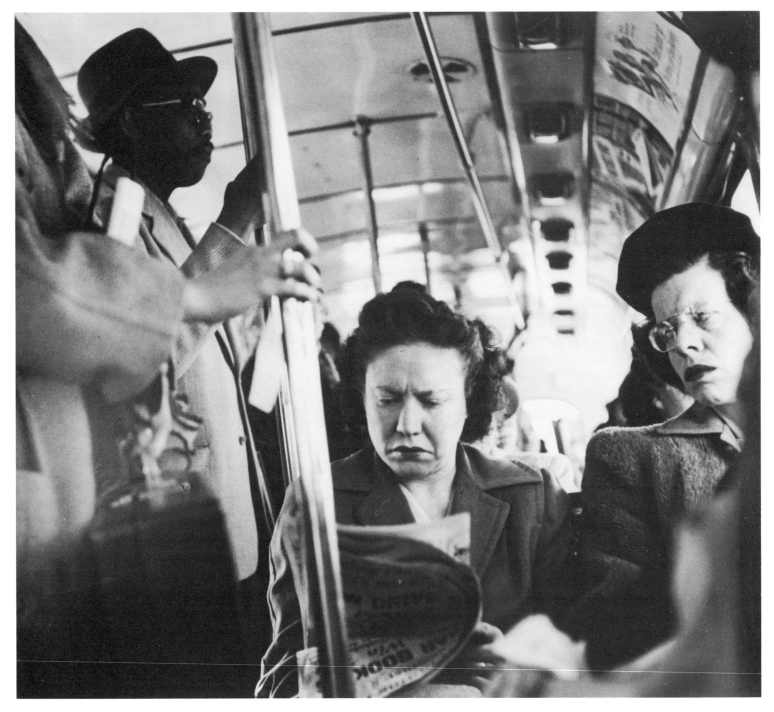

William Heick (b. 1917)
*San Francisco*, 1947
Gelatin silver print
The Art Institute of Chicago
Mary and Leigh Block Endowment

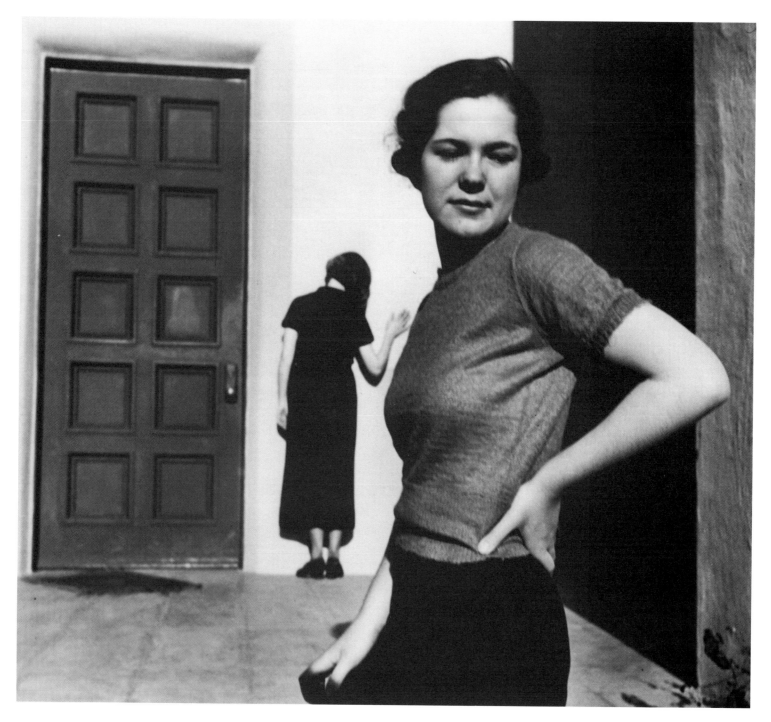

John Gutmann (b. 1905)
*Shrug of the Shoulder*, 1935
Gelatin silver print
Michael G. Wilson Collection
© John Gutmann

■ 143 ■

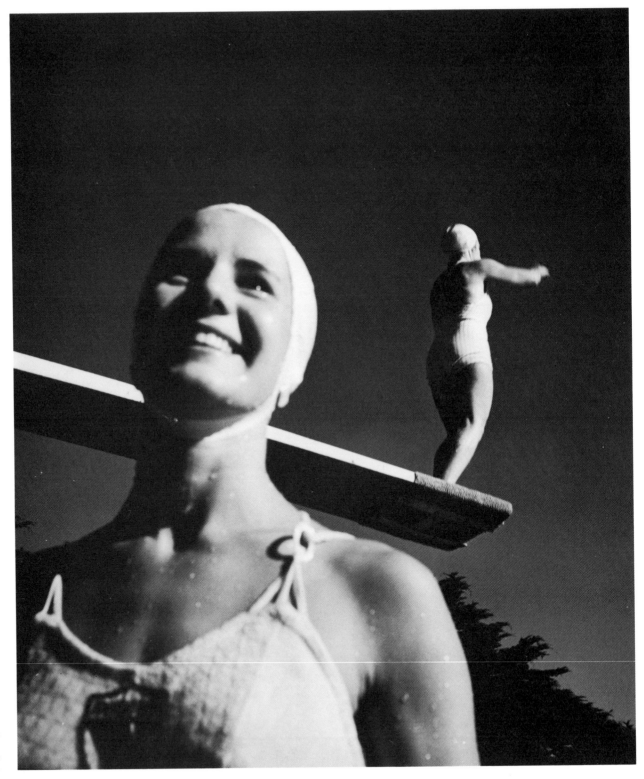

John Gutmann (b.1905)
*Helen Crenklowich, Champion*
*Swimmer with Diver*, 1939
Gelatin silver print
Courtesy of Fraenkel Gallery,
San Francisco
© John Gutmann

John Gutmann (b.1905)
*That Inward Eye,* 1949
Gelatin silver print
The Art Institute of Chicago
Mary and Leigh Block Endowment
© John Gutmann

John Gutmann (b. 1905)
*The Jump,* 1939
Gelatin silver print
Jane Levy Reed Collection
© John Gutmann

Hiromu Kira (1898-1991)
*The Thinker*, 1928
Gelatin silver print
Marjorie and Leonard Vernon Collection

Otto Hagel (1909-1974)
*Jack London's Wolf House – Death Mask*, 1949
Gelatin silver print
Courtesy of Susan Ehrens

Pirkle Jones (b. 1914)
*Garden Detail, San Francisco*, 1947
Gelatin silver print
Center for Creative Photography
© Pirkle Jones

George Hurrell (b. 1904)
*Ann Sothern*, 1940
Gelatin silver print
Fahey/Klein Gallery, Los Angeles

Dorothea Lange (1895-1965)
*Mended Stockings*, 1934
Gelatin silver print
The Oakland Museum
© The City of Oakland

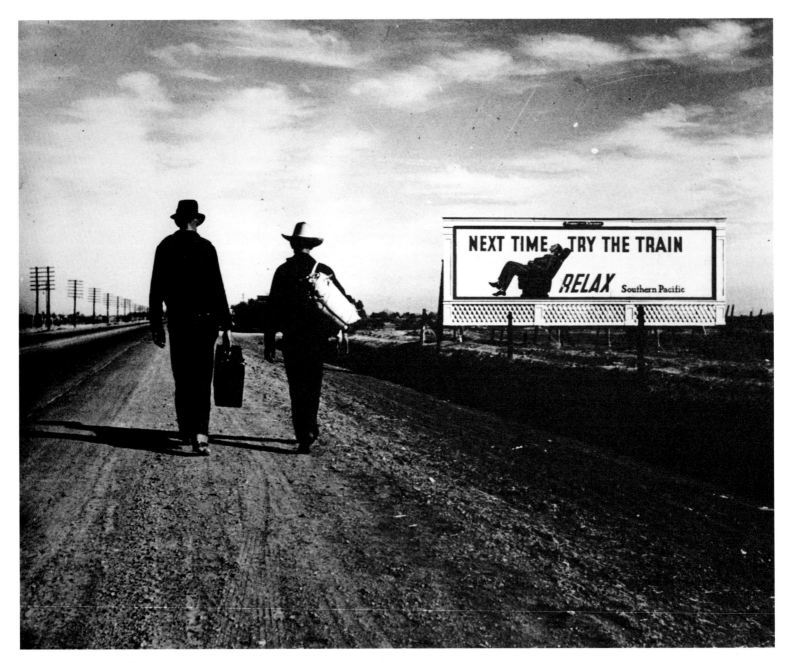

Dorothea Lange (1895-1965)
*On the Road Toward Los Angeles*, 1936
Gelatin silver print
The Oakland Museum

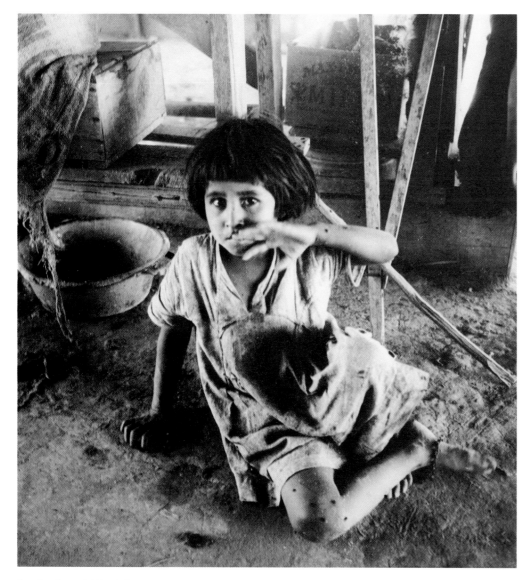

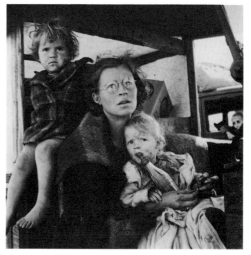

Dorothea Lange (1895-1965)
*Mexican Child, Imperial Valley, California,* 1935
Gelatin silver print
The Oakland Museum

Dorothea Lange (1895-1965)
*Tule Lake, Siskiyou County, California,* 1939
Gelatin silver print
Anonymous loan

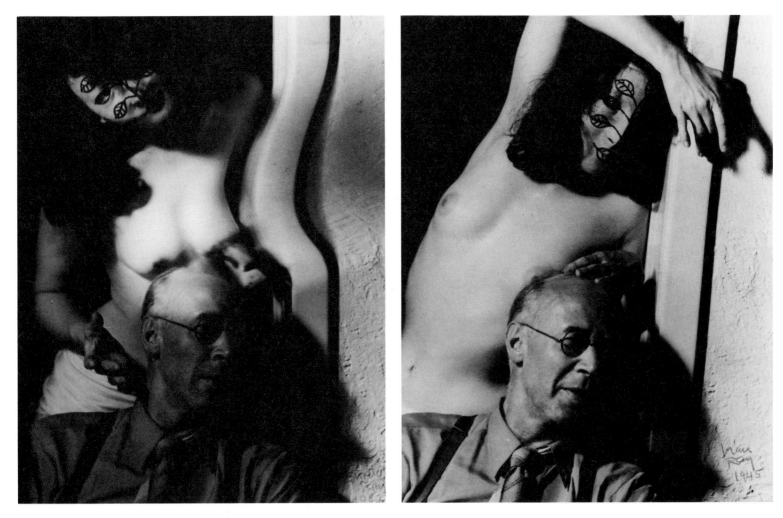

Man Ray (1890-1976)
*Henry Miller and Masked Nude (Distorted)*, c. 1942
Gelatin silver print
The J. Paul Getty Museum
© 1991 Man Ray Trust/ADAGP-PARIS/ARS-USA

Man Ray (1890-1976)
Untitled (rayograph), 1945
Gelatin silver print
The Art Institute of Chicago
Restricted gift of Miss Margaret Fisher

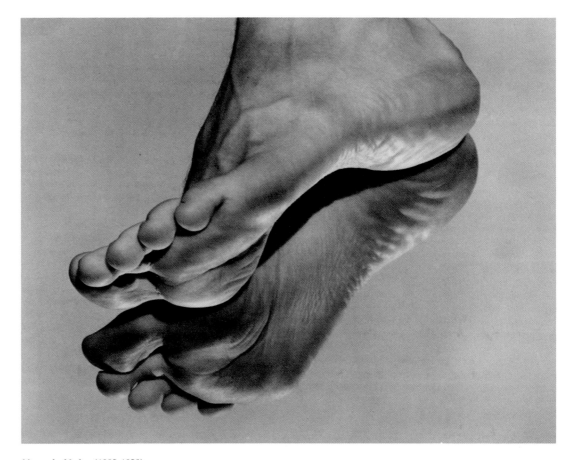

Margrethe Mather (1885-1952)
*Foot in Mirror*, 1927
Gelatin silver print
Center for Creative Photography

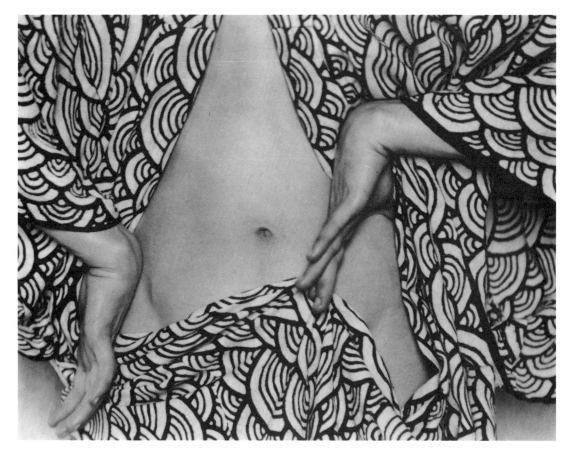

Margrethe Mather (1885-1952)
*Semi-nude Male*, 1923-1927
Gelatin silver print
Center for Creative Photography

Margrethe Mather (1885-1952)
*Billy Justema, Los Angeles*, 1923-1927
Gelatin silver print
Center for Creative Photography

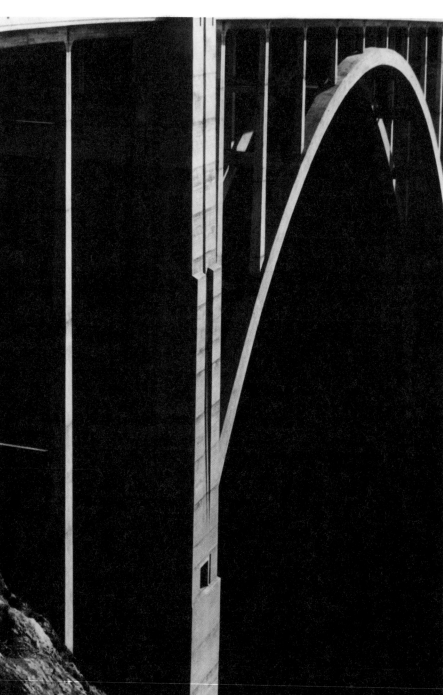

Wright Morris (b. 1910)
*Near Needles, California, Heading Into Arizona*, 1937-38
Gelatin silver print
Imageworks: Merrily and Tony Page

Peter Stackpole (b. 1913)
*View from Crossbeam Tower W2*, 1935
Gelatin silver print
The Oakland Museum
Founders Fund

Sonya Noskowiak (1900-1975)
Untitled (arch of concrete bridge), c. 1932
Gelatin silver print
Center for Creative Photography
© Arizona Board of Regents

Karl Struss (1886-1981)
*Sails (Sailing to Catalina)*, 1929
Silver bromide print
Michael G. Wilson Collection

Brett Weston (b. 1911)
*Silver Tower*, 1927
Gelatin silver print
Ron and Kathy Perisho Collection

Brett Weston (b. 1911)
*Sand Dune*, 1933
Gelatin silver print
Anonymous loan

Rose Mandel (b. 1910)
*On Walls and Behind Glass #20*, c. 1947-48
Vintage silver gelatin print
The Art Institute of Chicago
Restricted gift of Lucia Woods Lindley and
Daniel A. Lindley, Jr.

Edmund Teske (b. 1911)
*Mother McCrea, Brentwood, California*, 1946
Gelatin silver print
Leland Rice Collection

Edmund Teske (b. 1911)
*Jane Lawrence*, 1945
Gelatin silver print
Leland Rice Collection

Lou Stoumen (1917-1991)
*Children in the Window, East Los Angeles*, 1947
Vintage silver gelatin print
Jan Kesner Gallery, Los Angeles

Marion Palfi (1917-1978)
*Returning Evacuees, Los Angeles*, 1946-49
Gelatin silver print
Center for Creative Photography
© 1978 Martin Magner

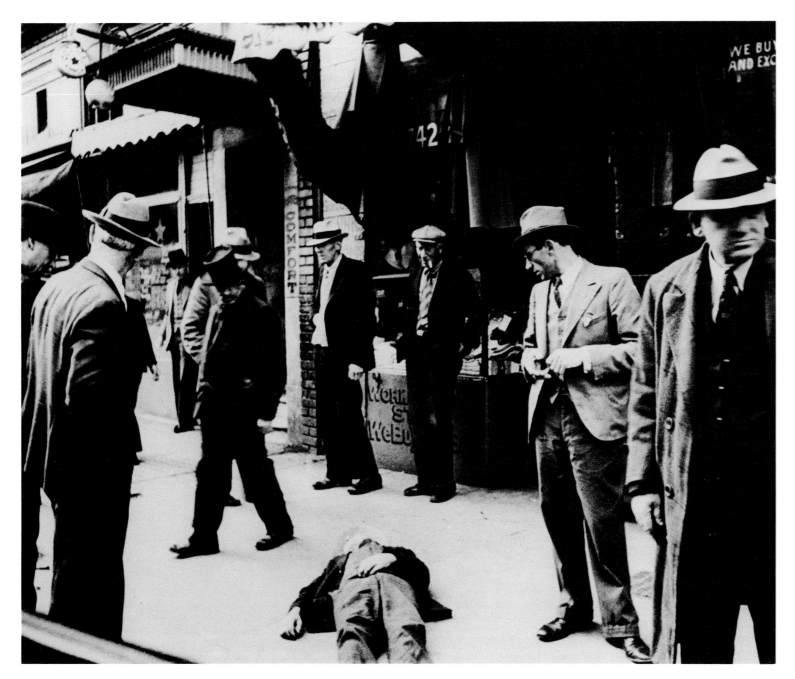

Hansel Mieth
*A Man Lies in the Street, S.F.*, 1934
Gelatin silver print
Courtesy of Susan Ehrens

Edward Weston (1886-1958)
Untitled, 1939
Gelatin silver print
Imageworks: Merrily and Tony Page
© 1981 Center for Creative Photography, Arizona Board of Regents

Edward Weston (1886-1958)
*Point Lobos, Dead Grass and Driftwood*, 1944
Gelatin silver print
The J. Paul Getty Museum

Edward Weston (1886-1958)
*Tide Pool, Point Lobos*, 1945
Gelatin silver print
Los Angeles County Museum of Art
Anonymous gift

Edward Weston (1886-1958)
*Pepper*, 1930
Gelatin silver print
The J. Paul Getty Museum
© 1981 Center for Creative Photography
Arizona Board of Regents

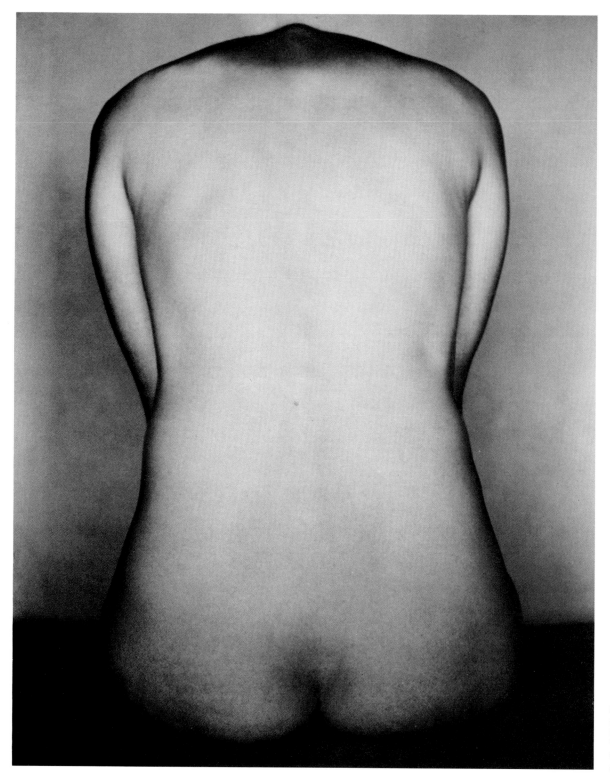

Edward Weston (1886-1958)
*Cristal, Glendale*, 1927
Gelatin silver print
The J. Paul Getty Museum
© 1981 Center for Creative Photography
Arizona Board of Regents

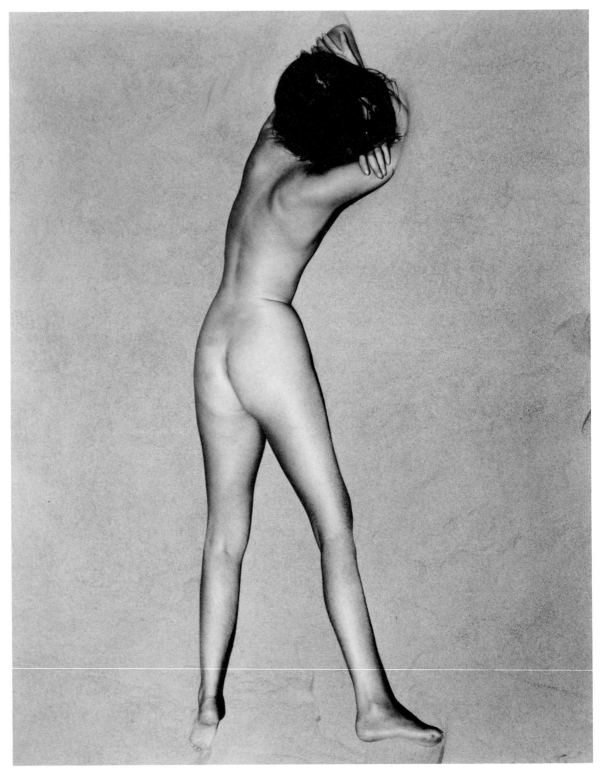

Edward Weston (1886-1958)
*Nude on Sand*, 1936
Gelatin silver print
Los Angeles County Museum of Art
Anonymous gift
© 1990 Museum Associates,
LACMA

Edward Weston (1886-1958)
*Storm Death Valley*, 1939
Gelatin silver print
Marjorie and Leonard Vernon Collection
© 1981 Center for Creative Photography
Arizona Board of Regents

Edward Weston (1886-1958)
*Shells*, 1927
Gelatin silver print
Marjorie and Leonard Vernon Collection
© 1981 Center for Creative Photography
Arizona Board of Regents

Minor White (1908-1976)
*Fourth Sequence (Nos. 1-4)*, 1950
Gelatin silver prints
Center for Creative Photography
© Minor White Archive, The Art Museum, Princeton University

Minor White (1908-1976)
*Ernest Gutierrez's Hand*, 1950
Gelatin silver print
Dr. and Mrs. Leo Keoshian Collection

Minor White (1908-1976)
Untitled (man looking down on branch), n.d.
Gelatin silver print
Imageworks: Merrily and Tony Page

Alma Lavenson (1897-1989)
*Self Portrait*, 1932
Gelatin silver print
Dr. and Mrs. Leo Keoshian Collection

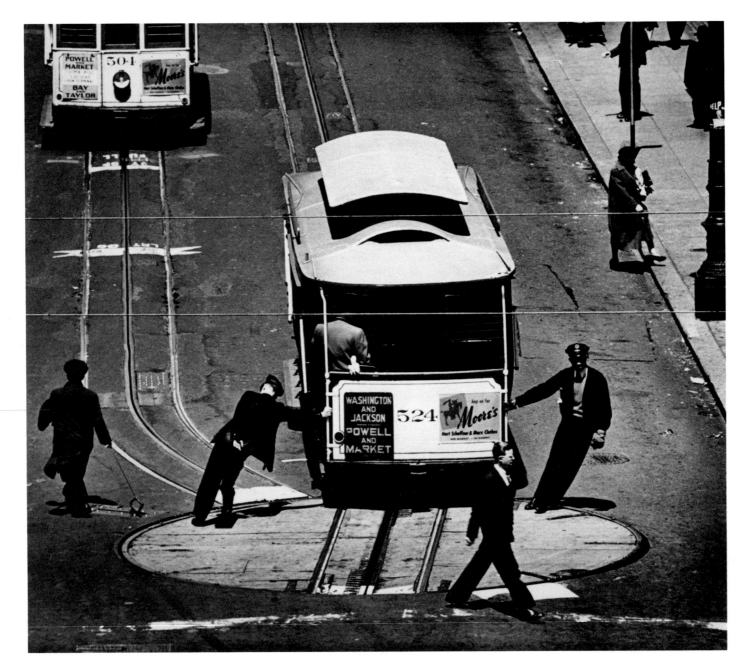

Max Yavno (1911-1985)
*Cable Car*, 1947
Gelatin silver print
Marjorie and Leonard Vernon Collection
© Max Yavno Estate

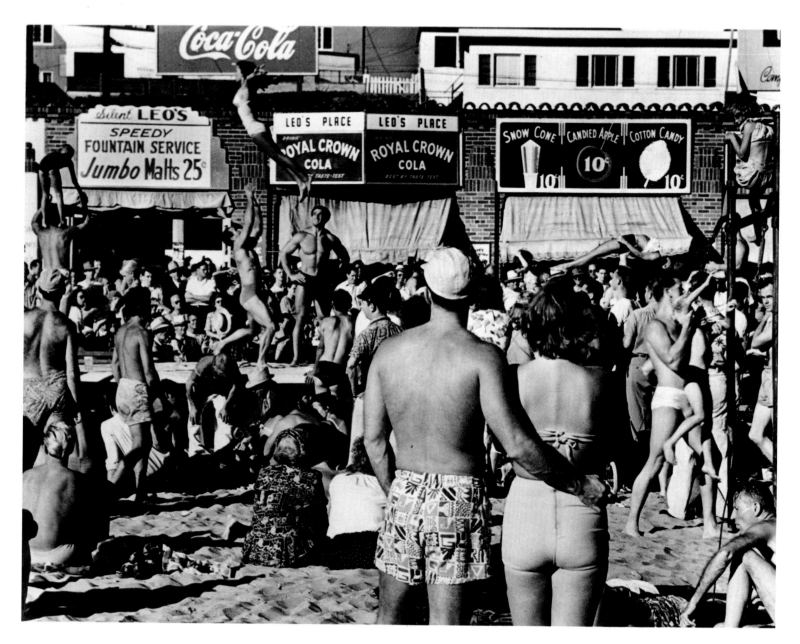

Max Yavno (1911-1985)
*Muscle Beach*, 1949
Gelatin silver print
Leland Rice Collection
© Max Yavno Estate

# BIOGRAPHIES

## ANSEL EASTON ADAMS

1902   Born in San Francisco, California on February 20. Originally trained as a concert pianist.

1916   Went to Yosemite, where he took his first photographs. Worked in San Francisco for Frank Dittman, photofinisher.

1927   Began career as photographer with Parmelian Prints of the High Sierras.

1928   Married Virginia Best.

1930   Met and was influenced by Paul Strand.

1932   Was founding member Group f/64. Members consisted of Imogen Cunningham, Sonya Noskowiak, Henry Swift, Willard Van Dyke, and Edward Weston.

1933   Opened Ansel Adams Photography and Art Gallery in San Francisco.

1937   Moved to Yosemite Valley, California.

1940   Assisted in founding of photography department at the Museum of Modern Art, New York.

1941   Worked for the Department of the Interior photographing the National Parks. Also taught in Los Angeles at the Art Center School.

1946   Founded the department of photography at the California School of Fine Arts, San Francisco.

1955   Taught workshops in Yosemite Valley.

1961   Awarded Doctor of Fine Arts Degree, University of California at Berkeley.

1962   Moved to Carmel.

1967   Founded Friends of Photography, Carmel.

1980   Awarded Presidential Medal of Freedom.

1984   Died of heart failure in Monterey, California.

## H. OLIVER ALBRECHT

1876   Born January 29 in Mannheim, Germany. Attended Heidelberg University; studied mathematics 1890s. Came to America; became a professional photographer.

1900s   Did series on 1906 earthquake, Chinatown, other San Francisco scenes.

1917   Married painter Gertrude Partington and turned to landscape painting; changed name to Albright.

1930s   Became established figure in the San Francisco art world, exhibiting throughout the area.

1944   Died in San Francisco.

## LAURA ADAMS ARMER

1874   Born in San Francisco, California. Considered "an introverted, dreamy child."

1893   Studied painting and drawing under Arthur Mathews at California 98 School of Design.

1899   Established studio in Flood Building on the corner of Powell & Market, San Francisco.

1901   Exhibited ten prints, First San Francisco Photographic Salon.

1902   Active in Berkeley. Studied at Mark Hopkins Institute of Art, San Francisco.

1902   Exhibited nine prints, Second San Francisco Salon.

1920   Became interested in Native American culture; worked among Hopi and Navaho in Arizona.

1922   Exhibited in First Annual International Exhibition of Pictorial Photography, San Francisco.

1928   Produced first Native American motion picture, *The Mountain Chant.*

1931   Wrote and illustrated children's books with husband Sidney Armer, among them, *Waterless Mountain.*

1938   Sold Berkeley home, moved to Crescent City, California.

1963   Died.

## ISAAC WALLACE BAKER

1810   Born in Beverly, Massachusetts.

1849   Came to California.

1853   Settled at Murphy's Camp, Vallecita, California. Traveled through mining camps by wagon; made daguerreotypes of workers. Made one of earliest known portraits of Asian-Americans. Died in Sumatra (date unknown).

## RUTH BERNHARD

1905   Born October 14 in Berlin, Germany.

1925   Studied at Academy of Fine Arts, Berlin.

1927   Moved to New York City.

1930   Started photography.

1935   Met Edward Weston.

1936   First solo exhibition, Pacific Institute for Music and Art, Los Angeles.

1942   Met Alfred Stieglitz.

1953   Taught private photography lessons in San Francisco; met Imogen Cunningham, Minor White, Ansel Adams, Dorothea Lange, Wynn Bullock.

1958   Began to teach at University of California and elsewhere.

1971   Taught at New York University.

1975   Exhibited in *Women of Photography: An Historical Survey*, San Francisco Museum of Modern Art. Lives in San Francisco.

## SIGISMUND BLUMANN

1872   Born in New York. Trained as a musician and music teacher, with photography a second career.

1906   Photographed San Francisco earthquake and fire.

1956   Died.

## ANNE W. BRIGMAN

1869   Born in Hawaii on December 3.

1884   Married Martin Brigman.

1886   Family moved to Los Gatos, California.

1902   Exhibited five prints at Second San Francisco Photographic Salon.

1903 Became Associate of the Photo-Secession.

1906 Elected a Fellow of the Photo-Secession.

1909 Prints published in *Camera Work*. Went to New York and met for the first time the members of the Photo-Secession.

1911 Exhibited in the International Exhibition, Albright Art Gallery, Buffalo, New York.

1922 Exhibited in the First Annual International Exhibition of Pictorial Photography at the Palace of Fine Arts, San Francisco.

1930 Discontinued photography because of bad eyesight, turning to poetry.

1949 Wrote *Songs of a Pagan*.

1950 Died in Eagle Rock, California.

## HORACE BRISTOL

1908 Born November 16. Studied at Stanford University.

1929 Began taking photographs while in Europe. Attended courses in architecture at Technischen Hochschule, Munich.

1931 Returned to California. Enrolled in Will Connell's photography program at Art Center in Los Angeles.

1933 Moved to San Francisco to work for *Call Bulletin*.

1937 Joined *Life* magazine.

1939 Joined *Fortune* magazine.

1941-45 Worked as one of Edward Steichen "chickens" photographing the war.

1945 Hired as *Fortune*'s Asian correspondent, based in Tokyo.

1947 Created his own company, East West Photo Agency.

1964 Last photography assignment.

1967 Moved to Guadalajara, Mexico.

1976 Relocated to Ojai, California, where he now resides.

## FRANCIS JOSEPH BRUGUIERE

1879 Born in San Francisco on October 16.

1905 Studied photography in New York. Member of the Photo-Secession.

1906 Returned to San Francisco and opened studio.

1909 Portrait photographer until 1919.

1919 Moved to New York and worked as a free-lance photographer.

1927 First one-man show in New York at the Art Center.

1928 Moved to London. Made honorary member of the German Secession Group.

1929 Participated in exhibition of the Deutsche Werkbund in Stuttgart.

1945 Died in London, England.

## CLARENCE SINCLAIR BULL

1896 Born May 23 in Sun River, Montana.

1906 Became fascinated with photography.

1909-10 Bought first camera; began work at printing company.

1914 Part-time job in camera store.

1915 University of Michigan student paper staff photographer.

1918 Moved to Hollywood—began at Metro Studio as assistant cameraman; took stills of stars at same time.

1918 Began to do stills and portraits for Goldwyn; received one of few Academy Awards given for still photography.

1923 Head of stills department at MGM until retirement.

1979 Died.

## WYNN BULLOCK

1902 Born April 18 in Chicago, Illinois.

1905 Family moved to South Pasadena, California.

1925 Studied music for two years at Columbia College in New York.

1928-30 Studied in Paris, Milan and Berlin.

1931 Finished studies at University of West Virginia.

1938 Enrolled at Art Center School, Los Angeles; was influenced by Edward Kaminski, his teacher.

1941 First one-man show at the Los Angeles County Museum of Art.

1942 Joined U.S. Army.

1943 Discharged to photograph for various aircraft companies.

1945 Moved to Monterey and worked as commercial photographer for Fort Ord military base.

1947 Solo exhibition at Santa Barbara Museum of Art.

1948 Met Edward Weston.

1959 Taught photography at San Francisco State University.

1975 Died in Monterey, California.

## ROBERT COBURN

1900 Born in Chateau, Montana.

1912 Father bought him first Kodak 2-A.

1917 Became cameraman in Hollywood for Sherwood Productions while attending Hollywood High School.

1918-24 Still photographer.

1925-34 Still photographer for Cecil B. DeMille, RKO.

1935-40 Co-director of Goldwyn portrait gallery; developed a natural color process for stills and became one of the first to produce them as in *The Goldwyn Follies* (1938).

1940 Freelanced, then became head of stills production department for Columbia. Began making dye-transfer photographs.

1944 Received first screen credit for a Hollywood portrait photographer.

1983 Work exhibited in National Portrait Gallery show, *The Art of the Great Hollywood Portrait Photographers*.

1990    Died July 3 in Canoga Park, California.

## WILL CONNELL

1898    Born in McPherson, Kansas.

1910    Started taking photographs.

1914    Moved to Los Angeles, California.

1917    Joined the Los Angeles Camera Club.

1925    Illustrated in *Colliers* and *The Saturday Evening Post*.

1931    Started the photography department at Art Center, Los Angeles.

1937    Published *The Missions of California* and *About Photography*.

1961    Died.

## IMOGEN CUNNINGHAM

1883    Born April 12 in Portland, Oregon.

1901    Attended University of Washington. Worked in the studio of Edward S. Curtis. Started to photograph.

1903    Received Bachelor of Arts degree in chemistry, University of Washington.

1909    Went on a scholarship to Technische Hochschule, Dresden, Germany, and studied under photo-scientist Robert Luther. Considered Kasebier & Utamaro major influences.

1907-09  Printed platinum prints for Edward S. Curtis in Seattle.

1910    Opened studio in Seattle.

1915    Married Roi Partridge.

1917    Moved to San Francisco.

1923    Joined Pictorial Photographers of America.

1932    Founding member Group f/64.

1940    Participated in group exhibition, "A Pageant of Photography," Golden Gate International Exposition, San Francisco.

1955    Joined Bay Area Photographers.

1969    Received Doctorate of Fine Arts at California College of Arts and Crafts, Oakland.

1973    Named Artist of the Year by San Francisco Art Commission.

1976    Died June 24.

## EDWARD SHERRIFF CURTIS

1868    Born in White Water, Wisconsin. Built his first camera as a child. Influenced by George Bird Grinnell, Native American expert.

1887    Moved to Seattle to work as a commercial photographer.

1896    Took his first photograph of a Native American.

1899    Was commissioned to accompany Edward H. Harriman's Alaskan expedition.

1900    Spent summer on Indian reservation in Montana; conceived idea of photographic study of all Indians west of the Mississippi.

1906    Awarded $75,000 grant from J. P. Morgan to compile *The North American Indian*; study was 20 volumes and 1500 published images upon completion in 1927.

1930    Moved to Los Angeles and worked as a still photographer.

1952    Died in Los Angeles.

## WILLIAM E. DASSONVILLE

1879    Born, place unknown.

1901    Had studio in San Francisco. Exhibited in First San Francisco Salon.

1902    Exhibited in Second San Francisco Salon.

1903    Exhibited in Third San Francisco Salon.

1906    Earthquake destroyed all his prints and negatives. Left San Francisco after the quake to photograph in the Sierras.

1920s   Began to experiment with making his own printing papers. Gave up studio to manufacture paper, Charcoal Black being his most popular.

1948    Had retrospective exhibition sponsored by the Bohemian Club, San Francisco.

1957    Died.

## FAUREST DAVIS

1906    Born in St. Louis, Missouri.

1930    Enrolled at University of Arizona.

1933    Started photographing with 8 x 10 view camera.

1936    Met Edward Weston in Santa Monica, California.

1939    Became commercial photographer.

1940    Exhibited in Golden Gate International Exposition in San Francisco.

1943    Discontinued photography as an art form.

1991    Died.

## MARGARET STRONG DE PATTA

1903    Born March 18 in Tacoma, Washington.

1921-23  Attended Academy of Fine Arts, San Diego, California.

1923-25  Attended California School of Fine Arts, San Francisco.

1926-29  Joined Art Students League, New York.

1930    Began work in jewelry.

1940-41  Studied at the School of Design, Chicago and worked with Moholy-Nagy.

1941-64  Experienced period of mature development as jewelry designer. Numerous individual and group exhibitions.

1964    Died in Oakland, California.

## JOHN PAUL EDWARDS

1884    Born on June 5 in Minnesota.

1902    Moved to California. Became amateur photographer; member Oakland Camera Club, Pictorial Photographers of America.

1930s   Daughter opened photography gallery in Oakland with Willard Van Dyke.

1932    Group f/64 held first meeting at gallery and Edwards became charter member.

1932    Participated in Group f/64 exhibition at de Young Memorial Museum in San Francisco.

1968    Died in Oakland.

## GEORGE R. FARDON

1807    Born in England.

1849-1859  Photographer in San Francisco.

1856    Published *San Francisco Album, Photographs of the Most Beautiful Views* and *Public Buildings of San Francisco*. Did portraits on leather of small size.

1859    Moved to Victoria, Vancouver Island, B.C.

1886    Died in Victoria, B.C.

## GEORGE FISKE

1835    Born in Amherst, New Hampshire.

1879    Became photographer in residence in Yosemite year round.

1918    Died.

## LOUIS FLECKENSTEIN

1866    Born in Faribault, Minnesota.

1890    Began to photograph.

1903    Won first place in Bausch & Lomb contest.

1907    Moved to Los Angeles.

1914    Organized and directed Los Angeles Pictorialist Club.

1924    Moved to Long Beach, California and appointed city's first Art Commissioner.

1943    Died in Long Beach.

## ARNOLD GENTHE

1869    Born January 8 in Berlin, West Germany.

1895    Went to San Francisco to tutor son of German family.

1897    Stayed on in San Francisco to pursue photography.

1898    Opened first studio on Sutter Street. Joined California Camera Club. Photographed celebrities of San Francisco.

1906    Earthquake destroyed everything except Chinatown photographs. Borrowed a camera and photographed the aftermath of the tragedy. Opened studio in Carmel.

1908    Photographed in Japan for six months.

1911    Moved to New York and opened portrait studio.

1918    Became United States citizen.

1942    Died in New York, August 9.

## JOHN GUTMANN

1905    Born in Breslau, Germany.

1926    Studied art and philosophy at the University of Breslau, Germany.

1933    Became interested in photography.

Landed job with *Presse-Foto* as photojournalist. Moved to San Francisco.

1934    Became member of California Camera Club.

1936    Found new job photographing for Pix, Inc., New York.

1937    Went back to San Francisco to teach art at San Francisco State College.

1938    One-man exhibition of photographs, *Colorful America*, M.H. de Young Memorial Museum, San Francisco.

1940    Published in numerous magazines including *National Geographic*, *The Saturday Evening Post*, and *Life*.

1941    One-man exhibition of photographs, *Wonderous World*, M.H. de Young Memorial Museum, San Francisco.

1942    Two-man exhibition, *Paintings by John Gutmann and Karl Baumann* at the San Francisco Museum of Art.

1943    Served with U.S. Army Signal Corps as a still and motion picture camera man.

1946    Instituted creative photography program at San Francisco State College.

1947    One-man exhibition, *The Face of the Orient*, M.H. de Young Memorial Museum, San Francisco.

1968    Honored for distinguished teaching by the California State Colleges.

1972    Began to print early negatives.

1976    Two-man exhibition with Walker Evans, *Vintage Prints of the 1930s*, Phoenix Gallery, San Francisco.

1977    Received Guggeheim fellowship.

1979    Resides in San Francisco.

## OTTO HAGEL

1909    Born in Fellbach, Germany.

1928    Moved to New York, then San Francisco. Worked as migrant worker.

1974    Died in Santa Rosa, California.

## JOHAN HAGEMEYER

1884    Born June 1 in Amsterdam, Holland.

1911    Came to the United States to work with brother in Santa Clara Valley.

1916    Went to New York where he met Alfred Stieglitz.

1917    Relocated to Los Angeles. Met Edward Weston.

1919    Moved to Bay Area and opened studio.

1920    Traveled to Europe.

1922    Published photographs in *Camera Craft*.

1923    Opened portrait studio in Carmel, California.

1927    Became photographer for *The San Franciscan*.

1938    One-man exhibition at the M.H. de Young Memorial Museum.

1939    Exhibited in the World's Fair Golden Gate International Exposition.

1952    Moved to Berkeley, California.

1962    Died May 20.

## ADELAIDE MARQUAND HANSCOM

1876    Born in Empire City, Oregon.

1880    Family moved to Berkeley, California. Studied at the Mark Hopkins Institute of Art, now the San Francisco Art Institute.

1902    Opened studio in San Francisco.

1903    Exhibited in the Third San Francisco Photographic Salon. Through exhibition became acquainted with the Photo-Secession. Published in *Photograms*.

1906    Lost negatives in the San Francisco earthquake.

1908    Married Gerald Leeson in Seattle, Washington.

1915    Husband died. Quit photography because of financial problems.

1920    Moved to Carmel with her two children.

1932    Died in a car accident.

## WILLIAM HEICK

1917    Born in Kentucky.

1940-41  Attended University of Cincinnati.

1942-45  Served as Naval Intelligence photographer in World War II.

1946-49  Continued education at San Francisco

State College and The California School of
Fine Arts, where he studied photography
with Ansel Adams and Minor White as
well as film, painting and sculpture.

1951    Started work with documentary film com-
pany, Orbit Films.

1954    Produced documentary films for Bechtel
Corporation.

1960-65  Produced anthropological documen-
taries.

1991    Resides in Mill Valley.

## GEORGE HURRELL

1904    Born in Cincinnati, Ohio.

1920    Studied art at Chicago Art Institute.

1922    Worked as photographer's assistant to
Eugene Hutchinson.

1925    Moved to Laguna Beach, California.

1927    Opened studio in Los Angeles. Met
Edward Steichen.

1930    Worked for Metro-Goldwyn Mayer.
Photographed famous personalities.

1933    Opened studio on Sunset Boulevard, Los
Angeles.

1935    Went to New York, photographing
portraits.

1938    Signed with Warner Brothers.

1942    Joined First Motion Picture Unit of the
U.S. Army.

1956    Formed partnership with Disney Studios,
producing motion pictures.

1965    Participated in show *Glamour Noses* at
Museum of Modern Art, New York.

1976    Exhibited in the show *Dreams For Sale* at
the Municipal Art Museum in Los Angeles.

1977    Published *The Hurrell Style.*

1980    One-man retrospective, Laguna Beach
Museum of Art, California.

1981    Portraits included in ABC's special, "Sixty
Years of Seduction."

1983    Selected photographs chosen for perma-
nent collection in George Eastman House.

## HENRY A. HUSSEY

1887    Born in Sacramento, California.

1909    Graduated from the University of
California, Berkeley. Bought first camera
while stationed in Germany during World
War I.

1920    Was founding member of Pictorial
Photography Society of San Francisco.
Published photographs and criticism fre-
quently in *Camera Craft.*

1939    Began working exclusively with
Kodachrome.

1959    Died.

## PIRKLE JONES

1914    Born January 2 in Shreveport, Louisiana.

1931    Bought a Brownie camera.

1936    Bought a Rolleiflex and began to photo-
graph seriously.

1941-46  Served in Armed Forces.

1946-49  Attended California School of Fine
Arts.

1949-52  Assistant to Ansel Adams.

1952-58  Taught at San Francisco School of
Fine Arts.

1960    Published documentary essay with
Dorothea Lange entitled "Death of a
Valley."

1966-70  Taught at Yosemite Valley Workshops.

1970-80s  Taught at San Francisco Art Institute.

1991    Resides in Mill Valley.

## ARTHUR F. KALES

1882    Born in Arizona.

1903    Graduated from University of California,
Berkeley.

1916    Exhibited in London Salon of 1916.

1920    Worked exclusively in bromoil transfer
process. Wrote articles for *Photograms of
the Year.*

1928    Exhibition of fifty prints at Smithsonian
Institution, Washington D.C.

1936    Died.

## FLORENCE B. KEMMLER

1900    Born in Columbus, Ohio.

1920    Moved to San Diego.

1922    Started photographing. Worked closely
with Dr. Roland Schneider. Member,
Pictorial Photographers of America.

1935    Work reviewed in the *American Annual of
Photography.* Showed in 229 salons in five
years.

1972    Died.

## HIROMU KIRA

1898    Born in Hawaii.

1914    Family moved to Canada.

1919    Started photographing with borrowed
camera.

1923    Exhibited two prints in Seattle Salon.

1924    Exhibited one print in Pittsburgh Salon
(annual competition of photography).

1925    Published print "Shade and Shadows" in
*American Annual of Photography.*

1926    Moved to Los Angeles.

1928    Was made Associate of the Royal
Photographic Society.

1929    Was made Fellow (full member) of the
Royal Photographic Society.

1942    Exhibited in Annual International Salon of
the Camera Pictorialists of Los Angeles.

1991    Died.

## DOROTHEA LANGE

1895    Born May 26 in Hoboken, New Jersey.

1915    Worked for Arnold Genthe in New York
and started photographing.

1917    Studied photography at Columbia
University under Clarence H. White.

1918    Moved to San Francisco and worked as
photofinisher.

1919    Opened portrait studio in San Francisco.

1920    Married painter Maynard Dixon on
March 21.

1934    Exhibited work in the studio of Willard
Van Dyke in San Francisco. Photographed

the Unemployed Exchange Association.

1935 Worked for Division of Rural Rehabilitation and Farm Security Administration. Exhibited in *The Plow That Broke the Plains.* Divorced, and married Paul Taylor.

1938 Worked with Taylor on *An American Exodus: A Record of Human Erosion.*

1940 Was photographer for Bureau of Agricultural Economics.

1942 Photographed Japanese Americans for War Relocation Authority.

1953 Worked with Ansel Adams on *Life* assignment, "Three Mormon Towns," September 6, 1954.

1960 Exhibited photo essay, "Death of a Valley," San Francisco Museum of Art and Art Institute of Chicago.

1961 Had one-woman exhibition at Siembab Gallery in Boston.

1962 Exhibited in "USA FSA: Farm Security Administration Photographs of the Depression Era."

1963 Recognized on Honor Roll of the America Society of Magazine Photographers on May 29.

1965 Died of cancer in Marin County.

## ALMA LAVENSON

1897 Born in San Francisco.

1915 Entered University of California; studied photography on her own.

1924 Practiced amateur photography; frequent exhibitor in photographic salons.

1930 Met Edward Weston, Imogen Cunningham, and Consuelo Kanaga. Became member of Pictorialist Photographers of America.

1932 Invited to participate in Group f/64 exhibition at M.H. deYoung Memorial Museum, which included members of Group f/64 and four invited exhibitors.

1933 Married; continued photography but never again as a livelihood.

1989 Died in Piedmont, California.

## MAN RAY

1890 Born in Philadelphia.
1910 Met Alfred Stieglitz at Gallery 291.

1915 Solo exhibition of paintings and drawings at Daniel Gallery, New York. Began photographing.

1921 Became professional photographer. Moved to Paris.

1922 Experimented using different photographic techniques in his photography. Made first cameraless images called Rayographs.

1940 Returned to U.S. when Nazis invaded France.

1942 Moved to Hollywood and worked freelance.

1951 Returned to Paris.

1960 Experimented with color photography.

1976 Died in Paris.

## ROSE MANDEL

1910 Born in Czantec, Poland.

1937 Spent two and one-half years in Paris.

1939 Attended Institut de Sciences de l'Education, Geneva, Switzerland, studying child psychology and education. After graduation, taught kindergarten and experimental school.

1942 Emigrated to the United States, traveled to New York, and settled in California.

1946-47 Studied photography with Ansel Adams and Minor White at the California School of Fine Arts, San Francisco.

1948 Solo exhibition, *On Walls and Behind Glass,* sequence of twenty photographs, San Francisco Museum of Art.

1948-67 Worked as art department photographer, University of California, Berkeley.

1951 Group exhibition, San Francisco Museum of Art; exhibition, Palo Alto Art Club.

1952 Solo exhibition, The Palindrome, Berkeley.

1954 "The Errand of the Eye," George Eastman House of Photography, Rochester, New York. Selection by Minor White.

1956 Portfolio of photographs, "The Errand of the Eye," selected by Minor White, published in *Aperture.*

1960 Group exhibition, *The Sense of Abstraction,* Museum of Modern Art, New York.

1962 Group exhibition, *From Subject to Symbol,* San Francisco Museum of Art. Group exhibition, Junior Center of Art and Science, Oakland, California, with Roy De Forest (paintings) and Sidney Gordin (sculpture). Group exhibition, Photography-USA National Invitational Exhibition, De Cordova Museum, Lincoln, Massachusetts.

1967 Received a Guggenheim fellowship in photography.

1989 Inaugural group exhibition, *Legacy: Northern California's Photographic Tradition,* The Friends of Photography, Ansel Adams Center, San Francisco.

1991 Resides in Berkeley, California.

## MARGRETHE MATHER

1885 Born in Salt Lake City, Utah. Settled in Los Angeles.

1912 Met Edward Weston and became his assistant and business partner in Glendale studio.

1914 Was one of the founding members of the Los Angeles Photo Pictorialists.

1931 With friend William Justema collaborated on the exhibition *Pattern and Photography* at the de Young Memorial Museum in San Francisco.

1930s Gave up photography.

1952 Died in Glendale of multiple sclerosis.

## OSCAR MAURER

1871 Born in New York. Nephew of Louis Maurer, artist for Currier & Ives and cousin of painter Alfred Maurer. Studied chemistry and physics, University of California, Berkeley.

1886 Took first photographs, shortly after arrival in San Francisco.

1906 Briefly shared studio with Arnold Genthe in San Francisco. Studio destroyed in 1906 fire. Made well-known series of earthquake and fire photographs, using folding Kodak #1.

1907 Established studio on Le Roy Avenue in

Berkeley; building designed by Bernard Maybeck. Organizer of San Francisco Camera Club. Exhibited in Photo-Secession Gallery, New York.

1939    Took series of photographs of Golden Gate International Exposition, San Francisco.

1965    Died in Berkeley, California.

## HANSEL MIETH

1909    Born April 9 in Fellbach, Germany.

1930    Left Germany.

1931    Joined Otto Hagel in San Francisco. Worked as migrant worker; then for Works Project Administration.

1937    Joined staff of *Life*, worked as freelance photojournalist.

1941    Purchased farm near Santa Rosa, California.

1991    Resides in Santa Rosa.

## WRIGHT MORRIS

1910    Born in Central City, Nebraska.

1930-33    Attended Pomona College.

1933    Bought first camera in Vienna.

1934    Returned to California.

1935    Bought Rolleiflex camera.

1938    Moved to Connecticut and began using view camera.

1940    Published a selection from *The Inhabitants*, one of first books to combine photographic images with printed words.

1942    Received Guggenheim fellowship and completed work on *The Inhabitants*; returned to California.

1947    Second Guggenheim fellowship.

1954    Third Guggenheim fellowship; continued to publish, teach and exhibit work widely.

1991    Resides in California.

## WILLIAM MORTENSON

1897    Born in Park City, Utah. Studied at the Art Students League, New York. Learned photography from Arthur Kales.

1920    Went to Hollywood.

1920s    Established successful career as Hollywood still photographer.

1925    Opened studio on Hollywood Boulevard.

1930s    Moved to Laguna Beach.

1930    Founded Mortenson School of Photography, Laguna Beach, which operated for 30 years and carried pictorialist tradition into era of "straight" photography.

1935    Began experiments with Metalchrome process, translating black and white into color. Wrote nine books on print control techniques.

1948    Solo exhibition, Smithsonian Institution, Washington, D.C.

1965    Died on August 12 of leukemia.

## EADWEARD JAMES MUYBRIDGE

1830    Born April 19 in Kingston-Upon-Thames, England.

1851    Went to New York.

1855    Moved to San Francisco where he sold books.

1867    Studied with Carleton E. Watkins.

1872    Photographed Leland Stanford's horses.

1873    Awarded International Gold Medal for landscape at Vienna International Exhibition.

1878    Succeeded in photographing Stanford's horses in motion.

1879    Invented the zoopraxiscope.

1881    Published *The Attitudes of Animals in Motion* (Palo Alto).

1882    Stanford published *The Horse in Motion* in April; no credit given to Muybridge.

1894    Returned to England.

1904    Died May 8 in Kingston-Upon-Thames.

## KENTARO NAKAMURA

1920s    Founding member of the Los Angeles-based Japanese Camera Pictorialists of California.

1926    Exhibited in first salon of Japanese Camera Pictorialist of California.

1935    Returned to Japan.

## SONYA NOSKOWIAK

1900    Born November 25 in Leipzig, Germany.

1915    Came to the United States.

1929-34    Studied photography and worked as darkroom assistant for Edward Weston, San Francisco.

1929    Worked as receptionist in Johan Hagemeyer's Los Angeles studio.

1932    Founding member, Group f/64.

1935    Worked for *Sunset* magazine and had own portrait and architectural photography studio.

1975    Died April 28 in Greenbrae, California.

## MARION PALFI

1907    Born on October 21 in Berlin, Germany.

1930s    Trained as dancer in Berlin.

1934-35    Freelance industrial and magazine photographer.

1935-36    Freelance portrait photographer.

1936-40    Established studio in Amsterdam.

1940-44    Emigrated to United States; worked as photofinisher in Los Angeles.

1945-78    Freelance social documentary photographer; received numerous awards.

1967    Received Guggenheim fellowship.

1974    Received National Endowment for Arts Photography fellowship.

1978    Died in Los Angeles on November 4.

## EMILY PITCHFORD

1878    Born in Gold Hill, Nevada. Attended Mark Hopkins Institute of Art, San Francisco.

1909    Won bronze medal at Alaska-Yukon Pacific Exposition, Seattle, Washington. Shared studio with Laura Adams Armer, Berkeley.

1911    Married William Hussey and moved to South Africa.

1921    Returned to Bay Area. Work often published in *Camera Craft*.

1954    Died.

## PETER STACKPOLE

1913    Born in San Francisco.

1930-32    Documented construction of Golden Gate and Bay Bridges; published in *Vanity Fair*.

1930s    Invited to join Group f/64 by founder Willard Van Dyke. Freelance photographer for *Time*.

1936    Hired as one of first *Life* staff photographers.

1938-51    Covered Hollywood for *Life*; war in 1944-45.

1951-61    Specialized in underwater photography.

1962    Freelanced for various publications.

## LOU STOUMEN

1917    Born in Springtown, Pennsylvania.

1927    First photographed with "vest pocket Kodak."

1939    Produced first "paper movie", a book of 50 photographs and 12 poems.

1940    Freelance photographer.

1946    Settled in Los Angeles.

1950s    Exhibited in group shows at Museum of Modern Art.

1956    Produced *The Naked Eye*, feature length documentary about photography.

1991    Died.

## KARL STRUSS

1886    Born November 30 in New York.

1908-12    Attended night classes in photography with Clarence White at Columbia University, New York.

1909    Invented a soft-focus lens.

1910    Participated in exhibition with Photo-Secession, Albright Gallery, Buffalo, New York.

1912    Member of Photo-Secession; eight prints in Camera Work.

1914    Took over Clarence White's studio.

1915    Founded, with Clarence White and Edward R. Dickson, the Pictorial Photographers of America.

1917    Published *The Female Figure*, reproductions of color prints.

1919    Went to Hollywood. Worked as still photographer for Cecil B. DeMille. After three months became cinematographer. Continued to exhibit in salons, but did most work as a cinematographer.

1981    Died in Los Angeles.

## ROGER STURTEVANT

1903    Born in Alameda, Calfornia.

1921    Opened portrait studio in home.

1926    Did commercial photography for Southern Pacific, MJB Coffee, Caterpillar Tractor and others.

1927    First architectural photos taken in Santa Cruz.

1960    Received first American Institute of Architecture Medal for Architectural Photography.

1982    Died.

## ISAIAH TABER

1830    Born in New Bedford, Massachusetts.

1845    Went to sea on whaling expedition.

1949    Arrived in San Francisco.

1852    Bought a ranch and made a fortune farming.

1854    Returned to New Bedford and studied photography.

1855    Opened gallery in Syracuse, New York.

1864    Returned to San Francisco as chief operator for photographic firm of Bradley and Rulofson.

1871    Opened own gallery in San Francisco.

1906    Earthquake ended career when all his glass plates, 20 tons of view negatives and 80 tons of portraits on glass were destroyed.

1912    Died.

## EDMUND TESKE

1911    Born March 7 in Chicago, Illinois. Taught himself photography.

1928    Became photographer but continued in family business.

1933-34    Worked in Hull House theatre department, doing everything including photography.

1934-36    Assistant photographer commercial studio.

1936-38    Established photo workshop at Taliesin, Spring Green, Wisconsin; was instructor at New Bauhaus Institute of Design.

1940-41    Was assistant to Berenice Abbott, New York.

1943    Settled in Los Angeles.

1944    Worked in photographic department, Paramount Pictures, Hollywood.

1962-79    Taught at various universities.

1969    Awarded Certificate of Recognition from Photographic Society of America.

1991    Resides in Los Angeles.

## SHIGEMI UYEDA

1902    Born in Japan.

1922    Came to United States; worked as a farmer.

1943    Sent to relocation camp.

1980    Died in Westminster, California.

## WILLARD VAN DYKE

1906    Born December 5 in Denver, Colorado. Taught himself photography; influenced by Weston, Adams, and Ralph Steiner.

1927    Received first prize, *Camera Craft*.

1930-35    Worked independently as social documentary photographer.

1932    Founding member of Group f/64, San Francisco.

1933    Had solo exhibition, San Diego Museum of Art, California.

1934    Became photographer for Public Works Administration Art Project, San Francisco.

1940-45    Appointed Technical Director, Film Section, Office of War Information, Washington, D.C.

1946-58    Producer, Affiliated Film Producers, New York.

1958-1981    President, Van Dyke Productions Inc., New York.

1986  Died January 23 in Jackson, Tennessee.

## CARLETON E. WATKINS

1829  Born November 11 in Oneonta, New York.

1849  Sailed for San Francisco with friend Collis P. Huntington.

1854  Learned daguerreotype and worked with Robert H. Vance in San Jose studio.

1856  First trip to New Almaden Quicksilver Mine.

1861  Daguerrean operator in San Francisco; first trip to Yosemite to make largest outdoor views of California to that time.

1864  Photographs became influential when Yosemite Act submitted to preserve area for the people.

1866  Photographed for California Survey party.

1867  Opened Yosemite Art Gallery in San Francisco. Won first prize for photographic landscape at Paris Exposition.

1870  Photographed for Clarence King's expedition.

1872  Expanded Yosemite Art Gallery.

1873  Studio and negatives auctioned; I. W. Taber bought everything and issued Watkins' photographs with Taber's stamp on them.

1906  Negatives destroyed in San Francisco earthquake.

1910  Committed to Napa State Hospital in Imola, California.

1916  Died in Napa, California.

## CHARLES LEANDER WEED

1824  Born July 17 in New York.

1854  Went to Sacramento. Worked for George W. Watson.

1858  Became gallery partner with Robert H. Vance.

1859  Took first photographs of Yosemite. Plates were made from his photographs to illustrate Hutchings' *California* magazine.

1867  Received highest award at Paris International Exposition for Yosemite views.

1903  Died August 31 in Oakland, California.

## BRETT WESTON

1911  Born December 16 in Los Angeles, California.

1925  Took first photographs using father's camera.

1926  Experimented with glossy paper.

1927  Had first exhibition at University of California, planned by Barbara Morgan; showed 20 prints alongside his father's 100. Exhibited with father at California Art Club in October.

1928  Opened portrait studio with his father in Glendale, California. Moved to San Francisco; then to Carmel, California.

1929  Exhibited in *Film und Foto* exhibition in Stuttgart; also at Denny-Watrous Gallery, Carmel.

1930  Returned to Glendale and established portrait studio.

1932  Invited by Group f/64 to exhibit in first show at M. H. de Young Memorial Museum, San Francisco.

1935  Opened portrait studio in Santa Monica with father; left at end of year for San Francisco.

1938  Began producing portfolios of work.

1943  Worked briefly as assistant cameraman at Twentieth Century Fox.

1945  Received Guggenheim fellowship.

1948  Moved to Carmel with brother Cole. Continued own work while aiding ailing father.

1949-80s Produced several portfolios, publications; over 100 solo exhibitions. Resides in Carmel Valley and Hawaii.

## EDWARD WESTON

1886  Born March 24 in Highland Park, Illinois.

1902  Made first photographs.

1906  Went to California and became door-to-door portrait photographer.

1907  Studied at Illinois College of Photography, Effingham, Illinois, but did not graduate.

1911  Opened portrait studio in Tropico (now Glendale), California.

1914  Founding member, Los Angeles Camera Pictorialists.

1917  Elected to London Salon.

1922  Solo exhibition, Academia de Bellas Artes, Mexico.

1923-26  Lived in Mexico intermittently; style underwent transformation; abandoned pictorial style to become leading proponent of hard-focused "straight photography."

1925  Shared studio in San Francisco with Johan Hagemeyer for six months.

1927  Exhibited at University of California and California Art Club; sixteen-year-old son Brett's work shown also.

1928  Opened studio with son Brett in Carmel, California.

1932  Founding member of Group f/64, San Francisco; first exhibition of group's work at M. H. de Young Memorial Museum, San Francisco.

1935  Opened portrait studio in Santa Monica with son Brett.

1937  Received Guggenheim fellowship.

1938  Moved to Wildcat Hill, Carmel, California.

1940  Published *California and the West*.

1946  Had major retrospective at Museum of Modern Art, New York.

1948  Made last photograph at Point Lobos, California.

1952  With help of sons and friends, published *50th Anniversary Portfolio*.

1958  Died January 1 in Carmel.

## MINOR WHITE

1908  Born in Minneapolis, Minnesota.

1933  Moved to Portland, Oregon.

1938  Awarded Works Project Administration grant to photograph in Portland, Oregon.

1940  Taught photography at LaGrande Art Center in eastern Oregon.

1942  Served in Army Intelligence Corps.

1945  Studied art history at Columbia University.

1946  Met Alfred Stieglitz. Taught at California School of Fine Arts, San Francisco.

1947  Produced *Second Sequence/Amputations.*

1952  Founded and became editor of *Aperture.*

1953  Became curator, George Eastman House, Rochester, NY.

1976  Died in Boston, Massachusetts.

## Edward L. Woods

1880-89  Active in California.

## Willard E. Worden

1868  Born on November 20 in Philadelphia, Pennsylvania. Taught self photography while stationed in the Phillipines during the Spanish-American War.

1900  Went to California.

1902  Opened professional studio in San Francisco.

1915  Was official photographer for the Panama-Pacific International Exhibition, San Francisco.

1946  Died September 6 in Palo Alto, California.

## Max Yavno

1911  Born April 26 in New York City.

1927  Studied at Columbia University.

1937  Photographed for Works Progress Administration.

1939  Elected president of Photo League.

1945  Was photography instructor in the Army.

1950  Photographs published in *The San Francisco Book* and *The Los Angeles Book.*

1953  Received Guggenheim fellowship.

1954  Opened commercial photography studio, San Francisco. Awarded gold medals from New York Art Directors' Club.

1972  Studied cinematography at UCLA.

1985  Died April 4.

# BIBLIOGRAPHY

Adams, Ansel. *Ansel Adams: Letters and Images, 1916-1984.* Edited by Mary Street Alinder. Boston: Little, Brown and Company, 1988.

——. *Born Free and Equal: Photography of the Loyal Japanese-Americans at Manzanar Relocation Center, Inyo County, California.* New York: V.S. Camera, 1944.

——, ed. *A Pageant of Photography.* Exhibition catalogue. San Francisco: Golden Gate International Exposition, 1940.

Adams, Ansel, with Mary Street Alinder. *Ansel Adams: An Autobiography.* Boston: Little, Brown and Company, 1985.

Adams, Laura. "The Picture Possibilities of Photography." *Overland Monthly* 36, 213 (September 1900): 241-245.

*Adelaide Hanscom Leeson: Pictorialist Photographer 1876-1932.* Carbondale, IL: Southern Illinois University, 1981.

Alinder, James. *Wright Morris: Photographs & Words.* Carmel: The Friends of Photography, 1982.

Baird, Joseph Armstrong, Jr., and Ellen Schwartz. *Northern California Art: An Interpretive Bibliography to 1915.* Davis, CA: Library Associates, University Library, University of California, 1977.

Baldwin, Neil. *Man Ray: American Artist.* New York: Clarkson N. Potter, Inc., 1988.

Bernhard, Ruth, and Margaretta K. Mitchell. *Ruth Bernhard: The Eternal Body.* Carmel: Photography West Graphics, 1986.

Brigman, Anne W. *Songs of a Pagan.* Caldwell, ID: Caxton Printers, 1949.

——. "What 291 Means to Me." *Camera Work* 47 (July 1914): 17- 20.

Bristol, Horace. *Photographer & Photography in My Life.* Unpublished manuscript, 1989.

Bunnel, Peter C. *Minor White: The Eye that Shapes.* Princeton: The Art Museum, Princeton University, 1989.

Buerger, Janet E. *The Last Decade: The Emergence of Art Photography in the 1890s.* Rochester, NY: International Museum of Photography at George Eastman House, 1984.

Burgess, Gelett. *Bayside Bohemia, Fin de Siècle San Francisco and its Little Magazines.* Reprint of 1894 edition. San Francisco: Book Club of California, 1954.

Caffin, Charles H. *Photography as a Fine Art.* New York: Doubleday, Page Company, 1901.

California Camera Club. *First San Francisco Photographic Salon 1901.* San Francisco, CA: Camera Craft, 1901.

The California Camera Club and San Francisco Art Association. *Catalog of the Third San Francisco Photographic Salon at the Mark Hopkins Institute of Art,* 1903.

——. *The Second San Francisco Photographic Salon,* 1902.

"California Camera Cracks Win Honors in Competition with All the World." *San Francisco Chronicle Sunday Supplement,*" 5 February 1905.

*Camera Craft: A Photographic Monthly* 1-9. San Francisco, 1900-1906.

*Camera Work* 1-50. New York, 1903-1917.

Chappell, Walter. "The Threshold of Vision." In *Minor White: A Living Remembrance.* Millerton, NY: Aperture, 1984.

Coke, Van Deren. *Brett Weston: Master Photographer.* Carmel, CA: Photography West Graphics, 1989.

——. *Photographs by Will Connell.* San Francisco: The San Francisco Museum of Modern Art, 1981.

Coles, Robert, and Therese Thau Heyman. *Dorothea Lange: Photographs of a Lifetime.* Millerton, NY: Aperture, 1982.

Conger, Amy. "Edward Weston's Early Photography, 1903-1926." Ph.D. diss., University of New Mexico, 1982.

Corn, Wanda M. *The Color of Mood: American Tonalism, 1880-1910.* San Francisco: California Palace of the Legion of Honor, 1972.

Cunningham, Imogen. *Imogen Cunningham: Portraits, Ideas, and Design.* Interview by Edna Tartaul Daniel. Berkeley: University of California, 1961.

Current [Sinsheimer], Karen, and William R. Current. *Photography and the Old West.* New York: Harry N. Abrams, 1978.

Danley, Susan, and Weston J. Naef. *Edward Weston in Los Angeles.* Exhibition catalogue. San Marino, CA: The Huntington Library; and Malibu, CA: The J. Paul Getty Museum, 1986.

Dassonville, W. E. "Individuality in Photography." *Overland Monthly* 40, 4 (October 1902): 339-345.

Dater, Judy. *Imogen Cunningham: A Portrait.* Boston: Little, Brown and Company, 1979.

Dicker, Laverne Mau. "Laura Adams Armer, California Photographer." *California Historical Society Quarterly* 56, 2 (Summer 1977) 128-139.

Dilley, Clyde H. *The Photography and Philosophy of Wynn Bullock.* Philadelphia: The Art Alliance Press, 1984.

Doty, Robert. *Photo-Secession: Stieglitz and the Fine Art Movement in Photography.* New York: Dover Publications, Inc., 1960.

Ehrens, Susan. *Alma Lavenson: Photographs.* Berkeley: Wildwood Arts, 1991.

Enyeart, James. *Bruguière: His Photographs and His Life.* New York: Alfred A. Knopf, 1977.

Ewing, William. *Ordinary Miracles: The Photography of Lou Stoumen.* Los Angeles: Hand Press, 1981.

Fahey, David, and Linda Rich. *Masters of Starlight.* New York: Ballantine Books, 1987.

"Fear Retards Woman, Avers Mrs. Brigman." *San Francisco Call,* 8 June 1913: 33.

Fels, Thomas Weston. *Carleton Watkins, Photographer.* Williamstown, MA: Clark Art Institute, 1985.

———. *Eadweard Muybridge: Animal Locomotion*. Albany: State University of New York, 1983.

Foresta, Merry A. "Art and Document: Photography of the Works Progress Administration's Federal Art Project." In Pete Daniel, et al., *Official Images: New Deal Photography*. Washington D.C.: Smithsonian Institution Press, 1987.

Fuller, Patricia Gleason. *Alma Lavenson*. Riverside: California Museum of Photography, University of California, Riverside, 1979.

Genthe, Arnold. "Rebellion in Photography." *The Overland Monthly* 43, 8 (August 1901): 92-102.

Gray, Andrea. *Ansel Adams: An American Place, 1936.* Tucson: Center for Creative Photography, University of Arizona, 1982.

Green, Jonathan, ed. *Camera Work: A Critical Anthology*. Millerton, NY: Aperture, Inc., 1973.

Haas, Robert Bartlett. *Muybridge, Man in Motion*. Berkeley: University of California Press, 1976.

Hall, James Baker. *Minor White: Rites & Passages*. Millerton, NY: *Aperture, 1978.*

Hamilton, Emily J. "Some Symbolic Nature Studies from the Camera of Annie W. Brigman." *The Craftsman* 12 (September 1907): 660-666.

Hart, James D. *A Companion to California*. New York: Oxford University Press, 1978.

Hartmann, Sadakichi. *The Valiant Knights of Daguerre: Selected Critical Essays on Photography and Profiles of Photographic Pioneers*. Berkeley: University of California Press, 1978.

Hendricks, Gordon. *Eadweard Muybridge—The Father of the Motion Picture*. New York: Grossman Publishers, 1975.

Heyman, Therese Thau. *Anne Brigman: Pictorial Photographer/ Pagan/ Member of the Photo Secession*. Oakland: The Oakland Museum, 1974.

———. *Celebrating A Collection: The Work of Dorothea Lange*. Oakland: The Oakland Museum, 1978.

———. *Mirror of California*. Oakland: The Oakland Museum, 1973.

———. *Slices of Time*. Oakland: The Oakland Museum, 1981.

———, ed. *Picturing California: A Century of Photographic Genius*. San Francisco: Chronicle Books, 1989.

Homer, William Innes. *Alfred Stieglitz and the Photo-Secession*. Boston: New York Graphic Society, 1983.

Johnson, William. *Sonya Noskowiak*. Tucson: Center for Creative Photography, University of Arizona, 1979.

Jones, Harvey. *Mathews: Masterpieces of the California Decorative Style*. Layton, UT: Gibbs M. Smith, Inc., in association with The Oakland Museum, 1985.

Justema, William. "Margaret: A Memoir." In *Margrethe Mather*. Tucson: Center for Creative Photography, University of Arizona, 1979.

Kanaga, Consuelo. *Consuelo Kanaga*. Exhibition catalogue. New York: Blue Moon Gallery and Lerner-Heller Gallery, 1974.

Katzman, Louise. *Photography in California, 1945-1980*. San Francisco: San Francisco Museum of Modern Art, 1984.

Kingston, Maxine Hong. "San Francisco's Chinatown: A View from the Other Side of Arnold Genthe's Camera." *American Heritage* 30, 1 (December 1978): 36-47.

Kozloff, Max. "The Extravagant Depression." In John Gutmann, *The Restless Decade: John Gutmann's Photographs of the Thirties*. New York: Harry N. Abrams, 1984.

Lange, Dorothea. *Dorothea Lange: The Making of a Documentary Photographer*. Interview with Suzanne Riess. Berkeley: University of California, Bancroft Library, 1968.

Maddow, Ben. *Edward Weston: His Life and Photographs*. Millerton, NY: Aperture, 1979.

———. *Max Yavno*. Berkeley: University of California Press, 1981.

Man Ray. *Self Portrait: Man Ray*. Boston: Little, Brown and Company, 1963.

Mann, Margery. *California Pictorialism*. San Francisco: San Francisco Museum of Modern Art, 1977.

———. *Imogen Cunningham, Photographs*. Seattle: University of Washington Press, 1970.

McGlynn, Betty Lochrie Hoag. *The Magic Lens of Dr. Genthe (1869-1942)*. Berkeley: The Bancroft Library, n.d.

Meltzer, Milton. *Dorothea Lange: A Photographer's Life*. New York: Farrar Staus Giroux, 1978.

Mitchell, Margaretta K. *Recollections: Ten Women of Photography*. New York: Viking Press, 1979.

Mozley, Anita Ventura, with Robert Barlett Haas and Francoise Forster-Hahn. *Eadweard Muybridge: The Stanford Years*. Palo Alto: Stanford University, 1972.

Muchnic, Suzanne. *Southern California Photography 1900-65: An Historical Survey*. Los Angeles: The Photography Museum, Los Angeles, 1980.

Muir, John. *Mountaineering Essays*. Salt Lake City: Peregrine Smith Books, 1984.

Naef, Weston J. *The Collection of Alfred Stieglitz: Fifty Pioneers of Modern Photography*. New York: Metropolitan Museum of Art, 1978.

———. *The Painterly Photograph, 1890-1914*. New York: Metropolitan Museum of Art, 1973.

Naef, Weston J., and James N. Wood, with Therese Thau Heyman. *Era of Exploration*. Boston: New York Graphic Society, 1975.

Newhall, Beaumont. *The Daguerreotype in America*. New York: Duel, Sloan, and Pearce, 1961.

——. *Supreme Instants: The Photography of Edward Weston.* Tucson: Center for Creative Photography, University of Arizona, 1986.

Newhall, Nancy. *Ansel Adams: The Eloquent Light.* San Francisco: Sierra Club, 1963.

Norris, Frank. *McTeague, A Story of San Francisco (1899).* New York: Rinehart and Co., 1950.

Ohrn, Karin Becker. *Dorothea Lange and the Documentary Tradition.* Baton Rouge: Louisiana State University Press, 1980.

Palmquist, Peter E. *Carleton E. Watkins.* Albuquerque: University of New Mexico Press, 1983.

Palmquist, Peter E., and Jeffrey Fraenkel. *Carleton E. Watkins.* San Francisco: Bedford Arts, 1989.

The Oakland Museum. Archives. Oakland, California.

——. *The Art of California: Selected Works from the Collection of the Oakland Museum.* Oakland: The Oakland Museum, 1984.

——. *A Directory of Women in California Photography Before 1901.* Arcata, CA: Peter E. Palmquist, 1990.

——. Photographers' Files on Adams, Brigman, Genthe, Dassonville and Maurer. Photography Department. Oakland, California.

Pepper, Terrence, and John Kobal. *The Man Who Shot Garbo: The Hollywood Photographs of Clarence Sinclair Bull.* New York: Simon and Schuster, 1989.

Reed, Dennis. *Japanese Photography in America, 1920-1945.* Los Angeles: Japanese American Cultural and Community Center, 1985.

Royce, Josiah. *California, A Study of American Character.* Boston: Houghton, Mifflin and Company, 1888.

Starr, Kevin. *Americans and the California Dream.* New York: Oxford University Press, 1973.

Stebbins, Jr., Theodore E. *Weston's Westons: Portraits and Nudes.* Boston: Museum of Fine Arts, 1989.

Stein, Sally. "Figures of the Future." In Pete Daniel, et al., *Official Images: New Deal Photography.* Washington, D.C.: Smithsonian Institution Press, 1987.

Stieglitz, Alfred. "The Photo-Secession—Its Objects." *Camera Craft* 7, 3 (August 1903): 80-83.

Stine, Whitney. *50 Years of Photographing Hollywood: The Hurrell Style.* New York: The John Day Company, 1976.

Sutnik, Maia-Mari, and Michael Mitchel. *Gutmann.* Exhibition catalogue. Toronto: Art Gallery of Ontario, 1985.

Tchen, John Kuo Wei. *Genthe's Photographs of San Francisco's Old Chinatown.* New York: Dover Publications, Inc., 1984.

Teske, Edmund. *Edmund Teske.* Exhibition catalogue. Los Angeles: Los Angeles Municipal Art Gallery, 1974.

——. *Images from Within: The Photographs of Edmund Teske.* Carmel, CA: The Friends of Photography, 1980.

Tucker, Jean S. *Group f/64.* Exhibition catalogue. St. Louis: University of Missouri, 1978.

*The Wave* 1-23. San Francisco, 1887-1901.

Weston, Edward. *The Art of Edward Weston.* Edited by Merle Armitage. New York: E. Weythe, 1932.

——. *The Daybooks of Edward Weston. Volume I: Mexico* and *Volume II: California.* Edited by Nancy Newhall. Millerton, NY: Aperture, 1973.

——. *Edward Weston: On Photography.* Edited by Peter C. Bunnell. Salt Lake City: Gibbs M. Smith, 1983.

——. *My Camera on Point Lobos.* Boston: Houghton Mifflin, 1950.

Weston, Edward, and Charis Wilson Weston. *California and the West.* New York: Duell, Sloan and Pearce, 1940.

White, Minor. *Mirrors Messages Manifestation.* Millerton, NY: Aperture, 1969; second edition, 1982.

Wilson, Charis. *Edward Weston: Nudes, A Remembrance by Charis Wilson.* Millerton, NY: Aperture, 1977.

Wright, David. "Arnold Genthe: Gentleman Photographer and Pioneer Photojournalist." *University Publishing* 12 (Winter 1984): 18-19.

# INDEX